Transforming Faith

Gender and Globalization
Susan S. Wadley, *Series Editor*

Other books in the Gender and Globalization series

Transforming Faith

◆ ◆ ◆

The Story of Al-Huda and
Islamic Revivalism among
Urban Pakistani Women

◆ ◆ ◆

Sadaf Ahmad

SYRACUSE UNIVERSITY PRESS

Material from chapter 3, "Of Allah and the Power-Point," will appear as "Al-Huda: Of Allah and the Power-Point," in *Islam and Society in Pakistan: Anthropological Perspectives*, Oxford in Pakistan Readings in Sociology and Social Anthropology. It will be published by the Oxford University Press in Karachi, Pakistan, in 2010, and has been reproduced by permission.

Material from chapter 5, "Culture Matters, Global Wars," appeared as "Identity Matters, Culture Wars: An Account of Al-Huda (Re)defining Identity and Reconfiguring Culture in Pakistan," *Culture and Religion* 9, no. 1 (2008): 63–80, and has been reproduced here by permission. The journal can be located at http://www.informaworld.com.

∞ The paper used in this publication meets the minimum requirements of the American National Standard for Information Sciences—Permanence of Paper for Printed Library Materials, ANSI Z39.48–1992.

For a listing of books published and distributed by Syracuse University Press, visit our Web site at SyracuseUniversityPress.syr.edu

ISBN: 978-0-8156-3209-2

Library of Congress Cataloging-in-Publication Data
Ahmad, Sadaf.
 Transforming faith : the story of Al-Huda and Islamic revivalism among urban Pakistani women / Sadaf Ahmad. — 1st ed.
 p. cm. — (Gender and globalization)
 Includes bibliographical references and index.
 ISBN 978-0-8156-3209-2 (cloth : alk. paper)
 1. Al-Huda' Intarneshal (Pakistan) 2. Islamic religious education—Pakistan.
3. Muslim women—Education—Pakistan. 4. Madrasahs—Pakistan. 5. Islamic renewal—Pakistan. 6. Religious awakening—Islam. I. Title.
 BP48.A4A36 2009
 297.7'70820549149—dc22 2009031581

Contents

Illustrations

Photographs

Table

Sadaf Ahmad is an assistant professor of anthropology at the School of Humanities, Social Sciences and Law, in the Lahore University of Management Sciences in Lahore, Pakistan. She received her Ph.D. in cultural anthropology from Syracuse University in the United States in 2006, and has master's degrees in gender, anthropology, and development from Goldsmiths College, the University of London, and in psychology from the National Institute of Psychology, Quaid-e-Azam University. Gender has been a crosscutting theme in all of her work to date, and has largely revolved around issues of gender-based violence and gender and religion. Her research interests also include body politics, identity matters, social movements, minority issues, and religion and culture, and her teaching reflects these interests.

Acknowledgments

THIS RESEARCH would not have been possible without the women affiliated with Al-Huda and other religious groups who shared their lives with me. Their stories have been gifts that continue to humble me.

I would like to thank my adviser, Susan Wadley, for being my guide through this journey, and my *ustad*, Tazim Kassam, whose insightful reflections and encouragement have given me the courage to produce an account that has allowed me to be true to myself. I would also like to express my gratitude to Ann Gold for her thought-provoking comments, and John Burdick for teaching me the usefulness of a multilayered analysis.

My entire family has contributed to this work in very concrete ways, but I particularly want to thank them for their unwavering support throughout this process. I especially want to thank my aunt, Fouzia Saeed, for listening to me every time I needed to talk and for providing me with many necessary "time-outs" during fieldwork.

Transforming Faith

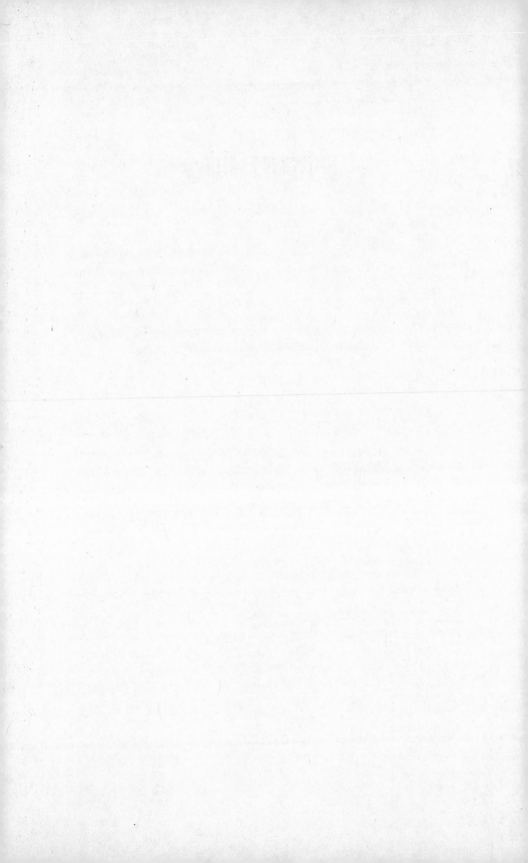

1 · The Cultural Politics of Fieldwork

"PAKISTANI WOMEN SOCIALITES embrace Islam: A new breed of scholar is inspiring Islamic study among Pakistan's last bastion of skeptics—the educated female elite" (Ali 2003). Headlines such as this one, describing Dr. Farhat Hashmi and her Islamic school for women called Al-Huda, can easily be found on the Internet and have become a common feature in newspapers and magazines in Pakistan in the past fifteen years (Alee-Adnan 2004; Siddiqi 2004). Literally meaning "guidance" and by extension "a place of guidance," this school-turned–social movement's uniqueness lies in the fact that it has been able to make inroads into the middle and upper classes of the urban areas of Pakistan, a feat other religious groups have been unsuccessful at accomplishing. Its success among urban women is manifest in the way a large number of them transform their ideology, behavior, and lifestyle in accordance with the religious discourse they internalize while at this school, and in the enthusiasm with which they work toward spreading its ideology in mainstream society through a variety of forms of *da'wa*,[1] or religious outreach, making them key players among other religious groups also interested in *da'wa*.

It was in order to understand Al-Huda's uniqueness in being the harbinger of social change among middle- and upper-class women, as well as understanding the reasons for women's engagement with this school's religious ideology, that I spent the months between September 2003 and July 2004 conducting fieldwork in my hometown of Islamabad. This is where Farhat Hashmi, along with her husband, Idrees Zubair, established

1. The meaning of non-English words will be given in the text the first time they are mentioned. The meaning of frequently repeated words can also be looked up in the Glossary.

1

Al-Huda in 1994 in order to "equip individuals with authentic knowledge of Qur'an and Sunnah [a collection of sayings and actions attributed to the Prophet Muhammad] so that they may apply it in all aspects of their lives . . . be better equipped to revive the humanitarian spirit of Islamic teachings and to invite others to Islam in a peaceful and non-aggressive manner . . . [provide students with counseling] to help them develop their personality, character and self-confidence, and to prepare them for their future roles as wives, mothers, sisters and beneficial members of society" (Al-Huda 2003). Al-Huda's aim, therefore, is to transform the women who engage with its discourse into ethical (Foucault 1997) or pious subjects (Mahmood 2005), with "piety" defined within the particular Islamic framework this school upholds. By infusing the individuals who engage with it with particular Islamic principles, Al-Huda aspires to give their faith a concrete form and create subjects infused with a unitary consciousness. It is with this aim in mind that it spreads its ideology into mainstream society through a variety of measures, the most well organized one being the one-year diploma course it offers its students. The discourse is further spread in mainstream society through *dars*, or religious study groups, offered by Al-Huda graduates to women in their neighborhoods.

I suggest, however, that it is not just the discourse itself but the manner in which the discourse is propagated that has allowed Al-Huda to achieve the success it has, particularly among the middle and upper classes of urban Pakistan. Al-Huda's particular pedagogies of transformation have built on women's faith in Allah and the Qur'an as the word of Allah, and played a critical role in facilitating them to discipline themselves (Asad 1993) into becoming pious subjects. Furthermore, the multiple ways women find religion and religious spaces significant, functioning as they do from particular locations within their society and the larger world, add meaning to their journey and facilitate their increased engagement with Islam.

However, cultures host a variety of ideologies that are upheld by the individuals making up that culture. It is erroneous to assume that people within a culture live uniform lives or believe in identical things, which is something that comes out most clearly in the reaction many in society had to Al-Huda once the school was established and its students began making their presence felt. I use this reaction, ranging from curiosity and

bewilderment to disdain and intolerance, to initiate a discussion about Al-Huda, largely because this reaction—the society's, and to some extent my own—was what led me to do this research in the first place. I elaborate on this point and my ideological positioning that ultimately frames this work below and move on to sharing the cultural politics of doing fieldwork as a "native anthropologist" on, what is for many Pakistanis, a contentious phenomenon.

The Initiation

Women who take the diploma course at Al-Huda or attend *dars* offered by Al-Huda graduates commonly undergo a range of changes, yet not surprisingly only the more visible changes draw comment from society. The most prominent of these changes is the manner in which these students begin covering themselves outside the classroom, wearing *hijabs* (head scarves) and *abayas* (cloaklike garments worn on top of clothes) and in some cases also covering their faces. These practices are largely unheard of in the upper classes these women belong to and are subject to much critique (Burney 2007). Other practices are made visible through people's everyday conversations about them and through the media. These practices are also subject to criticism and include these students' deeming music to be un-Islamic and hence throwing away their music CDs, their refusal to participate in folk Islamic rituals—believing them to be un-Islamic and telling those individuals who practice them that they are wrong to do so—and forgoing a number of cultural rituals that take place around major life events such as weddings and deaths. All these practices go against the dominant cultural norms of the society these women are part of, and it is therefore not uncommon to hear them jeered as "extremists," "*fundos*," or "ninjas."

I confess that I too, like many around me, was perplexed about why so many women from my hometown, who belonged to the same class I belonged to, were changing their behavior and lifestyle in the ways they were. Having had an appreciation of music, dance, and the other performing arts instilled in me from childhood, I was upset upon learning about people condemning these art forms, not even accepting them as appropriate means of connecting with the Divine. Having been brought up to be

alert to the systemic nature of power imbalances occurring within society at various levels, I could not help but see Al-Huda's emphasis on veiling in the manner they prescribed as anything but the reinforcement of a system that viewed women as sexualized beings who must be hidden in case they tempted men and created chaos in society—in other words, the perpetuation of a system that holds women (and their bodies) responsible for men's behavior. Furthermore, I did not understand why women were willing to engage with a school that seemed to offer them a very narrow path of acceptable behavior, a school that proclaimed that the path it offered was the only way of achieving piety and becoming a good Muslim, as seemed to be the case if the stories of Al-Huda graduates aggressively criticizing those people who practiced Islamic rituals considered un-Islamic by them were true. I grew up in a household where I was taught that when someone points toward the moon, I should look at the moon and not get caught up looking at the finger. All religions were considered different paths leading to the same end, and while basic ethics were always emphasized, the outer trappings of religion, the structure, the rituals, never were. As such, ideologies that were framed as "the truth" left me feeling very uncomfortable because they left no space for people to practice alternative truths, which in my opinion was a recipe for creating intolerance. Given my particular ideological positioning, I found myself questioning why this religious school had become so popular among women.

People who are disdainful toward the changes women undergo as they take the diploma course have their own theories regarding why women go to Al-Huda or, increasingly, attend *dars* offered by Al-Huda graduates. The most popular of these theories is that attending such events has become "fashionable" among the elite. Likewise, those individuals who approve of such changes claim that these women are Muslims; why would they not be interested in learning about Islam? I was dissatisfied with both of these theories. Wanting to follow a fashion cannot explain women's commitment to the changes they have made in their lives in the larger context of social disapproval. Likewise, is being a Muslim the sole answer? Why did being a Muslim not motivate them to increase their religious knowledge through other means before Al-Huda was established? Groups, both political and nonpolitical, have been offering religious *dars* in Islamabad from

the time of its inception in the late 1960s. What was it about Al-Huda that allowed it to reach such a large number of women belonging to the middle and upper classes of Islamabad, an accomplishment all the more unique in the face of the inability that other religious groups have shown in meeting this end? Wanting to find the answers to these questions, I knew I had to move away from the theories that different elements in society were giving me, put my own preconceived notions aside, and hear directly from the women who went to Al-Huda to study. I wanted to hear the stories of their experiences so I could begin to understand why they engaged with Islam via Al-Huda, the ways in which they found that engagement meaningful, and what their journey into "piety" entailed. I also wanted to study the school to better understand its uniqueness. It was thus that I found myself returning to Islamabad for a ten-month period that ended up being very enlightening, enriching, as well as extremely challenging.

The Field

Since Al-Huda's significance as the harbinger of change in society can be understood only through a comparison with other religious groups operating in the city, my fieldwork was not limited to studying Al-Huda or *dars* initiated by Al-Huda graduates but also included those classes offered by the Jama'at-i-Islami, Tehrik-i-Islam, as well as those classes not affiliated with any formal organization.

The Jama'at-i-Islami is Pakistan's oldest, and largest, religio-political organization, and its primary goal is to establish an Islamic state in Pakistan. Although most of its current activities revolve around political participation, imparting religious education to people has always been, and continues to be, a part of their larger agenda for bringing about social justice. The women's wing of the Jama'at was established in the 1950s and was initially composed of the wives of members, who were encouraged by the latter to join the party. Even today, the majority of women party members have male relatives who are a part of the Jama'at. These women have their own seminary that trains them to become preachers and teachers, and they are largely involved in disseminating Islamic knowledge through a variety of means (Nasr 1994). Women members of the Jama'at have been offering *dars* to women in their neighborhoods in Islamabad

since the city was created in the late 1960s. Nonmembers are allowed to sit in on the *dars*, but the ever-present goal is to recruit them as members so that they can be called upon whenever people are needed in political demonstrations and other such activities. Their adherents largely belong to the lower middle class.

The Tehrik-i-Islam primarily focuses on imparting religious education and, like the Jama'at-i-Islami, has a women's wing that offers *dars* to women. The religious leaders who formed this organization in 1994 were initially members of the Jama'at but broke away to make *da'wa* their first priority. Having been a part of the Jama'at, however, they too are highly organized (Nasr 1994), and draw on the religious writings of the founder of the Jama'at, Mawlana Mawdudi. Although not limited to it, their followers also largely belong to the lower middle class. Jameela,[2] the head *nazima*, or leader, of the women's branch of Tehrik-i-Islam in Islamabad, confirmed this fact as she informed me of the sectors of the city in which they held their *dars*. Not a single one took place in the sectors in which the relatively wealthier families reside.

The third group consists of *dars* not affiliated with any religious organization. Many of the women in these groups refer to themselves as Naqshbandi Sufis. The Naqshbandi Sufi order was initiated in Bukhara (what is now Uzbekistan) and came to the Indo-Pak subcontinent via Khwaja Baqi Billah in the late sixteenth century. These women follow an Islam that includes practices such as going to the shrines of saints, listening to Sufi poetry and music, and doing *dhikr,* the remembrance of Allah, usually through the ritual utterance of His name or His praise. A central component of worship in Sufism, *dhikr* is a practice these women, belonging to the middle and upper classes of Islamabad, engage in on a weekly basis. Their *dars* have been going on for as long as the ones offered by the Jama'at, yet their numbers are very small: I was able to locate only three to four groups in the months I spent in the field, and found a great overlap of attendees among them.

2. The names of all the women I interviewed have been changed to preserve their anonymity. The names of well-known public figures, such as Dr. Farhat Hashmi or Dr. Kanwal and Amina Ellahi later on, have not been changed.

It took me a while to locate and get to know people who ran *dars* or attended them. Kirin Narayan asserts that "even the most experienced of 'native' anthropologists cannot know everything about his or her own society," as "one knows about a society from particular locations within it" (1993, 678–79; D. Wolf 1996; Zavella 1996; Einagel 2002), a point that was driven home to me the first time I asked a *dars* teacher what time her class took place. Her response, that it took place after *'asr,* a time in the afternoon when one of the five "obligatory" prayers is offered, left me completely clueless, and forced me to ask when *'asr* took place. Despite having lived in Islamabad most of my life, and despite having known of the existence of *dars* in the city, I had neither ever attended one nor personally known of anyone who offered or attended them.

Sociologist Jayati Lal relates a similar experience of doing research in Delhi, a place she had lived in for many years as a student. However, her research took her to places in the city she had never visited before (factory settings, squatter slums), and she shares that "in many ways, I entered a world that was completely foreign to me. . . . I was a 'native' returning to a foreign country" (1996, 191–92). Although my own particular location within the sociocultural fabric of society precluded me from knowing anyone who was associated with religious groups, it was my and my family's membership in the larger society that facilitated the process of making initial contacts. For instance, my aunt put me in touch with a colleague who knew someone who gave *dars,* my grandmother connected me to her physiotherapist when she learned that the latter's sister was a member of the Jama'at-i-Islami, and so on. I got in touch with these individuals, who in turn put me in touch with others, and the process snowballed so that I eventually came to know a significant number of individuals affiliated with different organizations—or with no organizational affiliation at all—who offered *dars* for women. Being able to get in touch with *dars* leaders meant I was able to, in most cases, get their permission to sit in on their *dars* on a regular basis and make arrangements to interview their students if the latter were willing.

I was also able to obtain permission from Al-Huda to sit in on its classes and interview its students after I had submitted a short research proposal. Interviewing the students at the school, I learned, was a near impossibility

during school hours. A tight schedule with one class after another, and only a twenty-minute recess during the whole school day, was not conducive to being able to make contact and then talk to the students. Yet there were a number of occasions when teachers came across me and another student sitting cross-legged on the floor in some corner of the school, the student talking while I scribbled away in my notebook. Nevertheless, most of the students I spoke with—both current and graduates—were ones whom I was able to get in touch with through other means. Doing so allowed me to reach a stage of information saturation where "patterns of response begin to repeat themselves and generate no new information" well before I had to leave Pakistan (Schensul and LeCompte 1999, 262).

The purpose of conducting this research was not attaining a position from which I could make sweeping generalizations but to reach a place from which insights into the reasons for women's engagement with religion via Al-Huda, and subsequently for Al-Huda's success among women, could be gained via the patterns that emerged. Ethnography, with its emphasis on discovery and its focus on exploring the different factors associated with the phenomenon under study, thus becomes an ideal means through which insights into new trends can be gained (Schensul and LeCompte 1999).

Participant observation and in-depth, open-ended interviews were the two main ethnographic tools relied upon to obtain these insights. Most of the formal interviews took place in women's homes, where on my request they would relate the story of their relationship with Islam. The story was a "making" (Lawless 1988, 60), a means through which the identity of the storyteller as an individual who had begun her journey on the pious path was affirmed. This affirmation, in turn, became a part of the journey. Participant observation took place whenever I visited Al-Huda, attended its classes, or sat through various *dars*. It not only provided a direct look into the politics of knowledge production and the dynamics and processes that took place in these spaces but also provided me with information that I could later discuss with women. Participant observation also took place when I visited women's homes to interview them. The way their homes were decorated, what they wore, and even the kind of snacks I was served proved to be significant ideological and class indicators (Schensul

and LeCompte 1999, 111), and added to the depth of information women themselves provided me with via the interview.

I also felt the need to get a better grasp on the lived reality of women's lives and move beyond the pious self that came to the forefront during the interview situation. It meant moving beyond their discursive consciousness and into their lived lives as they interacted with people in different contexts. I was motivated to find "spaces" outside the interview or classroom situation where I could observe women in their daily lives. Research sites and spaces can often "displace subjects and subjectivities from the relative obscurity of the everyday and in so doing potentially position them under the spotlight of the research process. However, the problem with such displacement is that it also serves to fracture the 'reality' that we might wish to find in the everyday. . . . The challenge . . . is to conceive of fieldwork as a kind of mapping of the many links between those various subjectivities so that the webs of meaning that they collectively create can be understood" (Avis 2002, 197–98).

An unexpected way this challenge was partially met was through my car. Although most women walked to the *dars* in their neighborhood, a few were largely attended by women who did not live close enough to them to walk, and there were times when their drivers were not available and they needed a lift home. I became their unofficial driver, and not only drove many of them home after their classes but also frequently dropped them off at their doctors, or took them to marketplaces. One of them, a woman in her seventies, frequently began calling me up whenever she wanted a ride to her relative's house, or whenever she wanted me to pick her up from a friend's place and be dropped off at home. These drives also became a time when I was regaled with gossip—for instance, by Shagufta, a sixty-year-old woman who attended different *dars* in various parts of Islamabad and whom I frequently drove home after they ended. I would be plied with comments, such as that the former minister's[3] wife who attended a particular *dars* began doing so only after her husband lost an election. The Tehrik-i-Islam *dars* teacher whose *dars* I began to attend on a weekly basis told the

3. A minister is a politician who is in charge of a government department, such as education or finance.

organization's van driver that she would no longer need his services, and it became customary for me to take her home and spend some time chatting with her before leaving. The informal chats that took place within these spaces allowed closer relationships to develop, and often subsequently led to other, both formal and informal, research-related situations and events. No less important was the actual interview itself. Because the stories I was hearing were about the process women were going through in their lives—the changes they had undergone in different aspects of their lives, the support and resistance they were facing from their family members and friends—they inadvertently shed important light into the rest of the arenas of their lives as well.

Formal interviewing and participant observation were accompanied by a relatively more ongoing informal one—for instance, as I went around the city and saw the changed sociocultural landscape, whether it was the changed attire of women as they moved about in public spaces wearing *hijabs* and *abayas* or the presence of religious tapes in general nonspecialty bookstores. Furthermore, opportunities to hear people's opinions about my research and why they thought women were turning toward Al-Huda came up frequently, no matter what setting I was in. Being such a visible and recent trend, everyone had something to say about it, which provided me with a larger sense of not only how Al-Huda was perceived but also the different forms that people's faith took. Although Al-Huda is an "Islamic" school, there were a number of occasions when acquaintances, upon hearing that I was studying Al-Huda, immediately exclaimed, "May Allah keep you in His protection!"

Shifting Boundaries

A significant number of people I interacted with found much of Al-Huda's discourse to be problematic, and I included myself in that category, immediately making those women who subscribed to its discourse the "Others." This mutual "Othering" was perhaps at its strongest in particular moments, such as the times when some women exclaimed in shock upon learning that I did not pray five times a day. But I attempt to move beyond the overused categories of Self/Other, Insider/Outsider, seeing them as both essentialist and divisive. As Narayan asserts, "Given the multiplex nature

of identity, there will inevitably be certain facets of self that join us up with the people we study, other facets that emphasize our difference. . . . To acknowledge such shifts in relationships rather than present them as purely distant or purely close is to enrich the textures of our texts so they more closely approximate the complexities of lived interaction" (1993, 680).

Many feminist scholars have propagated an antiessentialist approach toward identity and selfhood, seeing it as uncertain and performative (Butler 1990), contextual (Visweswaran 1994), multiple (Hall 1989; Abu-Lughod 1990; Haraway 1991; Lal 1996; Avis 2002), and "historically and spatially contingent, provisional, and hybrid" (Marshy 2002, 124). It is within this context of shifting, multiple selves, within both the women I was studying and myself, that we were able to connect.

Connections

The fact that most of the women I met were referred to me by people they knew, as well as the fact that I was a fellow Pakistani, had grown up in Islamabad, and in most cases belonged to the same class they belonged to, helped create both trust and rapport. The informal conversations that frequently took place before and after the interview often revealed common intersections between us—for instance, discovering that a woman's daughter went to the same university I had attended in Islamabad or that we were both enthusiastically following the India-Pakistan cricket series. It is "as if there were two senses of self working through the exchange; there is the distanced, observational self—the me that is the researcher—and there is also a more involved and intimate self that is actually experiencing the conversation" (Avis 2002, 205). Such connections not only help the larger research process but also drive home how, at one level, "we are always part of what we study" (Abu-Lughod 1990, 27). So it is when the talk turned to cricket matches that I began "to accept the multiplicity of subject positions I claim[ed] and occup[ied] in the interview process, and to work with the idea that those positions overlap[ped] to create a mesh, which, while not always completely comfortable, facilitate[d] the research process" (Avis 2002, 205).

In a similar vein, "a person may have many strands of identification available, strands that may be tugged into the open or stuffed out of sight"

(Narayan 1993, 673), and so I found myself occasionally automatically sharing that my maternal grandfather had been an imam, or religious leader, of a mosque in Berlin for sixteen years after his retirement. One's subjectivity often subtly changes and becomes the subject of negotiation (Zavella 1996) in different dialogical interactions (Marshy 2002), and the social context often informs the defining identity we choose or accept (Narayan 1993).

Although such connections were often the source of lessening the distance and increasing the ease between us, the fact that I was a "native" and perceived as such did lead to situations that I would not have faced, or would have faced differently, had I been an outsider with reference to religion or nationality. Although most of the women with whom I interacted were unexpectedly generous in sharing their lives with me, a humbling experience in so many instances, a very small number were hostile. The root of that hostility is captured through the comments of Bushra, one of the teachers at Al-Huda: "I find it very strange that a Muslim girl is going around asking women what they find attractive in Islam. Don't you know? Haven't you read the Qur'an? . . . If you've read the Qur'an, then you know what the attraction is. The basic premise of this research is ridiculous!" Our conversation was brief. She refused to grant me an interview, and as my first, but certainly not last, such experience, I did not have the courage to prolong our chat. I shared the same nationality and religion as Bushra, and we both belonged to the same sociocultural environment: we both grew up in the same socioeconomic class in Islamabad, my brothers had attended the same school as her children, and at one point we had even volunteered at the same organization. But whereas it was my insider status that largely fueled her critique, it was my role as researcher whereby I was wary of making any unfounded assumptions that led us to approach this trend in different ways. Narayan argues that "even as insiders or partial insiders, in some contexts we are drawn closer, in others we are thrust apart" (1993, 676). In this case, and in many others, our differences outweighed our connections.

Chasms

It was my first week in Islamabad, and I was spending the night at my friend Rubina's house. Rubina, whom I had known most of my life, listened as I

told her about my research plans, and then quietly informed me that she had joined Al-Huda the month before. The time I spent in Islamabad was the time Rubina took the one-year diploma course there, which allowed me to get a very close look at the process she went through over time and to see what changes the Islam she learned about and engaged with at Al-Huda brought to her ideology, her behavior, and her relationships. One of the relationships that changed was our own. She was the only "subject" I allowed myself to argue with freely. One of our most memorable arguments began when she told me that she had just learned that we must not say "Assalamo'alaikum" to non-Muslims. Although technically a "Muslim" greeting, "Assalamo'alaikum" is used as a greeting by all Pakistanis, regardless of their religious background, and so for many the term has a nationalist rather than a religious connotation. When I asked her why she would no longer use this greeting, she said, "This Muslim greeting means you are showering blessings upon or blessing someone. How can we bless someone who is following the wrong path, and bless them to continue on that path?" I asked her what she would do if another friend of mine, a Pakistani Christian, walked into the room and learned that she would no longer be greeted with a *salam*. It was after a number of conversations— and after being repeatedly told in different ways that "the Muslim way" was the right way and only those individuals following the "right" path will be granted entry into heaven, no matter how good a human being they were otherwise—that I began to realize the futility of arguing. Each of us was upholding and functioning from within a very different ideology and worldview. As Kalyani Menon articulates, describing her own experience with women in the Hindu Nationalist Movement in India, "The disagreements were not just differences of perspective, but rather differences of principle that struck at the very basis of our constructions of morality, of right and wrong, of worldview" (2002, 43). I did not have faith in the doctrine and ideology she had complete faith in, nor did she in mine, and in that difference lay a vast distance between us.

Implications of Difference for Fieldwork

The role faith played in women's lives and the magnitude of its importance became clearer to me as I spent more and more time in the field,

listening to women's stories. One such unforgettable experience was that of sitting at Al-Huda, hearing a teenage girl tell me her story. She shared that the "day we heard the verses related to purdah [veiling], . . . the first thing I did when my brother came to pick me up from school was go to the market to buy myself a *hijab* and *abaya*." I later asked her to talk to me a bit more about what made her decide to do purdah, and she simply said, "Allah asked me to do it, and so I did." Yes, I remember thinking, Allah asked you to and that explanation is fine, but there have to be other socio-cultural reasons behind that decision as well—for instance, being tired of harassment on the streets. But no matter what approach I took to get her to talk to me about other facilitating factors, it kept coming back to the same thing. Reflecting on this conversation later, I began to realize that I was so caught up in trying to find out what she was supposedly not telling me that I was completely ignoring the significance of what she was telling me. I am not implying that sociocultural reasons are not present, because they are, in varying degrees for different people. But I learned a valuable lesson that day: by organizing women's experiences into a neat reductionist framework, as we are likely to do when attempting to understand anything unfamiliar, we risk silencing women's voices and losing something that may be central to their experiences.

Grasping the extent to which people had faith in an Islamic dogma, both before and after their turn toward religion via Al-Huda, was the "big surprise" I had while conducting this research. Perhaps the surprise lay in the fact that women's faith was not visible or manifest in a concrete "form" prior to their turn toward Al-Huda. Even when it is visible via language or behavior, one is forced to ask whether the reasons behind an apparently religious act are, in fact, religious. To what extent can one, through mere observation, judge a person's reasons for wearing a chador—a large rectangular cloth that women drape around their bodies, on top of their clothes—or celebrating an event like *'id*? Literally meaning "celebration," *'id-ul-fitr* takes place at the end of Ramadan, the month of fasting, while *'id-ul-adha* marks the completion of hajj, the annual pilgrimage to Mecca in the Muslim month of Dhilhaj. Yet, like Christmas, do all people celebrate it solely because of its religious significance? Can one draw a line between religious and cultural reasons for practices that are apparently

religious (Asad 1993)? Finally, research is ultimately conducted to understand those individuals who are different from us in some way. Although belonging to the same society brings women together in various contexts, belonging to a different subculture often prevents a prolonged interaction. For example, the work of many native South Asian researchers—whose position as locals also inadvertently breaks the essentialized category of third world women (Mohanty 1991)—illustrates that they are different from their subjects in some way (Qureshi 1990; Lal 1996; Saeed 2001; Menon 2002). There is no point to the research otherwise.

The standpoint theory presented by early feminists was based on an assumption that the closer the researcher is to her subjects, the better position she is in to understand them (S. Harding 1987). Although this theory has come under fire by later feminists for being essentialist (Lal 1996), for propagating the necessity of a matching skin color and ethnicity for understanding others' experiences (M. Wolf 1992), and for assuming that there can be a single standpoint for women (Haraway 1991), Tehmina, one of the women who did not let me interview her, certainly concurred with this position. She told me she could tell that I was approaching the whole issue of religious revivalism from outside the belief system. As she put it, "You can go and interview a thousand people, and you still will not find the answers you are looking for. You can interview as many women as you want. You'll only find the answers, you'll only understand the truth, when you open your heart to the Qur'an, as these women have done." Such an argument is based on two premises. The first one is that all the women who engage with the Qur'an or Islamic discourse have similar experiences. If my study were based on such a belief, I would have taken the assertion of the first woman I interviewed—that all people are born Muslim, and someone who becomes a Muslim or reverts to being a practicing Muslim is simply returning to what is a natural state of being through Allah's blessings—and generalized it to everyone else, in effect stopping my research before it began, depriving myself of a more complete and complex picture that, in the end, the women I spent time with provided.

The second premise of Tehmina's assertion, which is intertwined with the first one, is that the purpose of my research is to attain a truth that can be acquired only experientially. But is it not the experiential component

itself that prevents the existence of a singular objective truth? The notion of objectivity in ethnographic research is more a thing of the past than not (D. Wolf 1996), and it has been largely replaced by the notion of situated knowledge (Clifford 1986; Caplan 1993; Narayan 1993; Visweswaran 1994; Scheper-Hughes 1995; Rose 2002). An individual's positionality and subsequent cognitive mapping have a significant impact on how she sees things. Cognitive mapping varies "according to a person's perspective on the world," and "the world as we believe it to be depends upon our sensory capacities, our experience, and our attitudes and biases" (Downs 1977, 22, 24). Individuals, therefore, perceive things through their own particular lens, and the knowledge they produce is a result of their own situatedness. Such knowledge is partial, and as Donna Haraway explains, "only partial perspective promises objective vision" (1991, 190). She argues for the "politics and epistemologies of location, positioning, and situating, where partiality and not universality is the condition of being heard to make rational knowledge claims" (195). After all, "the only way to find a larger vision is to be somewhere in particular" (196), and this point was as true for me as it was for my informants. The goal of this research was to understand why women from a particular class background were engaging with Islam as it was propagated by Al-Huda, to understand the attraction to it and what the beliefs and practices understood to be associated with it had for *them* in a particular time and space. If shared experiences existed, I believed they would come up as patterns along the way. But I found the idea of basing and beginning my research on the premise of a shared partaking of a singular truth through the act of opening one's heart to the Qur'an, a personal and subjective experience in itself, undesirable.

The awareness of the similarities and differences my informants had with each other and with me marked both my fieldwork and the writing process, as did the awareness that I had to translate their experiences to the best of my ability within this context. A good researcher engages in fieldwork fully cognizant of both her and her informants' situatedness, and as Margery Wolf explains, "the better the observer, the more likely she is to catch her informants' understanding of the meaning of their experiences; the better the writer, the more likely she is to be able to convey that meaning to an interested reader from another culture" (1992, 5). At the same

time, when understanding is the ultimate goal, the debate of false con-sciousness and invented traditions (Hobsbawm 1984) is immediately laid to rest. The implication is not that we "abandon our critical stance toward what we consider to be unjust practices in the situated context of our own lives, or that we uncritically embrace and promote the pious lifestyles of the women" (Mahmood 2005, 39), as many recent works on Muslim women tend to do (Mahmood 2003). Such relativism "is the perfect mirror twin of totalization in the ideologies of objectivity; both deny the stakes in location, embodiment and partial perspective; both make it impossible to see well" (Haraway 1991, 191). In fact, as Clifford Geertz argues, the goal of ethnographic research is "to grasp concepts that, for another people, are experience near (i.e., the language they themselves would use to talk about their experiences), and to do so well enough to place them in illuminating connection with experience-distant concepts theorists have fashioned to capture the general details of social life" (1983, 58).

I strive to maintain some balance of "voice" in my writing. Given the larger social context within which people are very confident in their asser-tions of why women are engaging with Al-Huda—and the reasons range from their being brainwashed and its being a fashion statement to its being the logical act of Muslims—it is important that their reasons come forth. As such, I do my best to share their voices through their stories and com-ments. But I also make my own voice heard. Sometimes our mutual voices overlap; sometimes they do not. The stories are theirs; the larger analytical framing is mine.

Power Dynamics

In her much quoted article "Can There Be a Feminist Ethnography?" (1988), Judith Stacey expands on how feminist ethnography does not eradicate the power that the researcher possesses during fieldwork, or in the actual writing of the text; subjects can be exploited in both cases, she argues. Diane Wolf elaborates on the same theme in her edited book *Feminist Dilemmas in Fieldwork*, stating that power can be discernible in three interrelated dimensions. Whereas the first was the result of the dif-fering socioeconomic positions the researcher and researched occupied, the second and third were "power exerted during the research process,

such as defining the research relationship, unequal exchange, and exploitation; and power exerted during the post fieldwork period—writing and representing" (1996, 2). This theme has been purported by many scholars and academicians in recent years (S. Harding 1987; Narayan 1993; Visweswaran 1994; Rose 1997; Thornham 2000; Gold 2001).

However, ethnographers have also written about subjects displaying *their* power through their agendas (M. Wolf 1992; Visweswaran 1994; Shostak 2000). Nargis, a bright twenty-eight-year-old woman who worked at Al-Huda as an organizer of special events, and I had been chatting for an hour at Al-Huda when she informed me that she wanted a job at Action Aid, an international development organization of which my aunt was the country director at that time. A bit taken aback by her abrupt pronouncement, I hesitantly smiled and began making a vague reply when she interrupted me to firmly tell me that she was serious, and indicated that any further conversation with her would be conditional upon her getting a job. She was not the only one who clearly stated why she was willing to talk to me. Jameela, the *nazima* of the women's branch of Tehrik-i-Islam in Islamabad, agreed to talk to me on the condition that she would also use the time we spent together to convince me to open my heart to the Qur'an. Uzma, an eighteen-year-old student at Al-Huda, made me promise that I would tell her story to people in the West so that they could understand that Islam has liberated her, not oppressed her, and that she is following Islamic practices out of her own free will and not because anyone forced her to do so.

Women's power was occasionally manifest not only through their own agendas, as mentioned above, but also in their unwillingness to let me interview them. Some expressed their unwillingness indirectly, while others were more direct in their refusal. Rehana, a journalist who was taking a course at Al-Huda part-time, invited me to her house one morning, and on my reaching there did her best to convince me to drop my research project: "You only think doing this research is your idea. These people [Americans] no doubt influenced you in some way, and now you think doing this is your idea. They are going to take your research and use it to annihilate Islam. . . . If you are truly a Muslim, you will stop doing this research. You are selling your religion for a degree, for fame, for a job." The first thing I

did when I reached home was capture our conversation in my notes, and it was as I was typing this quote in this chapter in Syracuse the following year that I came to the uncomfortable realization that even though Rehana was unwilling to talk to me, it was her unwillingness that had inadvertently made her my subject (Visweswaran 1994). This recognition certainly begs for a reassessment of the power dynamics in play between researchers and their subjects.

As far as the actual research product is concerned, a number of writing strategies, such as bringing forth subjects' voices via quotes, have been employed to minimize the power dynamics that exist between the ethnographer and the subject in the production of the text (see, for example, Crapanzano 1986 and Tyler 1986), and it is a strategy that I have also used. However, many argue that the "research product is ultimately that of the researcher, however modified or influenced by informants" (Mascia-Lees, Sharpe, and Cohen 1989, 9), whether it is in the specific quotes selected or the theoretical framing employed in the analysis. Clifford Geertz argues that "what we call our data are really our own constructions of other people's constructions of what they and their compatriots are up to" (1973, 3). Yet he goes on to remind us that just because our involvement in the production of a text is a given does not imply that "one might as well let one's sentiments run loose" (1973, 30). Subjectivity does not imply a lack of rigor. Likewise, bias can never be eradicated, but a constant awareness of the possibility of bias—as it may creep in via one's own positionality—at each and every step of the research process can certainly minimize it. It requires, as Sandra Harding argues, certain honesty, so that "the researcher appears to us not as an invisible, anonymous voice of authority, but as a real, historical individual with concrete, specific desires and interests" (1987, 9). The introduction of such a "subjective" element in research is desirable, for it is necessary, she asserts, to make it more "objective" (Harding 1987; Lal 1996; Rose 2002).

It is in this spirit of honesty regarding one's own ideological positioning that I confess that one of the personal challenges I faced in this research, which I suspect I would not have faced had I been doing similar work someplace else, was the way I reacted to the discourse I ended up becoming very familiar with through constant exposure, a reaction that was possibly

heightened because, ultimately, the research was very personal, that is, the changes I was observing were occurring too close to home. There were countless occasions, such as when a *dars* leader spoke harshly about Shiites or critiqued music, dance, and other cultural traditions, when I would have to make a conscious effort not to leave the gathering. Hearing the intolerance for those individuals who were different and for practices that I consider to be the lifeblood of a culture was painful. Imagining the future of a society in which this intolerance was on the rise was frightening. Anthropologist Saba Mahmood, a fellow Pakistani whose book *Politics of Piety* is based on her study of women's participation in the mosque movement in Egypt, states, "The fact that this book focuses on . . . a place distant from the land of my birth and formative struggles is one indication of the kinds of intellectual and political dislocations I felt were necessary in order for me to think through these conundrums, puzzles, and challenges . . . a labor that cannot thrive under a pace of events that constantly demands political closure and strategic action" (2005, xii). I did not have the distance Mahmood did to her "field." But a reliance on rigorous self-awareness (Stacey 1988) and a commitment to *understanding* do make it possible to bring forth women's experiences and points of views; although situated knowledge makes it possible to point toward the power dynamics in play in different contexts, an attempt can be made to do so without taking away their sense of subjecthood (Mascia-Lees, Sharpe, and Cohen 1989).

Although the answer to the question of why women are engaging with Islam via Al-Huda may be answered differently by me and the women I studied as a result of our subscribing to alternative analytical frameworks, there is much agreement between facilitating factors as well, illustrating that one should not simply assume an opposition between narratives and analysis (Narayan 1993). Nevertheless, it is ultimately situated knowledge, I argue, that will make the analysis all the more interesting. Haraway articulates and I agree with her that "we do not seek partiality for its own sake, but for the sake of the connections and unexpected openings situated knowledges makes possible" (1991, 196). As far as the moral costs are concerned, I believe understanding the experiences of those individuals who are perceived as different, and therefore in many cases ridiculed and

feared, along with understanding this phenomenon in a larger sociopolitical context, gives the entire exercise some meaning and, hence, makes it worthwhile (Stacey 1988; Gold 2001).

Setting the Parameters

One of the challenges of doing research is determining when to pursue tangents that are always part and parcel of fieldwork. I began this research in order to understand why women belonging to the middle and upper classes were engaging Al-Huda's discourse. It was only when I went into the field that I realized the extent to which the school was also spreading its ideology among women of the lower middle class and in rural areas. Although I did not go to any rural areas, I did spend time interacting with and interviewing women who belonged to the lower middle class. I learned that most of them already had a strong relationship with Islam and the structures and rituals associated with it. As such, coming to Al-Huda was not a big step for them, not the way it was for many of their counterparts in the middle and upper classes. So although I do bring in their experiences in the following chapters, my primary focus remains on the middle and upper classes (even though one can argue that they, in all likelihood, may no longer make up the majority of women who engage in the larger Al-Huda movement today). Furthermore, because the middle and upper classes' engagement with religion is the subject of interest, the focus inadvertently comes back to Al-Huda and *dars* affiliated with it, as they have been the most successful in making inroads among these groups.

The women I interviewed and spent time with, who were affiliated with Al-Huda or attended non-Al-Huda-related *dars*, made for a diverse group. Their ages ranged from sixteen to eighty, and they were either married, single, divorced, or widowed. Unlike the middle- and upper-class professional Pakistani women who make up Shahla Haeri's book *No Shame for the Sun* (2002), the majority of these women were not artists, poets, pilots, activists, academicians, politicians, or doctors but rather students and housewives. The women attending classes at Al-Huda belonged to different socioeconomic groups, educational backgrounds, and age groups, whereas the individual *dars* groups were made up of

women who were largely similar to each other in age, occupation, class, and educational background.

With so much talk of "class," it is necessary to define what I mean when I use the term. I am going to avoid getting into a discussion of class analysis proposed in the Weberian and Marxist traditions but will instead present some general guidelines according to which I differentiated among different socioeconomic groups, acknowledging that there are no fixed boundaries. One general way of defining which class people belong to is by looking at where they live in Islamabad.

Islamabad is designed on a gridlike pattern with housing in different blocks, or sectors. The value of housing in these sectors, and the socio-economic groups they comprise, varies. For instance, sector E-7, situated at the base of the Margalla hills that surround Islamabad, is composed of large houses that are usually owned by the people who live in them. Those individuals who live in sector G-7, on the other hand, live in small identical government-owned housing that is given to them because they hold government jobs, which, more often than not, are low paying. Location and type of housing, along with income, the source of income, and the schools the children attend, are other indicators of class. Persons belonging to the middle class have white-collar rather than blue-collar jobs: teachers, engineers, doctors, accountants, and so forth. Wage earners in the upper class are usually businessman, landowners, and politicians. Almost all children of families in the middle and upper classes attend private English-medium schools, something the middle class takes great pride in.[4] Nevertheless, there is a hierarchy among English schools as well, with some more grounded in the middle-class values of "social respectability" than others and some more expensive than others. All these factors, in combination, become good indicators of where one is positioned in the social and cultural fabric of Islamabad.

4. All subjects—except Urdu, the national language of Pakistan—are taught in the medium of English in English-medium schools, hence the name. Public schools, in contrast, are Urdu medium. All subjects in Urdu-medium schools are taught in Urdu, and children usually do not begin learning English as a language until the sixth grade in most of these schools.

Overview of Chapters

Now that I have laid out my own ideological positionality and approach with reference to my informants and the larger field, I move in chapter 2 to situating Al-Huda and the Islam it propagates in the larger context of Islam in Pakistan and then highlight the techniques of expansion adopted by Al-Huda. This expansion is particularly critical, as Al-Huda aims to produce subjects informed by a unitary consciousness (Ewing 1997). I end this chapter by illustrating that the success and failure of Al-Huda's attempts to create such subjects can be understood only once the ideologies—dominant and otherwise—making up the larger culture are mapped and their potential influences on people making up that culture are recognized.

I examine the pedagogies of persuasion that have enabled Al-Huda to make inroads in the middle and upper classes of Islamabad in chapter 3. Combined with women's faith, these pedagogies play a critical role in facilitating women to discipline (Asad 1993) themselves into becoming pious or ethical subjects (Foucault 1997; Mahmood 2005). I also demonstrate that although Al-Huda's growth is facilitated by particular cultural codes—ideologies, values, beliefs—that preexist in the sociocultural landscape of Islamabad, competing cultural codes, particularly if they are very strongly embedded, can also constrain growth or produce or accentuate tensions among, and dissonance within, individuals associated with the movement.

Chapter 4 looks at the heterogeneity of Islam as a set of beliefs and practices in the social landscape of Islamabad by focusing on both Al-Huda and non-Al-Huda-affiliated *dars*. This comparison will inadvertently shed light on why women choose to engage with *dars* offered by Al-Huda graduates, particularly when other kinds of *dars* have been present in the city for much longer. By taking a close look into the ideologies and practices of these groups, this chapter will also illustrate how women use the space of a *dars* in multiple ways and how their own positionality within the social fabric of society has an impact on their reasons for attending a particular *dars*, on the manner in which they engage with its discourse, and the different ways they find meaning in it.

Chapter 5 looks at the impact that the larger sociopolitical environment has on women. An exploration of women's experiences in this space

reveals some crosscutting concerns that either increased their interest in gaining religious education, made them more amenable to engaging with religious discourse, or both. One set of concerns revolved around their perception of and reaction to "foreign" cultural values and trends in their society. Another set of concerns related to Muslims' being persecuted and attacked in different parts of the world. Both scenarios combined to produce a desire to study or turn toward religion, and facilitated them on their path toward piety. However, as the notion of "piety" that Al-Huda propagates is reflective of the Islam it upholds as the truth, the idea of what it means to be a good Muslim is something that women are (re)learning through Al-Huda, and it as they live their lives and encourage others to live their lives as Muslims within a particular religious framework that they are actively involved in the construction of a particular kind of Pakistani culture.

A number of changes, both internal and overt, are witnessed among the women who engage with Al-Huda, particularly the ones who take the diploma course at the main branch. Veiling, or purdah, is the most visible change, and in chapter 6 I shed light on the reasons that Al-Huda gives for its necessity and the techniques it uses to facilitate its adoption. I also present women's multiple motivations for their veiling, and examine the extent to which adopting it is a part of their attempt to transform themselves into pious subjects.

After highlighting the key "findings" of this research, in chapter 7 I question the impact that Al-Huda has had and will continue to have on the power structures, interpersonal relations, culture, and issues of identity within society. I also highlight some of the factors that have the potential to influence the future of the movement and will subsequently play a role in how it influences the larger society. I conclude by sharing the impact that conducting this research had on my own life.

2 · Setting the Scene

"ANYTHING INVOLVING large numbers of people will be driven by a variety of motives" (Bruce 2000, 9). But before expanding on middle- and upper-class women's reasons for engaging with Al-Huda's religious discourse, or highlighting the critical role that Al-Huda's pedagogical techniques play in facilitating these women's transformation, it is necessary to set the scene by explaining what Al-Huda is, placing it and the Islam it propagates within a larger context of Islam in Pakistan and then highlighting the techniques of expansion that have allowed it to turn into a social movement that is no longer just limited to the upper classes. This school aims to create subjects informed by a unitary consciousness, and as such its expansion can have a significant impact on society. Such an impact can be understood only in a larger cultural context made up of many ideologies, both dominant and otherwise.

Islam in Pakistan: An Overview of the Strands of Islam

Islam, as a system of beliefs and practices, may mean different things to different Muslims simply because they may adhere to and practice diverse kinds of Islam (El-Zein 1977). Perhaps the simplest way of dividing the larger tradition is into Sunni and Shiite Islam. The division between the two goes back to the issue of succession, that is, who would lead the Muslim community after the Prophet Muhammad's death in the year 632 CE. The group that later became known as Shiite wanted the leadership to remain in the Prophet's family, and developed a hereditary, hierarchical system of leadership over the succeeding years, along with rituals that reflected their beliefs and experiences (Pinault 1992). Their esoteric interpretation of the Qur'an that allows them to claim hereditary leadership as a part of a larger cosmological plan is an example of this system.

Taking part in mourning rituals by wearing black, engaging in varying degrees of self-flagellation, and singing *marsia* (special songs of mourning in *majales*, or lamentation assemblies) during the month of Muharram is yet another example of the practices and rituals reflecting their beliefs and experiences (Schimmel 1994; Hegland 2002). These mourning rituals not only link Shiites to the Prophet Muhammad's grandson Hussain, who was murdered in the month of Muharram, but also speak to their experiences of persecution as minorities throughout history and in the contemporary world. As the majority in most parts of the Muslim world, however, Sunnis—who did not limit leadership to the Prophet Muhammad's clan—have undergone their own particular historical development that has resulted in another trajectory of Islam (Watt 1998), one that I will talk about in the context of Pakistan.

Like most Muslim-majority countries, Pakistan is host to intrareligious sectarian variations, with 77 percent of the nation's 165 million people adhering to Sunni Islam and 20 percent to Shiite Islam. Although sharing a number of key beliefs and rituals by virtue of being sects of the same religion, they also have beliefs, rituals, laws, systems of religious leadership, and religious spaces that are unique (Schimmel 1994; Hegland 2002).

However, differences within religion exist not only between the two major Islamic sects but also within them. The Ithna' Ashari, for instance, are the most populous Shiite sect in Pakistan and can be found in the cities of Karachi and Lahore and in the southern parts of the province of Punjab, where they make up powerful landowning families. The Isma'ilis and Bohras, however, are much smaller in number. The former are largely found in the northern regions of the country and Karachi, while the latter are concentrated only in Karachi (Fair 2004). All three Shiite sects uphold a Shiite tradition that varies in some ways, whether it is in matters of ritual, authentic Shiite leadership, or eschatology.

Sunni Islam is similarly divided into sects that can be further organized into various Islamic strands. Hence, a useful way of looking at different Sunni subsects is on the basis of their key characteristics that epitomize different Islamic strands. As such, one of the most popular kinds of Islam practiced within the umbrella of Sunni Islam is Barailvi Islam, an amalgam of Sufi and folk traditions. Its adherents place a great

emphasis on honoring the Prophet Muhammad, and organize special events, such as on the occasion of his birthday, to valorize his qualities via stories and poetry (Schimmel 1985). Barailvi Muslims also frequently visit *pirs*, or spiritual guides and faith healers, for guidance (A. A. Ali 1997). Furthermore, they consider saints to be mediators between themselves and God, and go to the shrines of well-known saints to pray and seek solace for their problems (Durrani 1991; Warriach 1997). The death anniversaries of famous saints are marked by an event called *'urs*. People often travel from different towns to attend the *'urs* of their favorite saint, and partake in the singing and dancing that usually make up such events. Listening to *qawwali*, a musical genre based on devotional Sufi poetry that aims to guide its listeners, especially those individuals who understand the poetry, into a state of ecstatic trance is also a common feature of this event. Largely esoteric in nature, Barailvi Islam can be considered a manifestation of the pluralism that used to be a part of the land historically, when plural truth claims could exist side by side and when religious and spiritual traditions overlapped and borrowed from each other and even developed a synthesis (Alvi 1996; K. Ahmad 2000). More specifically, this form of Islam is attributed to Ahmed Reza, who founded the religious institution Dar-ul-Ulum Manzar Islam at Bareilly in 1904 to oppose the Deoband movement (Upadhyay 2003).

Deobandi Islam is another major strand of Sunni Islam found in Pakistan today. Created in 1867 as a reaction against the British colonists, the Deoband school, which soon turned into a movement, is an illustration of Sunni Islam ideologically influenced by Wahabism, the state religion of Saudi Arabia today. Sheikh Muhammad ben Abdel Wahab began the Wahabi movement in Saudi Arabia in the early eighteenth century and propagated "the stern principles of Islam, stripped of all the innovations developed through the centuries," in order to counter "the corruption of norms" he found prevalent in his society (Al-Munajjed 1997, 3). Hence, a common characteristic of the Deobandi and the similar-minded Ahl-e-Hadith school of Islamic thought, which is even more heavily influenced by Wahabi Islam than its Deobandi counterpart, is that they are both characterized by idealized visions of a return to a "Golden Age" of "pristine Islam," that is, when the Prophet Muhammad and his companions were

alive.[1] Any form of religious innovation that took place since that time is considered un-Islamic (Metcalf 1984; Werbner 1996; Al-Munajjed 1997; I. Ahmed 1999). Although different on a number of points,[2] both consider Islamic thought to be primarily made up of the Qur'an and Sunnah. They consider all activities that are not a part of what they consider to be the divine command to be frivolous, and promote the idea that individuals shall reap what they sow. Hence, both the Deobandis and the Ahl-e-Hadith critique the use of mediators between individuals and God, and as such eschew many of the practices that form the core of Barailvi Islam, such as seeking help from saints. Shiite Islam also comes under attack for straying from their norms and rituals. In fact, a religious leader at the Deoband school passed a fatwa, or religious decree, deeming Shiites infidels in the 1940s. Many Deobandi scholars later endorsed this fatwa after Pakistan's creation (Munir 1980). The Deobandis and Ahl-e-Hadith also emphasize the structure or form of religion via religious rituals, such as praying five times a day, and generally consider religion to be a complete code of life.

Scholars use various terms, such as "orthodox," "fundamentalist" (Mumtaz 1994), "exoteric," "formal" (K. Ahmad 2000), and "shari'i" (Hodgson 1974), when describing an Islam imbued with such characteristics. I avoid using these terms in this book, not only because many of them are contentious but also because "there are many shades of difference in belief, strategy and politics within each category, and many Pakistanis who might fall into these categories would not identify themselves as such unless they belong to particular groups or organizations that stress these categories" (cited in Fair 2004, 257). Hence, although labels are useful as general guidelines, they have a limited capacity to capture the reality on

1. Some consider the first few centuries of Islam, when the classical Islamic texts were written and when Islam rapidly spread to different parts of the world, to be a part of this golden period.

2. A significant difference between them is that although the Deobandis follow the Hanafi school of Islamic law, considered to be the most liberal of the four schools of Sunni Islamic law, the Ahl-e-Hadith follow the ulema of Saudi Arabia and, hence, the Hanbali school, the most rigid interpretative school of Islamic law (Fair 2004) that prefers weak or questionable sayings attributed to the Prophet over other techniques for making a legal decision (Hodgson 1974).

the ground. I therefore prefer to use simply the term "Islam." What kind of Islam or what kind of beliefs and practices are being referred to in different places in this text will be self-explanatory via the characteristics of that Islam.

Religion and Politics in Pakistan

Although Pakistan is home to much intrareligious diversity, with religious experience spanning the esoteric-exoteric spectrum, it has been a particular kind of Islam, one that has been affiliated with the Deobandi and Ahl-e-Hadith schools of thought, that has gained increasing space in the country since its independence. One of the key reasons is the manner in which Pakistan was conceived, which played a critical role in setting the stage for future religio-political developments.

Pakistan is a country where religion is both officially and popularly seen as its raison d'être. Both the Muslim leader Muhammad Ali Jinnah and the Muslim League political party were forced to depend on ideological tactics to mobilize the masses behind the cause of Pakistan, and religion[3] was the most obvious means of uniting a very diverse group of people. The groundwork for the success of such tactics had already been laid by the British colonists, whose "decision to use religion as the basis for not only enumerating but also governing a complex and highly differentiated society like India" led to "the privileging of the religious factor in the definition of identity" (Jalal 2001, 40, 42).

Religion has played a more important role in the legitimization process in Pakistan than in most countries because it came into being lacking the traditional characteristics of a state: a common ethnic, linguistic, or territorial identification (Saigol 1994; Wilder 1995). This fact does not mean that Islam was the only reason that people were motivated to support the movement. There were a variety of motivations among Muslims: fear of economic or political domination by the Hindus once the British left, an opportunity to improve one's socioeconomic position, and the elites' wish

3. This "religion" that was repeatedly referred to revolved around the very basics of the faith tradition that are embodied in the Muslim declaration of faith. This strategy allowed the discourse to speak to all Muslims and transcended sectarian divisions.

to maintain their position, all of which were easily united under the Islamic banner (I. Ahmed 1991; T. Hashmi 1992). Slogans such as "Islam in Danger" were adopted to unite diverse Muslim communities (Gilmartin 1998). Even Muhammad Ali Jinnah, popularly referred to as the "founder of the nation" and well known for his secular-mindedness, began using Islam in his speeches, as an excerpt from 1945 illustrates: "Remember, Muslims can never be crushed. They have not been crushed during the last 1,000 years by any power. . . . Our religion, our culture and our Islamic ideals are our driving force to achieve independence" (quoted in A. Ahmed 1997, 82).

So although Pakistan was created as a secular state in 1947, the role religion played in legitimizing it has led to politicians' walking a tightrope since then: trying to hold on to a secular state, on the one hand, and adopting certain "religious" measures and policies to illustrate their religious credentials and thereby secure their own position by keeping the ulema, or religious scholars, happy, on the other (Mumtaz 1994; Wilder 1995).[4] Politicians have also relied on religion when it has suited them, usually in cases where it would allow them to retain their power. Ayub Khan, for instance, who established martial law in the country from 1958 to 1968, was interested in modernizing the nation. He adopted an anticlergy position (International Crisis Group [ICG] 2002), and the progressive Family Laws Ordinance of 1961, which increased women's rights with reference to inheritance and divorce and curbed polygamy, is attributed to him. Nevertheless, his progressive stance did not prevent him from extracting a fatwa from the ulema declaring Fatima Jinnah's candidacy—she had been

4. The Islamic ideology surrounding Pakistan's creation, therefore, led the country to develop in a way that was different from the common pattern followed by many other Muslim nation-states, such as Iran and Egypt, where freedom from colonialism was followed by a formation of a secular government, which then repressed Islamic groups. The public eventually became dissatisfied with the performance of the government and turned toward religious parties, either as a reaction, as a way to fill the welfare gap, or both (Keddie 1999). Pakistan's example, as well as the examples of Tunisia (Charrad 1998), Niger, Nigeria (Cooper 1998), and Kazakhstan (Michaels 1998), is an illustration of how factors such as the circumstances surrounding a country's independence, experience with colonialism, ethnicities, and local culture can lead a country to follow its own path of development. Islam played a different role in each country mentioned above.

chosen by the Combined Opposition Parties to challenge Ayub Khan's presidency—un-Islamic on the grounds of her being a woman.[5] Ideological purity became a matter of political expediency.

Zulifqar Ali Bhutto, the founder of the Pakistan People's Party and the country's first elected prime minister, is remembered as a liberal. Women were allowed into the Foreign Service during his administration, and their presence increased in both government and private sectors under his leadership. He also added an article in the 1973 constitution prohibiting discrimination on the basis of sex (Rosenbloom 1995). All such measures were in line with the "developmental project of the modernizing state" (Rouse 1996, 55). Yet he too was no stranger to using a repressive and exclusionary form of religion for political legitimacy. The manner in which he began using religion upon taking the reins of the country in 1972, a year after East Pakistan's secession, illustrates this fact. Pakistan was created into East Pakistan and West Pakistan in 1947, the former making up the region that is Bangladesh today, and the latter making up what is currently known as Pakistan. West Pakistan's continuing dominance of East Pakistan not only led to the latter's secession and independence in 1971 but also dealt a serious blow to the notion of Islam as a unifying force. It was in this context that Bhutto began using religion in a particular way. The goal was damage control. Hence, the 1971 separation was portrayed not as a failure of religion as a unifying force, or a failure of the government to hold on to its territories, but rather as a result of the failure to adopt Islamic principles. It was by framing the secession in such terms and by introducing many "Islamic" measures that Bhutto hoped to appease the masses, as well as the religious parties who critiqued his socialism.

Bhutto introduced many changes that were symbolic in nature in order to secure his own standing in the face of the opposition religious parties. For instance, "he switched the weekly holiday from Sunday to Friday, banned the sale of liquor and all forms of gambling, closed nightclubs and

5. In a similar vein, ironically enough, the Jama'at-i-Islami, the main religious political party in Pakistan, supported her, despite its assertion that "in Islam, active politics and administration are not fields of activity for the women folk" (Haq 1995, 162; Mumtaz and Shaheed 1987).

placed copies of the Qur'an in first class hotels and government rest houses" (Mumtaz and Shaheed 1987, 14; Wilder 1995). He declared Ahmadis, a Muslim sect whom the other religious groups had been persecuting, to be non-Muslims, arranged to increase religious content in school curricula, and strengthened ties with the Muslim world. By highlighting Pakistan's Muslim identity, he inadvertently gave increasing power to the Islamic political parties (Wilder 1995). So "the Islamic parties, which had been routed in the 1970 elections, were able to assert themselves in the writing of the 1973 constitution, which declared Islam the state religion and mandated the Council of Islamic Ideology to propose measures to Islamize Pakistan" (ICG 2002, 7).

Bhutto also took a number of steps that directly strengthened religious groups. For instance, he nationalized all schools except madrassas. These schools for religious study, usually attached to a mosque, remained autonomous. It was during these years that these madrassas formed linkages with external sponsors, such as Saudi Arabia. Literature from these external sources, as well as money to open new madrassas, began to flow into the country (ICG 2002). Strengthening his religious credentials, however, did not appease the masses in the country, and they critiqued Bhutto for his failure to keep his promise of improving their socioeconomic condition. Anti-Bhutto campaigning by a coalition of nine political parties further heightened the growing public dissent. This coalition came together to oppose Bhutto in the provincial and national elections of March 1977. Although Bhutto won, the coalition accused him of rigging the elections, and he was ousted from power by the military later that year, to be hanged in 1979.

Gen. Zia-ul-Haq established martial law in 1977 and remained in power for eleven years, until his death in a plane crash in 1988. He came into power on the basis of his claim that he needed to make Pakistan an Islamic state. However, before taking any specific steps, he had to formally establish the fact that Pakistan was created to be an Islamic state. This task was not that difficult, given the fact that the way had already been paved by the manner in which Islam had been used in the Pakistan movement and the manner in which politicians in the postpartition period had taken concrete steps to institutionalize Islam in the state machinery. Zia

continued the process and did so in such a way that it had far-reaching consequences. One example is his project of rewriting history (Rouse 1996). Historian Khursheed Aziz explains that it was under Zia's rule that the University Grants Commission instructed textbook authors to "demonstrate that the basis of Pakistan is not to be founded in racial, linguistic, or geographical factors, but rather, in the shared experience of a common religion. . . . To guide students towards the ultimate goal of Pakistan—the creation of a completely Islamized state" (1993, 159).

Zia provided a general atmosphere within which religious groups gained more prominence. He propagated a monolithic Sunni Muslim identity and ideology that gave space to Wahabi Islam to foster in Pakistan (M. Ahmad 1991; Weiss 1998a; Upadhyay 2003). The Saudis not only sent madrassa students to open madrassas in Pakistan during his rule but also provided financial backing to a number of Sunni groups and madrassas.[6] By enforcing a particular Sunni Islamic ideology at the political, economic, and social levels (Burki 1998), Zia denied the differences within the Muslim community and was thus directly responsible for the increase in sectarian violence, particularly between the Shiite and Sunni Muslims (Abbas 2002; ICG 2002). He contributed to sectarian violence by both funding Sunni religious groups, such as the ones run by the Deobandi ulema (Fair 2004), and introducing legal measures based on Sunni Islamic law. Shiites, for instance, reacted to his introduction of the Zakat and Usher Ordinance in 1979, according to which, for the first time, the collection and distribution of *zakat*, or almsgiving, were brought under the state's control. The Shiite demand was that they be treated in accordance with their own personal laws, not in accordance with beliefs that were not their own, a demand that was met by the government in 1980 after fifty thousand Shiites from all over Pakistan held a demonstration in front of the parliament house in Islamabad (Abbas 2002).

Zia "revitalized the Council of Islamic Ideology . . . to review existing laws and make recommendations for bringing them in line with Islam" (Mumtaz and Shaheed 1987, 17), and also introduced many discriminatory laws such as the Hudood Ordinance. The Hudood Ordinance, based on

6. Shiite madrassas had financial support from Iran (Abbas 2002).

the government's interpretation of Islamic law, and largely dealing with issues of adultery, theft, drinking, and gambling, was especially harmful for women. For instance, if a woman reported being raped but was unable to produce four male Muslim witnesses of good character to support her claim, she was charged with the "crime" of engaging in premarital or extramarital sex, imprisoned, and lashed a hundred times.[7] Sex outside of marriage became an offense against the state. The religious trappings of the Hudood Ordinance became a hindrance for Pakistani activists who wanted these laws repealed and have been one of the key reasons democratically elected leaders since Zia have been reluctant to address them. They have not been willing to face the backlash from the religious parties.

Apart from the introduction of many discriminatory and harmful laws in the name of Islam, Zia also introduced many symbolic "Islamic" reforms, such as ordering people to offer afternoon prayers in their offices, and beginning all office correspondence with the words "In the name of Allah, the Beneficent, the Merciful." Although his orders were not followed across the nation, they did have an impact on society, as "the fanatical elements within society suddenly assumed they had been given a carte blanche to become self-styled moralists." Occupying positions of influence, these "elements" were successful in getting the state television network to ban music programs, increase the number of religious programs, and propagate a version of Islam that was "conservative, bigoted and fanatical" (Mumtaz and Shaheed 1987, 17). Zia's policies were also pivotal in establishing an environment that created job opportunities for religious school graduates, which strengthened them and the ulema, allowing them to influence communities and gain prominence.

Zia also encouraged the religious groups to share their notions of what a good Muslim woman's role should be. Not surprisingly, it entailed women observing purdah and staying at home to raise their families (the

7. According to one estimate, approximately three thousand women have been imprisoned since the inception of this rule (McKenna 2006). According to another, there were at least six thousand women and children in jails across the country in June 2005. Of this number, 80 percent faced charges under the Hudood Ordinance (Human Rights Commission of Pakistan 2006).

popular phrase "chador aur char divari," the "veil and four walls," used by
the women's movement originated from Zia's policies regarding women).
Women were acceptable only in their "natural" roles of wife and mother.
The ulema under Zia worked with him to introduce a number of policies
that had a direct impact on women (Rosenbloom 1995). For instance, in
1982, for the first time since independence, women were excluded from
the national games on the rationale that Muslim women should not be
seen by men who are *na mehram*, that is, men whom they can potentially
marry. Another policy was put through in 1983 according to which single
women would not be able to serve abroad in the Foreign Service. Accord-
ing to yet another government policy, women were forbidden to come on
television in any capacity unless their hair was covered. It was during Zia's
time that the women's movement—which had until then largely engaged
in social welfare work—changed its nature and began to openly challenge
the government's policies on women. A group of women from the upper-
middle and upper classes formed the Women's Action Forum as a direct
result of the state's policies and endeavors that threatened women's rights
of equal citizenship.[8]

A period of democratically elected leaders followed Zia's death in 1988.
Benazir Bhutto, Zulifqar Ali Bhutto's daughter and the leader of the Paki-
stan People's Party, was prime minister from 1988 to 1990 and again from
1993 to 1996. Nawaz Sharif, the leader of the Muslim League, was also
prime minister twice, from 1990 to 1993 and 1997 to 1999. Both leaders
never completed their full terms in office, were accused of corruption, and
were brought down either by the president or by the military.

Ironically, being democratically elected made these leaders more vul-
nerable to religious groups, for they did not have as much power as the mil-
itary dictators had enjoyed. They thus continued in the footsteps of their
predecessors in an attempt to keep the religious Right happy. Benazir, for

8. The book *Women of Pakistan: Two Steps Forward, One Step Back?* (1987) by Kha-
war Mumtaz and Farida Shaheed and anthologies such as *Locating the Self* (1994) edited by
Nighat Khan, Rubina Saigol and Afiya Zia and *Muslim Feminism and Feminist Movement*
(vol. 2, 2002) edited by Abida Samiuddin and R. Khanam shed light on the activities fem-
inists engaged in during General Zia's era and the difficulties they faced in the process.

instance, never took any steps against the religious parties or challenged their Islamic laws. The madrassas were never audited and continued to grow during Nawaz Sharif's time (Rashid 2000), and many mosques were built without first gaining permission from the development authorities. These moves served to establish Nawaz Sharif's religious credentials, as well as his support for the religious parties. Signposts with Qur'anic verses were suddenly visible in all the cities under his government, and Islamic studies and Pakistan studies were formally emphasized in school curricula (Weiss 1998b). Despite the fact that Nawaz Sharif had a two-thirds majority in the National Assembly, he did not make any attempts to get rid of laws such as the Hudood Ordinance (Abbot 1968; Wilder 1995).

By the mid-1990s, the religious parties had gained increased popularity due to people's disillusionment with "democratic" governments and the corruption associated with them (Weiss 1998b).[9] However, despite their popularity, they did not actually win seats in the National Assembly until the elections in 2002. Cashing in on the anti-American feelings that had emerged as a result of the American bombing of Afghanistan in the wake of the events of September 11, 2001, an alliance of six religious parties, the Muttehida Majlis-e-Amal (MMA), won a significant number of seats in the national elections for the first time in the history of Pakistan. This victory allowed them to form a majority in the North West Frontier Province (NWFP) in 2002, and they have since used their position to introduce many "reforms" there. These reforms are based in religious beliefs and include, but are not limited to, the banning of female sports, women's ultrasonography by male technicians, and the playing of music in public transportation. In 2004 the MMA forced government officials to pray during office hours. Losing their jobs was the alternative (Shehzad 2005). Such formal directives have been accompanied by other "informal" activities, such as setting movie theaters on fire and smashing billboards displaying women. Although many living in the NWFP will be the first to call members of the MMA extremist, the top political leadership and

9. Dissatisfaction with the performance of the government and subsequently turning toward religious parties as an alternative has been a phenomenon witnessed in other parts of the Muslim world as well. For instance, see Tessler 1996 and Keddie 1999.

the measures they take do play a crucial role in determining what kind of atmosphere prevails and strengthens in a region. It was the basis of Zia's success in the 1980s and the MMA's success more recently.

Gen. Pervez Musharraf came to power via a military coup that brought down Nawaz Sharif's government in 1999. He made attempts to curb the power of the radical and militant religious groups in the country, and opened up a debate regarding the Hudood Ordinance that resulted in its repeal and the introduction of the Women's Protection Act in 2006. Such actions, along with his support of the United States in its "war on terror" in Afghanistan, did not win him any points in the politico-religious camp, and there have been a number of attempts on his life since 2004.[10] A chain of actions in 2007 led to a downward spiral in his popularity among the masses, and eventually resulted in his resignation as president in August 2008. He has been replaced by Asif Ali Zardari, the late Benazir Bhutto's husband.

Ultimately, the way Islam has developed in Pakistan—where politicians made harmful policies cloaked in Islamic rhetoric to secure their powerful positions either by keeping the religious Right happy or by providing an environment where religious groups were allowed to flourish or both—has contributed to the increased strength of certain religious groups and a particular kind of Islam in Pakistan. Stronger links with countries such as Saudi Arabia and the Gulf states also have a direct impact on the kind of Islam being spread in society, leading to an environment where a particular form of religion, one that is heavily influenced by Deobandi and Ahl-e-Hadith ulema, is taking root.

The increased space enjoyed by such religious groups and parties is overtly manifested in the social landscape of the country—for instance, posters inform people how to perform various activities, such as drinking water, according to the Sunnah (Hoodbhoy 2004). Driving through Islamabad, one now sees small boards advertising Arabic-language courses,

10. Pervez Musharraf's political actions in the year 2007—such as suspending Chief Justice Iftikhar by bypassing the judiciary in March, imposing a state of emergency in the country in November, and banning some television channels when they made him a subject of their critique—weakened the country's institutional structures and eventually led to his exit from politics.

a number of new Islamic schools for children, and, in the case of Al-Huda, an Islamic school for women.

Al-Huda

The defining characteristics of Al-Huda's religious discourse are more or less the same as those strands of Islam that have become stronger over the years.[11] As such, Farhat Hashmi can be said to occupy a particular place in the diverse religious landscape of the country. A glimpse into her background can help explain where she situates herself, and why, and can also prevent one from succumbing to a "myopia of the present," that is, a lack of recognition of the fact that events and trends are historical products and do not come into existence in isolation (Hannigan 1991, 325). John Hannigan proclaims that this myopia prevents individuals from recognizing "the continuity and comparability of many of these movements with those in the past" (1991, 325).

Farhat Hashmi

Farhat Hashmi grew up in the small town of Sargodha in Punjab, and received her initial religious education from her father and from accompanying her mother to *dars*. *Dars* literally means "lesson," and *dars* groups are regularly held gatherings where groups of men or women get together to listen to religious lectures or read the Qur'an and hear its exegetical commentary from the *dars* leader. Farhat Hashmi and her mother attended *dars* offered by the religio-political organization Jama'at-i-Islami.

Jama'at-i-Islami is the most prominent religio-political party in Pakistan today and is unique in transcending sectarian and ethnic differences. It was created in 1941 by Mawlana Mawdudi, who headed the party for thirty years, and played a critical role in giving it its current structure and infusing it with an Islamic ideology he developed over time. Influenced by Deobandi scholars, Western literature, and the weak position occupied by Muslims in colonial India, Mawdudi developed a vision for the social

11. This heightened strength is seen through the adherents of these strands: through their increasing numbers, their increasing political participation, and their increasing number of madrassas (Abbas 2002; ICG 2002).

transformation and political empowerment of Muslims and gave it concrete form via the Jama'at. Mawdudi's interpretive reading of Islam and its history began with the denunciation of traditional Islam and its centuries-old institutions. He argued that Islam had no possibility of success as a religion or a civilization unless Muslims removed the encumbrances of cultural accretion and tradition, rigorously reconstructed the pristine faith of the Prophet, and gained power. Politics was declared to be an integral and inseparable component of the Islamic faith, and the "Islamic state" that Muslim political action sought to erect was viewed as the panacea to all problems facing Muslims (Nasr 1994, 7).

Although the Jama'at began as a *da'wa* movement, it soon made political participation its primary agenda. Nevertheless, both its men and its women's wings continue to offer *dars* all over the country. The goal of the *dars* is to inculcate Mawdudi's religious teachings via his Qur'anic interpretation and exegesis among men and women and recruit them into the organization. Farhat Hashmi attended the Jama'at's *dars* with her mother as a young girl. Both of her parents were members of the Jama'at, and she herself was active in the Jam'iat,[12] the student wing of the Jama'at, during her college days at Punjab University in Lahore. She married shortly after completing her master's degree in Arabic.[13] After spending a number of

12. Created by the sons of Jama'at workers in 1947, the Islami Jam'iat-e-Tulabah, or Jam'iat as it is popularly called, is the student wing of the Jama'at. Although it was initiated as a *da'wa* movement, it soon took on a life of its own and began using violence as a means to crush what were perceived as its opponents. Leftist groups headed the list, and clashes between them became common on campuses. It infiltrated and eventually took over Punjab University, the intellectual center of students, in the late 1970s. Drama, theater, and musical events are forbidden on their orders today, and men and women must sit in separate sections of the classroom (Nasr 1994; Hoodbhoy 2004).

13. Farhat Hashmi's husband does not play a primary role at Al-Huda. Although also known as a religious scholar, he only occasionally came to Al-Huda to give guest lectures during the time this research was conducted. Students do, however, mention him as a learned scholar. According to some of the teachers in the Al-Huda administration, he plays an active role, helping Farhat Hashmi manage Al-Huda's national and international activities. Both he and Farhat Hashmi moved to Canada in 2005. Both of them offer Islamic classes there.

years teaching at the Islamic University in Islamabad, both she and her husband left for Glasgow, Scotland, where they both earned their Ph.D. degrees in Islamic studies, with a specialization in hadith[14] sciences. Also known as "tradition," hadith refers to the sayings attributed to the Prophet Muhammad and forms a part of the Sunnah.

Farhat Hashmi offers her own Qur'anic exegesis to her students, but it is heavily influenced by Mawlana Mawdudi's teachings; Mawdudi himself was largely influenced by the Deobandi movement. Like the Deobandis and Ahl-e-Hadith, Farhat Hashmi too draws on a literal interpretation of the Qur'an, relies on the Sunnah, and has an idealized image of the first Muslim community. She too desires to remove cultural accretion and tradition from society, places a great deal of emphasis on ritual, critiques the practices that people subscribing to Barailvi Islam and Shiite Islam engage in, deems Islam to be a solution to all human problems, and so forth. Although neither Farhat Hashmi nor her students at Al-Huda affiliate themselves with any Muslim sect or group, claiming instead to practice the one "true" Islam, the kind of Islam they propagate has remarkable similarities with these other Islamic strands in the country. As such, they play a key role in both reinforcing and spreading a particular form of Islam into more and more segments of mainstream society. I elaborate on how they do so in the following section.

Technologies of Expansion

Although Farhat Hashmi is known to have given *dars* in Islamabad in the 1980s, it was only in the early 1990s that she began acquiring a name for herself among the general public, both through the *dars* she delivered in people's homes and through the *Daura-e-Qur'an* she offered every Ramadan. Literally meaning a "journey through the Qur'an," the *Daura-e-Qur'an* refers to a practice undertaken in the month of Ramadan, in which a teacher goes through the translation and gives a brief exegetical account of one *siparah*,

14. A specialization in hadith sciences is a clear indicator of the kind of Islam being followed. See Berg 2000 for a detailed account of multiple positions taken by different scholars with regards to the reliability of hadith literature that was collected a few hundred years after the Prophet's death.

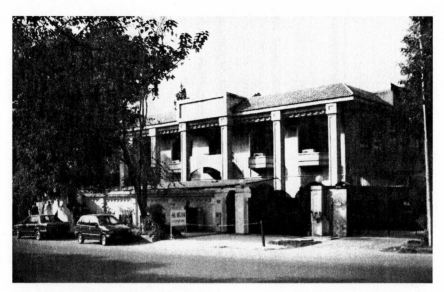

1. Central Al-Huda Branch, Islamabad

or section, of the Qur'an per day. Hence, the thirty *siparahs* that make up the Qur'an are completed within the thirty days of the month.

Farhat Hashmi began Al-Huda in her own home in 1994, but today the school is situated in a large three-story house on Nazimmudin Road in Islamabad. One of the main roads of the city, Nazimmudin has a green belt—a strip of land heavily dotted with trees and shrubbery—on one side and large houses belonging to members of the middle and upper-middle classes on the other. Some of these houses are used by private educational institutes. Al-Huda is one of them.

The green belt opposite the school is packed with cars during the day when school is in session. Al-Huda's core activity is offering one-year diploma courses, with classes taking place between 7:30 a.m. and 1:45 p.m., six days a week, covering topics such as the translation and explanation of the Qur'an, Arabic grammar, Islamic history, Muslim heroes, *Sirah* (a biography of the Prophet Muhammad), hadith, *tajvid* (the art of Qur'anic recitation), *fiqh* (Islamic jurisprudence), and so on.

The school initially offered one-year diploma courses to students who had completed their bachelor's degrees, but it has since expanded its

selection criteria. Other diploma courses offered today include a one-year course for girls who have at least completed the tenth grade. The enrollment for these two types of courses at the time this research was conducted was approximately three hundred students per course. Two-year diploma courses, offering the same subjects, are also available. One such two-year course caters to housewives and takes place for three hours during the day, every day, while the children are at school and husbands are at work. Another is offered for women who have day jobs and students who go to other schools during the day. These classes take place on a daily basis in the evenings, once again for three hours. The provision of different kinds of courses immediately makes the school accessible to women of varying ages, educational backgrounds, and occupations. It is important to make clear here that the majority of students enrolled in this school are *not* employed and never have been but are either housewives, girls who are between degrees, or women who have completed their education. Although the number of students enrolled in the evening classes is very small, the presence of this particular course is, for the first time, giving women with daytime commitments an option to study Islam formally.

The only other formal religious institute that offers degrees in Islamic studies is the Islamic University in Islamabad; their undergraduate program takes three years, a length of time only the very interested and committed can give. Their medium of instruction is Arabic, a language most Pakistanis do not speak or understand. In contrast, the medium of instruction at Al-Huda is Urdu—the national language of Pakistan—but courses are also offered in English. This option has expanded the attendance still further, particularly as it is the only religious institution to offer its students this choice. Although the majority of girls take the course in Urdu, a small percentage is made up of girls—both Pakistani and non-Pakistani—who have lived in other countries most of their lives and do not know Urdu. Another small group is composed of Pakistani students who have lived in Pakistan most of their lives but have attended English-medium schools and are thus more comfortable studying in English.

The building that houses Al-Huda has three floors, each with large hallways. The courses are organized by floor, with each floor serving a different diploma course. For instance, students enrolled in the course that

can be taken only by women who already have their bachelor's degrees attend classes in the basement. All three hundred students in this group take all of their classes together.

The teacher, always dressed in a pale-green *abaya* and a large *hijab*, sits behind a desk on a small elevated platform in the front of the room. The students sit in neat rows on the sheet-covered floor, facing her. They have their bags next to them and their books opened on a foot-high "desk" that runs the width of the room. While senior teachers lecture, junior teachers walk the length of the room, ensuring that the students do not talk to one another. A variety of subjects are taught by various teachers, but the most important course is the word-by-word translation and exegetical commentary of the Qur'an, which Farhat Hashmi continues to teach. Although she moved to Karachi to open a branch of the school there in 1999, her audiotaped lectures are used in class. Large speakers attached to the hall's walls ensure that all the students are able to hear her, which is essential since about three hours per day are spent hearing the translation and exegetical commentary of a *ruku*. Made up of about ten or fewer verses of the Qur'an, each new *ruku* in the Qur'an is marked in the margins of the book.[15] Teachers have the students get up and do two-minute stretching exercises every hour in order to ensure their alertness in this rather long class.

While students fill the front three-quarters of the room, the "listeners" fill in the chairs placed at the back. Most classes at Al-Huda are open to women from the general public, and the listeners are women who come to the lectures without enrolling as students. Most women usually come for the *tafsir*—the exegetical commentary of the Qur'an—and their numbers increase during that time of the day. These women are primarily housewives, usually in their forties or older. Hence, by opening its doors to listeners, Al-Huda gives many women the space they need to attend the classes of their interest without having to pay the registration fee, and without being bound to any rigid schedule, thus allowing them the flexibility that they often need.

15. A *ruku* also refers to the act of bending down while standing during *salat*, or prayer.

As the type of audience at Al-Huda has expanded, so have the courses. Summer crash courses, which take place in both English and Urdu, have become an important part of Al-Huda. These courses offer students a taste of different topics: they are, for instance, made to learn a few *du'as*. A *du'a* usually refers to the personal supplicatory prayer, but it is not quite so personal in this context. Al-Huda places a great deal of emphasis on the *du'as* that the Prophet Muhammad is said to have made on different occasions, such as before beginning a journey, while stepping inside a house, before eating or drinking anything, and so on. As he is considered an exemplary human being, students are encouraged to emulate his behavior. Apart from learning selected *du'as*, students also listen to lectures on a number of topics related to their lives, such as purdah, cleanliness, and male and female relationships, and listen to the translation and exegetical commentary of a few selected Qur'anic chapters called *surahs*.

Classes within the summer course take place on a daily basis for four to eight weeks, depending on the nature of the course, and become a way for students to fill their time during their summer break. Although there is no age limit in these courses, they are largely composed of teenage girls. Parents often complain about their child's wasting his or her summer vacation, and a few of them make their daughters attend these courses in order to solve that problem. Likewise, some young girls also consider these shorter courses to be a more feasible option given the fact that a number of them do not want to interrupt their education by taking a yearlong course. Al-Huda also offers weekly programs on various themes on an ongoing basis, allowing women who are interested in something special to pursue their interest without having to commit to the full load of a diploma course. One of these programs includes women getting together once a week to learn *tajvid*. Another program focuses on learning different hadith.

Al-Huda also organizes special programs on occasions of religious significance, such as lectures on how to perform the annual pilgrimage to Mecca known as hajj, or how to celebrate 'id in a "proper" manner. It also arranges a *Daura-e-Qur'an* in both English and Urdu during Ramadan.

After expanding the audience base in Islamabad and in the neighboring town of Rawalpindi, which is just a fifteen-minute drive from Islamabad, through the provision of different kinds of courses and classes, the

next step was opening the school to women outside these twin cities. The addition of a hostel made it possible for women living farther away to enroll. Financial assistance is available for girls who come from small towns and villages. For most of those women who attend the school and live in the Islamabad-Rawalpindi area, however, affording the low registration fee and obtaining books and the uniform are not a burden. The uniform is made up of a white *shalwar kamiz,* the national dress of Pakistan that consists of baggy pants and a long shirt. A white or blue head scarf, the color of which depends on what kind of courses the students are enrolled in, is also a part of the uniform.

The kind of Islam being propagated at Al-Huda is no longer limited to the women who go there to study, and it is through *da'wa,* a significant part of the school's agenda, that the school's religious discourse further spreads in the larger society. Al-Huda graduates are encouraged to teach what they have learned and are trained to influence others, be it their family members, friends, or strangers. This training specifies what approach they should take in order to maximize their success: "Present yourself and your behavior so beautifully that people come onto this path on their own," advises Farhat Hashmi. "Show wisdom in judging when Allah's message will have the most impact on people. An ill-timed overdose will harden people's heart," she continues (Hashmi n.d.a). Such advice is combined with, and given authority through, reference to specific Qur'anic verses, such as the following in *Surah Nahl:* "125: Invite people to the way of your Lord with wisdom and beautiful preaching; and reason with them in the most courteous way."

Apart from elaborating on the general approach they should adopt, students are also told that *da'wa* activities can range from informal advice to formal instruction. Farhat Hashmi narrates an incident to her students in order to illustrate how religious outreach can be undertaken informally. She shares how upon hearing Punjabi music in a taxi, she took out a tape of Qur'anic recitation from her purse and gave it to the taxi driver to play. "The driver asked me if he could keep the tape with him when we arrived at my destination," she laughed. On a more formal note, students are given summer assignments in which they have to offer a three-day course to their friends or neighbors. Teachers are available to share teaching tips

and help guide the students in designing their curriculum, making them comfortable with the exercise of doing *da'wa* and increasing the likelihood of their doing so once they graduate, regardless of the level.

Hence, all students make attempts to do *da'wa*, whether it is by sharing what they have learned with their families, offering weekly *dars* to women in their neighborhood, opening up a branch of the school in their part of town, or engaging in other kinds of religious outreach activities. Lectures offered by Al-Huda graduates that aim to impart basic Islamic knowledge and inculcate religious curiosity among young people, for instance, are organized at schools and colleges all over the city, and are an illustration of *da'wa*. Another common activity Al-Huda graduates enrolled in other educational institutes engage in involves their taking over empty classrooms to speak on various topics. A group of girls inevitably gathers around, and these meetings become regularly scheduled occurrences in these institutes. It is also within this context of *da'wa* that we see branches of the school opening up around the city, country, and the world.

Although Al-Huda itself has opened branches in all the major cities of Pakistan, such as Lahore and Karachi, in recent years, some day scholars who have attended these main branches in their respective hometowns have chosen to set up their own branches in their part of town once they have completed their diploma course. Likewise, students who come to attend the school from small towns and villages, and who live in the hostel, often open up branches or spread their knowledge through other more informal means once they have completed their courses and gone back to their homes. The main Al-Huda school offers to help them set up these branches, providing them with basic teaching resources as well as limited funding if it is needed.[16] A small percentage of students in the main

16. None of the teachers at Al-Huda was willing to disclose anything about where Al-Huda gets its funding. But from what I did hear, it seems that it mostly runs on donations. Giving religious institutions, such as mosques, and religious teachers donations is an old custom. Although the teachers at the school never solicit donations, there is a box in a corner of their main hall where people wishing to make a donation can do so. People desiring to give a large donation approach the school administration directly. The fact that a large number of Al-Huda students are women from affluent classes ensures that Al-Huda is in a better position to receive funds than many other religious groups that

Al-Huda branches are also made up of Pakistanis who are settled abroad, usually in the United States, the United Kingdom, or Dubai, but come to Pakistan for a year just so they can take this course. A number of them have now opened up branches in their countries of residence.

The main Al-Huda branches in assorted cities keep some record of the larger branches opened by their students, both nationally and internationally, and this information proves to be useful when women get in touch with them, asking them if they know of a branch that is close to their homes. Many women claimed that they could not go to the main school because of transportation issues. The availability of a branch that was within walking distance solved this problem and added to the convenience for many women. Branches opened by students offer the diploma course over a period of two years, primarily because they do not have enough teachers to cover all the subjects at once or because they cannot invest more than a specific number of hours per day in the school. This two-year program works out for many of the students as well, who likewise cannot spend too much time in class every day because of their responsibilities at home. If the branch is a relatively large one, teachers from the main branch may be asked to visit and teach a subject on a daily basis. But many branches, often not even called branches, are much smaller informal establishments. Zahida's class offers one such example. A married Al-Huda graduate with a six-month-old baby at the time I met her, Zahida lived with her husband in the upper portion of a house in a lower-middle-class neighborhood in Islamabad. Three to four women in her neighborhood came to her house for a couple of hours every day, and they spent that time listening to Farhat Hashmi's explanation of Qur'anic verses on Zahida's small tape recorder. Zahida answered any questions that they had and also gave short talks on diverse issues, such as the importance of rituals like fasting and praying,

cater to people belonging to the lower socioeconomic classes. The houses in which their main branches are located in Islamabad, Lahore, and Karachi, for instance, are donations. Examples of people who have regularly invited Farhat Hashmi to give *dars* to them include the mother and wife of Farooque Leghari while he was president of the country in the early 1990s, and the royal Saudi family. It would be fair to assume that she or her school, or both, was well compensated for her efforts.

or issues more central to their lives, like personal hygiene. Her motivation in offering these classes was not only *da'wa* but also to create a means through which she could keep in touch with the Qur'an. As she put it, "I felt very isolated after getting married, moving to a new house, having a baby. I felt I was losing touch with all I had learned, and you cannot keep on the straight and narrow unless you are constantly in touch with the Qur'an. These classes are not an ideal situation, but this is all I can do in the time I currently have." Due to the amount of work that goes into setting up and maintaining a branch, many women who want to teach either end up teaching at the main branch or, more frequently, begin offering a weekly *dars* in their home.

Apart from a mushrooming of formal and semiformal modes of information dispersal among different kinds of women in the local, national, and global contexts, information—which has a persuasive and potentially transformative nature—is also disseminated through the media. The use of both the electronic and the print media has been shown to be quite popular among religious movements, who use it for "a new socialization, recruitment, and organization of their members," in order to "restore spirituality and decency" (Tehranian 1993, 316; Mendelsohn 1993), and to aid in the formation of a larger community (Hegland 2002). Listening to religious sermons on cassettes, for instance, is a popular practice among urban Muslims in Egypt, who use it as a tool for ethical self-discipline (Hirschkind 2001). Markets in Egypt are flooded with tape-recorded sermons that both men and women buy in order to receive guidance about how to live their daily lives in an Islamic manner (Mahmood 2005). Likewise in Islamabad, Farhat Hashmi's lectures are available in most of the larger bookstores in the city, as well as a small shop, Al-Masoud, not far from Al-Huda. This shop sells recordings of Qur'anic recitations and audio cassettes and CDs of lectures by scholars, including the complete collection of Farhat Hashmi's lectures. These recordings not only include the translation and explanation of the Qur'an[17] but also her lectures on various topics.

17. Farhat Hashmi's word-for-word translation of the Qur'an and exegetical commentary come in a set of three hundred cassettes. These cassettes are used by the main school in Islamabad, as well as by her students in their branches. Hence, most of her quotes in

2. Browsing at Al-Masoud, Islamabad

Farhat Hashmi's lectures cover topics that are more spiritually inclined, such as "Allah Is the Light of the Heavens and the Earth"; show the importance of Islamic rituals, such as "The Importance of Praying"; touch on "Islam's" position on various practices, such as "Islam and Photography" and "How to Express Love: Sacrifice or Valentine?"; and lectures that give direct guidelines on how to behave, such as "Don't Make Fun of Others," "The Key to a Successful Family Life," or "Covering and *Hijab*." These tapes are frequently used by former students who set up their own branches, and are also used as gifts to give one another on special occasions. Even women who do not study at Al-Huda in any capacity often buy her tapes on topics that interest them and frequently play them in their cars as they drive from one place to another, or as they work in their kitchens. In addition, Farhat Hashmi had a twenty-minute radio

this work have been taken from her audiotaped lectures when they were played in the main Al-Huda branch in Islamabad.

show at the time this research was conducted, in which she gave the translation and explanation of a few verses of the Qur'an on a daily basis. She also made frequent appearances on television during that time, especially during the month of Ramadan, when she gave a lecture on a different topic each day of the month. Moreover, her lectures can also be heard through the Al-Huda Web site on the Internet, making them accessible to individuals who do not own her tapes.

Women also frequent Al-Balagh, a small bookstore in the same shopping compound as Al-Masoud, that sells exegetical commentaries of the Qur'an by scholars, books on different aspects of Islam, as well as items like bumper stickers (Smile! Allah loves you), cards for various occasions, and small brochures and booklets that contain du'as for specific purposes, such as "Incantations for Cure" and "Prayers while Travelling." Such material, "marked by a concern for ease of comprehension and practical applicability," is also consumed elsewhere in the world, whether in the mosque movement in Egypt (Mahmood 2005, 79) or in rural and urban India (Wadley 1983). Urban Pakistani women are avidly consuming this "modern" arrangement of knowledge. I was given many of these brochures as gifts when I went to interview women in their homes, and frequently saw women buying them during my trips to this bookstore. For instance, on one occasion I heard a woman asking the shopkeeper if he had something for her to read that would make her daughter have children. A new variant has therefore been added to the more traditional practice of going to pirs and asking them for such incantations.

Thus, Al-Huda's discourse is being spread into mainstream society through a number of means. One of the most important is through its spin-offs. For instance, one of Al-Huda's graduates had begun offering weekly Islamic classes for boys and young men in 2003. One of Al-Huda's most successful spin-offs, however, is called Colors of Islam, and it is a weekly two-hour class held for five- to twelve-year-old children within Al-Huda's premises. The objective of this class is to use activities like skits, artwork, and small-group discussions to teach children basic Islamic knowledge and values in a fun manner. Dr. Kanwal, a pediatrician trained in the United States and an Al-Huda graduate, opened this school because she claimed, "When I came towards religion, I wanted my children to have the same

experience I did." Unable to find such an institute for children, she, with Farhat Hashmi's encouragement, decided to open one herself. One of the teachers I met there explained what was so special about this school. As she put it, "The way these children are being taught about Islam is very different from the way most of us learned about it when we were young. Being forced to read the Qur'an with the *maulvi*[18] is such an unpleasant experience for most children that they spend the rest of their lives running away from Islam. . . . We, on the other hand, are careful not even to say the word 'sin' or 'hell' when we teach. Our emphasis is on positive strokes."

With the basic objective of trying to inculcate a love of Allah among their students, the teachers at Colors of Islam, all dressed in fawn-colored *abayas* and mauve *hijabs*, are very enthusiastic as they teach children basic concepts in a simple manner, as the following sentences addressed to them illustrate: "You know when you buy a TV, it comes with an instruction manual. If you follow the manual, you will know how to use the TV. Well, in the same way, we also have an instruction manual. Do you know what that is? That manual is the Qur'an. Allah speaks to us through the Qur'an and tells us how to live our lives, so we can function properly."

I saw a number of performances. In one, young children were dressed up as flowers and sang a song for the older children about being *jannat kay phul*, or the "flowers of heaven." I saw an interactive skit in which two young boys acted out the roles of a *maulvi* and a student, with the former coming to the latter's house to teach him the Qur'an. The *maulvi* would begin teaching, and the student would start chewing gum, or stretching, or begin playing with his ball, or go to sleep. After each instance a teacher would make them "freeze" and ask the rest of the children what the student, named "Tinkoo," was doing wrong. The children would reply accurately, and the play would continue until "Tinkoo" made a new mistake, at which point the same procedure would be repeated. At the end of the play, the teacher, with the student's input, made a list of things that they must not do when reciting the Qur'an. All of this took place amid much giggling and excitement. Later on in the class, there was group activity and

18. A *maulvi* is a religious cleric who is allowed to preach and officiate at religious rituals and functions.

discussion in which the children learned that if they want to go to heaven, they must do good deeds, and what those deeds entailed. This activity was followed by an artwork exercise that reinforced this concept: they had to sift through pictures showing children engaging in a number of activities, from watching television to helping their parents at home, and identify and paste the pictures showing "good works"—works that would enable them to enter heaven—on their chart papers. The midafternoon prayers came halfway through the class, and a teacher led the prayers for the children out loud so that they would eventually learn the words. The class ended with snack time, and this activity too was used as an opportunity to bring children's behavior into line with what is deemed normative Islamic behavior. For instance, whenever a child ate with his or her left hand, the group leader would correct him or her by stating that Muslims eat with only their right hands and explaining why.

A weekly group associated with Colors of Islam is known as the Mothers' Forum, and it is for mothers who want to know what their children are learning there. Mothers are taught the concepts that their children are taught, but at an adult level. The teacher then explains how those concepts were simplified for the children in their class. A significant portion of the class is also spent discussing issues that women may have regarding child rearing—for instance, what to do when there is a clash between religion and social norms. They often discuss other problems they may be having as well, such as with their husbands or in-laws. These women are provided with a space where they can share their problems with other women, and they end up with a support group where discussions generate "Islamic" solutions to their problems.

Hence, the reliance on a variety of methods of information dispersal and techniques of expansion has guaranteed that the school that once catered only to the upper classes of Islamabad is now spreading its ideology not only across a larger cross section of society within Pakistan but also among Muslims living abroad. Al-Huda's success, visible both in its expansion and in the manner in which a large number of women affiliated with Al-Huda alter their ideology, behavior, and lifestyle, is connected to the larger hegemonic religio-nationalist discourse that most women internalized while growing up in Pakistan. Yet it is the presence of alternative ideologies within the

same culture that also makes their task of producing subjects informed with a unitary religious consciousness a challenging one.

Women and the Hegemonic Religio-Nationalist Discourse in Pakistan

According to the official state narrative, Pakistan's existence is based on the Two-Nation Theory. Presented by reformer and educator Syed Ahmad Khan in the latter half of the nineteenth century, this theory proposed that since Muslims and Hindus were two different religious groups, they were therefore two different nations. Later co-opted by the Muslim League, this theory became the basis of the independence movement. The immense diversity among Muslims, whether it was ethnic, regional, or class based, was ignored. All these other identities were subsumed under a monolithic religious identity, but they "asserted themselves with a vengeance [after partition] destroying the very basis of the Two Nation Theory in the violent separation of East Pakistan from the rest of the country in 1971. Other regional nationalisms also became vibrant and assertive" (Khan, Saigol, and Zia 1994, 5). The state adopted standard means to deal with the insecurity felt in the face of class and regional conflicts, as well as local nationalisms: it drew on "fundamentalist religious and militantly nationalistic discourse to impose the illusion of unity from above," giving "further impetus to the ideology of nationhood, religion, and centralization of State" (6–7).

Whether it is the government's and military's fear of being bombarded with ethnic conflicts and local nationalisms or people questioning their own national identity (K. Ahmad 2000), the solution is often the same: holding on to—and in many cases creating—an "authentic" national culture. "A national culture starts out as nationalist ideology" (Fox 1990, 4), and the latter is closely tied to religion, as for many people "Islam is an important—for many the most important or even the only legitimate—force of cohesion in today's world" (Stowasser 1994, 5). This belief is particularly strong in Pakistan where the ideology of the country, the notion of Pakistan being created for Islam, is a "truth" children begin learning as soon as they begin school. "It is the most important thing that students need to learn," asserted Pakistan's former prime minister Zafarullah Jamali

(as cited in Hoodbhoy 2004). This fact does not imply that people who propagate this truth necessarily believe in it. Pervez Hoodbhoy, a leading social scientist in Pakistan, recalls that a former vice chancellor of his university "privately defended indoctrination and false information in textbooks, by arguing that if we tell the truth, Pakistani children will question the very existence of Pakistan" (2004). After all, "whether a nation will survive as a dream or not depends on how long it can sustain its self interpretation as a sensible symptom of its existence" (Gourgouris 1996, 1). The truth or disruption of the dream provokes fear, and the fear is dealt with by holding on to the ideology more firmly.

The creation of a national culture, based on the national ideology, is dependent on the use of Islam as a unifying force. Women are commonly seen as symbols of this national culture (Abu-Lughod 1998; Menon and Bhasin 1998; Mankekar 1999), and this image is reinforced by their roles as wives and mothers, their dress, their behavior, and their affiliation with the private sphere of the home (Chatterjee 2001).[19] So in a way, "the home . . . was not a complementary but rather the original site on which the hegemonic project of nationalism was launched" (cited in Mankekar 1999, 104). Ayesha Jalal asserts that "there was consolation in the knowledge that the real strength of the Islamic social order lay in the continued stability of the family unit and more specifically in the social control of women" (1991, 80). The unity of the family was linked to cultural authenticity, which was subsequently linked to national integrity, and the women provided the link.

Anita Weiss (1998b) explains that Pakistani women have been used as symbols in state policy in three different kinds of instances: the redefinition of traditional culture, an affirmation of identity against an Other—for

19. A case in point is how the notion of seeing women as the caretakers of a culture initially became increasingly important for the Muslims (that is, Muslim males) when their rule ended and the subcontinent came under British colonial rule. "Muslim identity and respectability were seen to reside in the 'protection' [read: segregation and seclusion] of women" (Rouse 1996, 50). Whereas it became acceptable for the men to participate with the colonizers in public life, women were relegated to the private sphere and the family and were made into symbols of Muslim identity. Women in such contexts often become "symbols of the authentic and sacred community of believers" (Ask and Tjomsland 1998, 8).

instance, British colonists, Hindus, or the "West"—and the preservation of group unity in the face of swift, and what is perceived to be threatening, change. Hence, a key aspect of the nationalist discourse, based on the nationalist ideology, which is intricately linked with religion, is using women for the "maintenance of indigenous values and 'cultural authenticity'" (Stowasser 1994, 5). Honor is one of these values, and in Pakistan a woman's honor is closely tied to her "sexual purity" (Haeri 2002, 35).[20] Any activity deemed culturally inappropriate thus results in the loss of honor, and not just hers but also her family's, and eventually her nation's. This honor is located in women's bodies (Menon 2002). Thus, the control of women's sexuality is necessary in order to continue the patriarchal family lineage, and because women are seen as "the cultural symbols of a collectivity, of its boundaries, as carriers of the collectivity's 'honor' and as its intergenerational reproducers of culture" (Yuval-Davis 1997, 62).

An active propagation of this discourse in a society that is already patriarchal has led to the emergence of a hegemonic discourse about the ideal Muslim woman in Pakistan, one who is passive, obedient, confined to the private sphere of the home, and the upholder of her family's honor through her modest dress, behavior, and sexual "purity." Many in Pakistan internalize this discourse simply because that is the reality presented to them as they grow up in Pakistani society. However, history shows the acceptability of expanding traditional roles during times of crisis, as well as for political expediency (Mumtaz and Shaheed 1990; Mankekar 1999; Haroon 2002). It also shows that "competing ideologies . . . have emerged in the process of nation-building in Pakistan" (Ewing 1997, 5). Competition can exist between slightly different national ideologies. For instance, a woman's "ideal" role is largely dependent on the political leader in power, and what he or she perceives the country needs at that particular moment. Whereas the ideal of a woman as a caretaker of the home was at its height under the leadership of dictator Zia-ul-Haq in the 1980s, the ideal woman,

20. This factor, however, is not true of the non-Muslim Kalash women of the North West Frontier Province of Pakistan, who primarily identify themselves against their Muslim counterparts. It is within this context that their sexual "purity" is neither valued nor considered a sign of prestige or honor for Kalash men (Maggi 2001).

according to Jinnah, was one who fully engaged in public life in order to lead her country into development. In a speech made at Aligarh Muslim University in 1944, Jinnah stated that "no nation can rise to the heart of its glory unless your women are side by side with you. . . . It is a crime against humanity that our women are shut up within the four walls of the house as prisoners" (Rosenbloom 1995, 248).

Even when the dominant national cultural discourse is internalized by many women, their behavior, as they live and function within a society, often goes against this norm because the "national culture is constantly being molded as individuals and groups confront their social worlds and try to (re)form them" (Fox 1990, 2). Expanding his point further, Richard Fox claims that "even when one nationalist ideology becomes dominant and a national culture is produced, internal contradictions and new nationalist ideologies produced 'from the bottom up' make a national culture rubbery, perhaps nearly molten under some circumstances—and certainly not possessing the 'iron strength of cultural walls' that Margaret Mead wrote about" (5). Thus, just because a dominant discourse regarding an ideal woman exists does not mean that women do not challenge it or disrupt it. Weiss illustrates the difference between the dominant ideal cultural discourse and practice among women in the urban areas of Pakistan by asserting that "various political figures intimate the need for separate women's bank branches, separate seating areas on buses, and even separate universities. The reality, however, is that many women have already crossed the lines: they bank wherever they want, sit wherever they can, and freely enroll at all major universities" (1998a, 125).

The difference between this ideal "Woman" and real "woman" (Mohanty 1991, 57) exists because the latter is drawing on the variety of ideological systems (Hall 1985) or the larger "cultural field" (Comaroff and Comaroff 1991) that is present in any society. Gillian Rose explains that "situating a self in a space of boundaries . . . is an awkward process . . . because these boundaries are imagined and experienced as highly complex, multiple, overlapping, diverging, articulated through various media, fleshy and psychic, emotional and analytical. They are also shifting, permeable, and to some degree unpredictable . . . highly resistant to mapping in conventional ways" (2002, 257). This complexity suggests that women's lives

and identities are not merely determined by a dominant national-religious discourse or even religion. In her study of professional Pakistani women, Shahla Haeri (2002) rightly notes that the *nikah,* or Muslim marriage contract, is the least elaborate of all the wedding rituals. The wedding takes place over a three-day period, and each day has its own rituals and functions. *Mehndi,* for instance, takes place the first day. Relatives put henna on leaves placed on the couple's hands, and there is much singing and dancing. The Islamic *nikah* is only one part of the three-day wedding.[21] Hence, a unitary framework of religion does not inform most people's experiences.

Complex relationships exist among factors such as religion, culture, ethnicity, gender, class, age, and forces of nationalism and modernity (Kandiyoti 1991; Wadley 1994; Abu-Lughod 1998; Saliba, Allen, and Howard 2002). As Saba Mahmood argues, "Just as scholars have been attentive to the multiplicity of commitments, ideals, and goals that co-exist in any given Western liberal society, it is equally important to be attentive to the variety of projects, conceptions of selfhood, structures of authority, and goals that exist among women living in Islamic cultures, none of which are reducible to a singular framework (such as religion, economic self-interest, gender equality)" (2003, 312).

Growing up in such a context, where an individual has access to a number of different ideologies, gives rise to an individual whose life is informed by a number of competing identities (Haeri 2002; Saliba 2002) and takes us a step beyond the notion of a self that is "unified, coherent, self-centered" (Rose 1996, 4). As Clifford Geertz elaborates, "The Western conception of the person as a bounded, unique, more or less integrated motivational cognitive universe . . . organized into a distinctive whole and set contrastively both against other such wholes and against its social and natural background, is, however incorrigible it may seem to us, a rather peculiar idea within the context of the world's cultures" (cited in Ewing 1990, 256). A young girl who believes that listening to music is forbidden

21. These other rituals and celebrations associated with marriage are deemed a part of Hindu culture and are highly criticized at Al-Huda (see chapter 5). Many Al-Huda graduates do their best to ensure that their marriage is undertaken in an "Islamic" manner, that is, with only a *nikah* and a *valima* (the reception the day after the *nikah*).

in Islam may not listen to it during Ramadan, a time during which her Muslim identity may be at its strongest. It does not mean she does not listen to music in everyday life, when she is functioning as a young person living in a culture in which music is a part of normal day-to-day existence. A person may, at any moment, experience her self as a "symbolic, timeless whole, but this self may quickly be displaced by another, quite different 'self,' which is based in a different definition of the situation" (Ewing 1990, 251). What self an individual projects or what identity is at the forefront is largely context dependent. As Stuart Hall (1996) explains, identities are built over varying, often conflicting, positions and discourses and are, therefore, fragmented and multiply constructed. Such a notion of identity can be understood only when, rather than being "reducible to a closed system of signs and relations, the meaningful world always presents itself as a fluid, often contested, and only partially integrated mosaic of narratives, images, and signifying practices" (Comaroff and Comaroff 1991, 27).[22]

The women who study at Al-Huda possess such multiply constructed identities by virtue of growing up in a culture that, like most cultural settings across the globe, is informed by more than one ideology; they live their lives not within one framework, such as a religious one, but within many different ones. They do not possess a unitary consciousness. "Third world women" are often perceived and represented as monolithic subjects living ahistorical lives (Mohanty 1991), a perception that is particularly prevalent for Pakistani women, because apart from belonging to the "developing" world, the majority of them are also Muslim, another label that seems to allow many to forget that women's lives are historically and culturally heterogeneous.

A danger of viewing subjects as possessing a unitary consciousness informed by a single (religious) framework is that it fosters a simplistic,

22. There is a dearth of ethnographic literature on urban Pakistani women, and the literature that is present deals with women belonging to the lower socioeconomic working class, such as Fouzia Saeed's *Taboo!* (2001) or Anita Weiss's *Walls Within Walls* (2002). Shahla Haeri's *No Shame for the Sun* (2002) is the only work on women belonging to the urban upper classes in Pakistan. All of these works do, however, bear testament to how women's lives are informed by a number of ideological frameworks.

one-dimensional view of both their lives and the culture they live in, and they are seen as either "determined by a discourse . . . or totally outside of that discourse" (Ewing 1997, 18). Although this is "inadequate to capture subjective experience in the face of the clash of discourses and the competition of ideologies characteristic of postcolonial societies" (19), it is in line with Al-Huda's core goal, and its activities are geared toward bringing those women "outside of the discourse" inside. How successful it is in accomplishing this goal is dependent not only on the strength and nature of women's prior religious beliefs and the power of alternative ideologies in their lives but also on their motives for engaging this religious discourse as they function from their own particular positions within the sociopolitical climate of both their city and the larger world. The extent to which they are successful in creating a unitary subject will determine the extent to which binary dualisms—religious-secular, religious-religious in a different manner—will exist among women in society, and the more their success, the less the overlap between them.

3 · Of Allah and the PowerPoint

AL-HUDA'S UNIQUENESS lies in its success in being able to make inroads into the middle and upper classes of Islamabad, and women's stories of their personal journeys reveal the critical role the school's pedagogical techniques play in enabling its success. As such, its importance in facilitating women to discipline themselves (Asad 1993) into pious and ethical subjects (Foucault 1997; Mahmood 2005) cannot be overstated. This success is facilitated by particular cultural codes—ideologies, values, beliefs—preexisting in the sociocultural landscape of Islamabad that many women have internalized. However, as every society is made up of individuals carrying a variety of, often competing, cultural codes, the presence of the latter, particularly if they are very strongly embedded, can also constrain growth and produce or accentuate tensions among, and dissonance within, individuals associated with it.

Al-Huda: A Social Movement

What once began as a school in Farhat Hashmi's own home has now turned into a social movement. Her school, which initially began with thirteen students, has gained increasing popularity each year. The 2003–2004 class in the main Al-Huda branch in Islamabad had approximately one thousand students, and many had to be turned away because of a lack of space. The school has expanded its base by offering a variety of courses, inculcating the spirit of *da'wa* among its students, relying on the mass media to disseminate its discourse, and through its numerous spin-offs. It has thus been successful in attracting a very large number of students who are no longer limited to the upper classes, and in spreading its ideology among those women who do not attend its main branches, hence influencing people around Pakistan and the world. It is within this context that I refer to it as a social movement.

Social movements are popularly regarded either as a gathering, often spontaneous, of individuals who get together to voice grievances and bring about change or as an organized collective action to promote a cause in the face of some structural strains (Larana, Johnston, and Gusfield 1994). There is an abundance of literature available on recent Islamic revivalist movements around the world, and much of it focuses on religious parties as they gather mass support and resist or challenge the government in both colonial and postcolonial contexts (Munson 1988; Esposito 1999; Keddie 1999; Nasr 1999). However, unlike these instances, there is no well-defined closed group against which women affiliated with Al-Huda react, and neither do they join the school because they feel they are oppressed. Yet I persist in seeing these women as part of a social movement.

Spreading its ideology into mainstream society through a variety of measures, Al-Huda is committed to infusing the individuals who engage with it with particular "Islamic" principles so that they can transform themselves into pious subjects. Many of the students who internalize this ideology, regardless of where they are placed or how they hear its message, are taking it upon themselves to spread it further, be it only among their family and friends or among larger segments of society. The process continues, taking on a life of its own, as many of the women who learn from others also begin spreading the ideology. It is like a domino effect, and it is within this context that I claim that Al-Huda has turned into a social movement, albeit an informal one. Recent literature has focused on how many Islamic groups have adopted a "bottom-up" approach, encouraging people to "bridge the gap between religious discourse and practical realities" in their daily lives, hence increasing the "Islamic" atmosphere in their societies (Ask and Tjomsland 1998, 2). Many women are active participants in contributing to the religious atmosphere of their homes and societies within this larger context, and it is here, within this less formal understanding of social movements (Wiktorowicz 2004), that I place the women who engage Al-Huda. Those women who are influenced by Al-Huda's ideology or spread it further may not be linked with the institution physically. They may have never been to the main Al-Huda branch. They may not even spread the message in the name of Al-Huda. But they are linked to it through its ideology, and through their individual efforts to

transform themselves, and in many cases others, into particular kinds of pious subjects.

Al-Huda's phenomenal success is perhaps not that surprising when one remembers that it is not functioning in isolation but rather drawing on values that already exist to some degree in society. This phenomenon is known as frame resonance in social movement theory (McAdam 1994; Hart 1996; Benford and Snow 2000; Wiktorowicz 2004). The greater the frame resonance, the greater the ease of accepting the discourse. "Where a movement frame draws upon indigenous cultural symbols, language, and identities, it is more likely to reverberate with constituents" (Wiktorowicz 2004, 16), and this cultural material—also known as cultural codes—includes the "extant stock of meanings, beliefs, ideologies, practices, values, myths, narratives, and the like" (Benford and Snow 2000, 622). Cultural codes may be altered or transformed by the movement, but they are not a completely foreign import, and these cultural narratives and experiences pave the way for the movement's success.

The women with whom I spent time grew up internalizing the Two-Nation Theory they were taught in school. That Islam is Pakistan's raison d'être has been reinforced through textbooks and the mass media and was something that the women I spoke to had been exposed to and believed in wholeheartedly. Furthermore, almost all these women came from backgrounds in which one or both of their parents prayed, where they had gone over the Qur'an in Arabic as a child with a *maulvi*, and where they usually fasted during Ramadan. Their parents often forced them to pray when they were young, which led to their stopping the practice as soon as they were older. But they would begin praying regularly during times of hardship, such as examinations, and stop as soon as the crises were over.

Although religion was not the sole framework informing women's lives as adults, and they did not know what the Qur'an said, usually did not follow what are popularly believed to be Islamic injunctions on a regular basis or at all, and often differed in terms of what Islam meant to them, most of them did, I learn, have faith. Neither familiarity with theological discourse nor possession of a clear cosmic framework is a prerequisite for having faith (Smith 1962; Asad 1993). They had all been taught to believe in God, in

the Qur'an as the Word of God, and in Muhammad as the Messenger of God at a young age; they all had faith in these beliefs.

It is the presence of faith, no matter how weak or strong, and regardless of whether it is overtly manifested through religious practices or plays a significant role in one's life, that plays a critical role in determining the ease with which women initially join Al-Huda and later alter their ideology, their behavior, and their lifestyle. Most important, it leads to their willingness to listen to the discourse, and as Susan Harding claims in her account of Jerry Falwell's fundamentalist movement in the United States, it is this willingness to listen that begins the process of conversion (2001, 57). Not all women who initially went to Al-Huda shared its ideology, or even knew what its ideology was. A young computer programmer shared her experience of discovering Islam through Al-Huda, and enthused, "I felt like Harry Potter! Discovering a whole new world that had always existed but of which I knew nothing about." Only a small proportion of women initially went to the school because their ideology matched the convictions of the school. A larger number of students, however, consisted of women whose predisposition toward Islam vis-à-vis their faith led them there but whose ideology altered after they had joined the institute. The phenomenon of ideological conversion following recruitment, rather than preceding it, is well documented in social movement research (Wickham-Crowley 1992; Brysk 1995; Clark 2004), and is certainly applicable in the context of Al-Huda.

Even if women's predisposition toward Islamic discourse is not enough in itself to motivate them to join the school, it does make them more amenable to being encouraged to attend it by their friends, acquaintances, or family members. Numerous research illustrates that "network channel is the richest source of movement recruits" (Snow, Zurcher, and Ekland-Olson 1980, 790; Brysk 1995). I heard a number of stories like Shazia's, a young girl studying at Al-Huda at the time I interviewed her. Her neighbor, a teacher at Al-Huda, kept urging her to join the school and played a key role in her decision to attend. "So when I was free after taking my Matric [tenth-grade] exams, I thought, why not take her up on it?" If girls are hesitant about committing a whole year, short-term options are also available.

Interestingly enough, a large number of girls who had come to Al-Huda for the one-year course at the time this research was conducted had been exposed to the Islamic discourse in another context, which had then whetted their appetite for more in-depth knowledge. These contexts include the short summer course, and in many cases a *Daura-e-Qur'an* during Ramadan. People who have attended them, listened to Farhat Hashmi via any form of media, or been exposed to lectures on Islam by guest speakers in their schools and colleges have all been made "structurally available," or structurally predisposed, to join the one-year course (Klandermans and Oegema 1987, 530). A young woman shared that a teacher from Al-Huda had come to her college as a guest lecturer, and in her talk on Islam, she remarked on how everything has a purpose: "She commented, 'A pen has a purpose, a chair has a purpose, but do we know what our purpose is?' This question, its basic simplicity, shook me. This was the moment of truth for me. Once I made the decision to learn more about Islam, I joined Al-Huda."

A few go to the school hoping to make sense of a personal tragedy in their lives, while some go in the hope of answering some religious questions. There is also that small proportion of students who go to Al-Huda because their family members force them to do so, illustrating that individuals who are not part of the mobilizing potential may still end up being exposed to the discourse. The personal desire to learn, however, does eventually rise within them, although it may take time. As one former student laughingly shared, "I slept in class the first few weeks." Nevertheless, women's faith and connection with Islam go a long way in easing the path for them.

The processes women undergo as they interact with the discourse force us to move away from perceiving them as passive recipients of a hegemonic discourse. Yet women's faith plays a critical role here, as do the pedagogical techniques employed by the school, which build upon this cultural code and facilitate women's journey by initially creating the will to change and then providing concrete means through which to do so. Hence, women's faith is elaborated and given a concrete shape on the basis of a particular understanding of religious piety as they go to the school. It is important to note, however, that these pedagogies are not equally effective on, and the religious discourse not completely internalized by, all Al-Huda students. But because most of the women who come to Al-Huda usually have not

had access to an alternative Islamic discourse, their faith in the authority and ideal nature of the one they do end up engaging results in dissenters being more of an exception than the rule.

Pedagogies of Transformation

Although Al-Huda is catering to a wider spectrum of women in terms of class, age, and occupation, the fact remains that its increasing popularity among the middle and upper classes of Islamabad is unprecedented. The question that then arises is why women from these classes did not avail themselves of the educational opportunities provided by other religious groups functioning in the city. The politico-religious Jama'at-i-Islami's women's wing has been organizing *dars* around Islamabad since the late 1960s. The Tehrik-i-Islam and Tablighi Jama'at are other organizations that devote themselves to spreading religious knowledge. But the popularity of most of these groups is limited to the lower middle class. Clearly, the mere presence of faith was an insufficient motive for further Islamic study for these women. The answer to why Al-Huda has been successful among the middle and upper classes when these other religious groups have failed lies in women's stories of their experiences.

Islam is generally perceived as a holistic worldview that "encompasses in it all things material, spiritual, societal, individual, political, and personal" (cited in Clark 2004, 168), and the Qur'an is popularly referred to as "a complete code of life." Yet despite an unwavering belief in the truth of this statement, usually learned in Islamic studies in primary school, most women claimed to be vague about how the Qur'an was relevant to their daily lives. In Pakistan, the cultural emphasis has always been on reading the Qur'an in Arabic, and most children end up doing so with the guidance of a *maulvi* by the time they are eight or nine. Yet they usually have no idea what they have read. The importance of reading it in Arabic precedes the importance given to decoding the text, a phenomenon found among Muslims in other parts of the world as well (Lambek 1990). This point helps explain why most women had previously not read the translation of the Qur'an and did so for the first time at Al-Huda.

However, it was not just the fact that the students at Al-Huda were exposed to the translation but the manner in which they were exposed

that made all the difference. Many women claimed that they found it difficult to understand the Qur'an when they read it on their own. As Ayesha, a young medical doctor who had lived in the United States most of her life, explained, "To tell you the truth, I'd pick up the Qur'an, and read *Surah Baqra* [the second Qur'anic chapter titled "The Cow"], and I would be like, it's a story about this cow or whatever, and fine, but so what? I'd feel good that I'd read the Qur'an, but what was the point? I knew that the Qur'an was something holy, it was something I respected . . . but it truly had no effect here, in my heart." Al-Huda's gift, many women claim, is the way each and every verse of the Qur'an is made relevant to their lives. Termed "experiential commensurability," this process adds to the relative salience of the frame offered by Al-Huda and makes it more resonant with students' lives (Benford and Snow 2000). The second chapter of the Qur'an, for instance, devotes a number of verses to the Hypocrites, individuals who professed to being Muslim in the Prophet Muhammad's time but secretly worked against him. After listening to Farhat Hashmi's explanation of those verses in class, the teacher in the large hall where we were sitting asked the students to make a list of the traits the Hypocrites had and then think about and identify which of those traits *they* had. One of the students immediately said that although she was a Muslim, she often lacked the courage to defend Islam when it was made fun of in gatherings of family friends. Other girls nodded in what seemed to be a personal recognition of such a shortcoming.

The primary focus in Al-Huda is self-reflection, looking at one's own behavior and changing it for the better. The goal is to make individuals what Foucault calls "ethical subjects," and one of the essential steps of this process is the "modes of subjectivation," that is, "the way in which people are invited or incited to recognize their moral obligations" (1997, 264). "They make us conscious about the little everyday things. They tell us to pick up a wrapper that comes up in our way when we are walking; they talk about proper hygiene. They don't make religion superfluous to our lives," shared a fifty-year-old woman who had been attending Al-Huda as a listener for a year. Farhat Hashmi constantly makes her students conscious about their behavior through her *tafsir* and lectures, as illustrated in an excerpt from one of the talks she gave while visiting the Islamabad branch

as I was doing my research: "Where does it say that a bride cannot offer her prayers? People feel embarrassed, are amazed, if they see a bride praying. In war, in sickness, even when you are lying on your deathbed but can breathe, you cannot forgo your prayers. But we are afraid that we will spoil our makeup on which we spent thousands of rupees." She provides her students with a particular "schemata of interpretation," a frame through which they can judge their behavior and compare it to the standard provided by the Qur'an and Sunnah (Benford and Snow 2000, 612; Ferree and Merrill 2000).

Consciousness of behavior is then ideally followed by "self forming activities" (Foucault 1997, 265), that is, attempts to modify one's behavior so that it is in accordance with the guidelines laid out in the Qur'an, which is portrayed and perceived as a divine plan for life. Qur'anic verses are used to provide guidelines regarding how to behave with the opposite sex, how to treat relatives, how to dress, what to eat, how much to give to the poor, how to establish a closer relationship with God—the entire dos and don'ts of life. This movement has what Saba Mahmood refers to as a "strong individualizing impetus," in which individuals must fight a constant battle with themselves in order to become pious subjects based on hegemonic Islamic guidelines (2005, 30). However, as Talal Asad argues, "The formation/transformation of moral dispositions depended on more than the capacity to imagine, to perceive, to imitate—which after all are abilities everyone possesses in varying degrees. It required a particular program of disciplinary practices" (1993, 134). These practices are what Michel Foucault terms "technologies of the self, which permit individuals to effect by their own means or with the help of others, a certain number of operations on their own bodies and souls, thoughts, conduct, and the way of being, so as to transform themselves in order to attain a certain state of happiness, purity, wisdom, perfection, or immortality" (1988, 18).

Al-Huda employs a variety of techniques in order to facilitate students' transformation into pious subjects, and gives them the means through which they can operate on themselves. The purpose is to provide them with a disciplinary program that initially brings about consciousness of behavior, transforms their inner motive, and then connects it to their outer behavior (Asad 1993). Assignments reinforcing that day's lessons are

one example of such a disciplinary program. Students, for instance, are urged to take five minutes to reflect on their day's activities before going to bed every night. They are also required to keep a weekly journal where they record their thoughts and the process they are going through as they read the Qur'an. Group time is another effective tool. Although most classes take place collectively in the large hall, the students are divided into groups of about twenty students each. Each group has a "group in charge," and she meets her group on a daily basis for forty minutes first thing every morning. This time is spent going over students' lessons from the day before, asking them what they learned and how they related it to their lives, and answering their questions. Discussions are geared toward practical knowledge rather than more abstract notions. This point is illustrated through the following short excerpt from one of my visits to these groups. This particular conversation took place in the English discussion group. Rafia, a young teacher in her midtwenties who grew up in Britain, sat on a chair in the middle of the small room that is normally used as a cloakroom and staff room during the rest of the day. About fifteen girls sat around her on the carpeted floor. After spending some time testing the girls on the Arabic of the verses they had studied in their *tafsir* class the day before, she began the discussion:

> RAFIA: [reading the verses they had gone over the day before]: "What is the essence of this verse? . . . So what does this mean for us? . . . Yes, a criteria for friendship. What kind of friends should we have?"
>
> STUDENT 1: "Pious?"
>
> RAFIA: "But are you always attracted to pious people?"
>
> STUDENT 2: "Hardly!" [The class laughs.]
>
> RAFIA: "You must spend time amongst friends who strengthen your faith. . . . What happens when you spend time with friends who are not religious? What kind of things do you usually end up talking about?"

As "interaction and activity are a crucial part of the culture making process" (Hart 1996, 89), a close study of the dynamics that take place within these spaces is key to understanding why students undergo a change over time. Discussions such as this one, touching the lived reality of girls' lives, serve to make them conscious of their behavior even when they are

outside the school environment so that they, as they explained to me, end up hearing their teacher's voice in their heads whenever they are exposed to a situation they had discussed in class, something I too personally experienced (and continue to experience) as a result of being exposed to the discourse for hours every day. The effectiveness of the institution lies in its ability to inculcate within its students a desire to order their own behavior outside of school, away from their teachers (Foucault 1995). Accounts such as this one also illustrate not only how disciplinary practices create pious subjects but also how the students remain pious subjects.

What is important is that suddenly the Qur'an is no longer merely a book that is carefully and respectfully placed on a bookshelf but something that women are engaging and thinking about, even when they are not in their classrooms. It is a very intense one-year process. I asked a teenage girl who was in the process of taking the course whether it did not become too much sometimes, and her reply—"Well, you're doing it for Allah and because you can enter heaven. And for that you have to pay. You have to work your butt off!"—summed up the attitude of most of the women with whom I conversed. This work involved constant self-awareness and disciplining. It required "honing one's rational and emotional capacities so as to approximate the exemplary model of the pious self," so that "one learns to express spontaneously the right attitudes" (Mahmood 2005, 31, 129). This work, in many cases, also involves transforming one's discursive consciousness, "involving knowledge which actors are able to express on the level of discourse," into practical consciousness, "tacit stocks of knowledge which actors draw upon in the constitution of social activity" (cited in James 1996, 26). Asad refers to Saint Augustine as having claimed that "the final, individual act of choice must be spontaneous; but this act of choice could be prepared by a long process" (1993, 34). Although reference is being made to another faith tradition, the process women undergo through their interaction with Al-Huda is such a process.

Teachers facilitate this process by striving to make their students strong in the face of the resistance they know they will encounter in mainstream society. Parallels were drawn between the students and the Muslims in the Meccan period, the time when the Prophet Muhammad was just beginning to spread his message and all the new converts had to face much

criticism and hardship from the rest of the society. Such comparisons brought students into the very fold of Muslim history itself and, as some students claimed, motivated them and gave them strength to overcome any criticism or ridicule they might endure from family or friends. Farhat Hashmi also constantly encourages her students: "When you do the right thing, people's criticism of you is a matter of course. Be patient in the face of difficulties. . . . [The people who make fun of you,] these are the people who try to present logic so they can get out of following the commands" (Hashmi n.d.b).

This encouragement was accompanied by a somewhat novel characteristic of Al-Huda that all the students claimed to love: they were not forced to adopt "Islamic" behavior. No one told them that they must cover their heads outside of Al-Huda or that they had to go home and throw away all their music CDs or that they should immediately begin praying five times a day. If a listener is hearing the Qur'an in the large hall at Al-Huda with her hair uncovered, no one will come to her and ask her to cover her head. As a teacher remarked, "Our job is merely forwarding the word of Allah. The rest is up to them." However, while the teachers at Al-Huda do not apply overt force, it is apparent that their pedagogical techniques go beyond a "mere" mention of Allah's word.[1]

1. Daily handouts given during the *Daura-e-Qur'an* organized by the main Al-Huda branch during the month of Ramadan also illustrate the careful pedagogical planning employed by the school. The thirty *siparahs* of the Qur'an are covered in the thirty days preceding '*id-ul-fitr*, which takes place at the end of the month of Ramadan. The one-page handout the listeners get every day begins with the number of the *siparah* being covered that day, followed by a heading that reflects a message in that *siparah* that the teacher wants to highlight for the students that day. The heading of *siparah* 21, for instance, was "Remembrance of Allah." This heading was followed by a Qur'anic verse, taken from the *siparah*, mentioning the desirability of remembering Allah. The next section of the handout was titled "Learning Outcome" and contained two hadith, or sayings attributed to the Prophet Muhammad, in which he tells his companions about the importance and benefits of remembering Allah frequently. The last section of the handout was titled "*Du'a* of the Day" and contained a prayer, in this case one beseeching Allah to help the person uttering the prayer to remember Him, worship Him, and be grateful to Him. Whereas the content of the handouts changed on a daily basis, the format remained the same.

A standard of "correct" behavior is revealed as more and more verses of the Qur'an are read, and women's process of transformation is made all the more intense as their peers and teachers appreciate those students who have changed. Women who change in the face of adversity at home are appreciated even more, and often become a source of inspiration for others. Countless women told me that they looked at women who had altered their behavior or their dress and thought to themselves that if they can do this, so can we. There is also constant support, affirmation, and encouragement present that help ease the process of transformation. It is important to remember, however, that the very fact that women who change are appreciated creates powerful pressure for social conformity (Wickham 2004), and an argument can be made that such pressure may end up being more effective than the use of overt force—generously applied in other religious groups—in the long run.

Another characteristic that sets Al-Huda apart from other religious organizations is its "modern" way of teaching. This quality is particularly relevant in a social context where Islam has always been closely associated with the *maulvis* of Pakistan. They are generally perceived by the masses in general, and women in particular, as uneducated, unkempt, misogynist, and extremist. Islam had largely been associated with them, and, therefore, it too became infused with a specific meaning, that is, of being "out-of-date" and "backward" through mere association. It became something with which these women, who prided themselves on being "modern," did not associate. As a twenty-year-old student at Al-Huda informed me, "I was never interested in religion. There is this mind-set, right, that if you go towards religion, people will call you *paindu*.[2] And the *maulvis* who tell us about religion don't know anything. They don't know where the world is going, what practical life is, or how to make religion practical in today's day and age."

Al-Huda has appropriated the meaning of Islam and presented it as not something that illiterate and ignorant people engage with but as something very modern. The use of PowerPoint presentations and other audio-visual aids contributes to the modern atmosphere of the school and plays

2. A Punjabi word, *pind* literally means "village." *Paindu* is derived from it and is frequently used, as it is in this case, to mean "backward."

a role in increasing its validity, as does the fact that Farhat Hashmi has a doctorate from abroad. Social movement research clearly indicates that the greater the credibility of the frame articulator, the greater his or her success at persuading others (Brysk 1995; Benford and Snow 2000), a fact of which Farhat Hashmi is clearly cognizant. She is often quoted as once having laughingly remarked that the only reason she got her doctorate was so educated people would take her seriously. As one of her young student affirms, "My friends don't take what I am doing [the course at Al-Huda] seriously until and unless I tell them Dr. Hashmi has done her Ph.D. from Glasgow." Such an attitude is typical of individuals who are "heirs to the postcolonial legacy, citizens of a nation state" (Haeri 2002, 32), who put great stock in the values of science, rationality, and Western education. The phenomenon of the education of a frame articulator increasing credibility is found elsewhere in the world as well. Patricia Horvatich's study of the Islamic reform movement among the Sama of the southern Philippines illustrates that the Sama are interested in the teachings of the Ahmadiya movement,[3] because it is headed by "educated elites" and its teachings "appeal to their intellect. The Ahmadi do not follow their *imam* blindly. They want to understand the meaning of Islam and the purpose of their activities" (1994, 821).

Although the students at Al-Huda all believed that faith was the cornerstone of religion, many of them were very vocal about how they were now learning the rationality behind Islamic precepts and how understanding made acceptance much easier. This point is most relevant for the middle class, who have more often than not subscribed to the "high Islam of the scholars and elites . . . [that] provides a more sophisticated religious interpretation attractive to the growing modernized section of

3. Ahmadis are a Muslim sect founded by Mirza Ghulam Ahmad—who regarded himself as a reformer sent by God to restore Islam—in the nineteenth century, in Punjab. They are now divided into two subsects, the Qadianis, who consider their founder to be a prophet, and the Lahori Jama'at, who consider him to be a reformer (Glasse 2002). Regarding the group as heterodox, the Pakistani government, under the leadership of Zulifqar Ali Bhutto, declared Ahmadis non-Muslim in the constitution of 1973 in the hope of appeasing the religious parties and securing support among the masses.

the population" (Ask and Tjomsland 1998, 4), the parallels of which are observed in other faith traditions as well (Schultze 1993). Although it is false to make an artificial division, with high Islam considered to be found only in urban areas and low Islam only in rural areas (Ask and Tjomsland 1998), Ernest Gellner's thesis that the former "reflects the natural tastes and values of urban middle classes," such as "order, rule-observance, sobriety, learning," along with its emphasis on scripture, makes it applicable to the urban women in this study (1992, 11).

The novelty at Al-Huda, therefore, is the space given to rationality.[4] The institution's ideology is not very different from the hegemonic religious ideology that is propagated by many *maulvis*—Al-Huda, too, is reinforcing a patriarchal system with gender roles as natural and the man as head of the household—but it is presenting it in a very different manner, so that women come to realize, for instance, that being made responsible for the house is actually a favor Allah has done for them, as working outside is very difficult for a number of reasons. The novelty lies "not so much [in] the originality or newness of its ideational elements, but the manner in which they are plied together and articulated, such that a new angle of vision, vantage point, and/or interpretation is provided," with logic and rationality as its bedrock (Benford and Snow 2000, 619). What comes

4. The importance given to rationality is also beautifully illustrated in the flyers advertising a summer camp for boys. This camp was organized by an Al-Huda graduate and was scheduled to take place in her home in the summer of 2004. I came across these flyers in the main Al-Huda branch on one of my visits. Printed on colored paper, these flyers invited boys between the ages of fourteen and twenty-four to "become young men of intellect." This emphasis on developing their intellect was combined with faith in God and in the Qur'an as the Word of God ("Open the door of your mind to the vision of Al-Qur'an" and "God's Message awaits your attention"). Thus, intellect and faith were portrayed as existing in a noncontradictory, dialectical relationship. The invitation to become young men of intellect, an attraction in itself, was made further attractive through the use of language that was specifically geared toward drawing young people of a particular class background. Hence, the "summer camp" was presented as a "proactive, vibrant youth group" where students could learn about Islam through modern pedagogical techniques such as "interactive sessions" in order to make Islam relevant to their lives through relating "the Qur'an to one's self, finding guidance and answers to everyday problems."

forth is a dialectical relationship existing between faith and rationality. The presence of the former was clearly not enough to make women engage with religion the way they are doing now, but at the same time, many claimed that they would have found it difficult to accept many religious commands if they did not have that faith.

In a similar vein, Farhat Hashmi's reliance on science and scientific facts also plays a role in paving the way for understanding and acceptance among girls. It increases the empirical credibility of the frame, making it more resonant, and hence more acceptable to students (Benford and Snow 2000). As one of her former students remarked enthusiastically, "I personally love the way she constantly relies upon science, and brings in science, in her arguments and her explanations. As a former atheist, science was my God, and so logical, scientific explanations have a large impact on me." Another student, who gave a specific example to illustrate her point, seconded this view:

> One of the things I had always had trouble with in Islam and which I discussed with her [Farhat Hashmi] at length was why, when a person could only do limited good or bad in their world, their stay in heaven or hell is eternal. She used the chaos theory to explain things to me. . . . How something like a butterfly fluttering its wings in Australia can, through a chain of events, cause a storm in another part of the world. She used that and explained to me that we never know what kind of impact our deeds, small or big, will have in this life, and whatever we do will remain and keep on having an impact on our world long after we have gone, and I immediately understood.

Farhat Hashmi's students often quote her encouraging them to listen to the various opinions of different religious groups, subsequently taking that which they think is in accordance with the Qur'an and Sunnah, something that greatly builds her credibility in their eyes. However, although she may never deride any competing Islamic discourses directly, her propagation of what Islam is puts other Islamic interpretations down by default.

Farhat Hashmi and the other teachers at Al-Huda aim to attain a hegemonic status for their ideology and are aggressively involved in the "creation of a particular structure of knowledge and value systems" (Fontana 1993,

140). Her interpretation of the Qur'an is a literal one, and her particular exegetical commentary and her addition of Sunnah to the umbrella of truth provide her students with a particular frame of reference through which they perceive and judge different kinds of Islamic discourse.[5] A monolithic form of Islam is propagated as the truth, where "particular discourses and practices . . . [are] systematically excluded, forbidden, denounced—made as much as possible unthinkable; others . . . [are] included, allowed, praised, and drawn into the narrative of sacred truth" (Asad 1993, 35). The fact that most of these women do not have ready access to an alternative religious discourse—and that most come to Al-Huda to increase their Islamic knowledge and to discover what Allah says in the Qur'an—makes their acceptance of this discourse, and their inability to see that there are other ways of engaging with the Qur'an as a text, all the more understandable. What they are learning is, they believe after all, the word of Allah, and is in keeping with Al-Huda's objective, "to promote *purely* Islamic values and thinking on sound knowledge and research, *free* from all kinds of bias and sectarianism" (Al-Huda 2005; emphasis added).

Ideological closure occurs in most cases. It is a moment of "recognition" when "the fact that meaning depends on the intervention of systems of representation disappears and we [become] secure within the naturalistic attitude" (Hall 1985, 105). This "naturalization" or ideological closure that occurs when "truth" is seen to transcend and be divorced from all representational systems is in line with the notion of hegemony, which is, after all, "that part of a dominant worldview which has been naturalized, and having hidden itself in orthodoxy, no more appears as ideology at all" (Comaroff and Comaroff 1991, 25). Al-Huda is involved in creating a hegemonic discourse, which includes "the order of signs and practices, relations and distinctions, images and epistemologies—drawn from a historically situated

5. A case in point is a hadith frequently quoted by students at Al-Huda. The Prophet Muhammad is said to have informed his companions that one day Muslims would be divided into seventy-three sects but only one sect would make it to heaven, the one that followed the Qur'an and Sunnah. It is a circular argument, claim the proponents of a purely Qur'anic Islam, for the authenticity of a Muslim sect being based on the Qur'an *and* Sunnah is based on a hadith, which makes up the Sunnah.

cultural field—that come to be taken for granted as the natural and received shape of the world and everything that inhabits it" (23).

The manner in which Farhat Hashmi translates each and every word of the Qur'an, drawing on rules of Arabic grammar to do so and bringing forth the historical context of Qur'anic verses, adds to the hegemonic nature of the discourse. Its power lies in its being "nonnegotiable and therefore beyond direct argument." The power "may not be experienced as power at all, since its effects are rarely wrought by overt compulsion. . . . Yet the silent power of the sign . . . may be as effective as the most violent coercion in shaping, directing, even dominating social thought and action" (22).

Farhat Hashmi's personality also plays a key role in attracting her students. Although most of her students argued that they went to Al-Huda for the Qur'an and not for her, almost all of them also shared how dynamic and charismatic they found her. After listening to her speak, both live and on tape, what comes across repeatedly is how easy it is to understand what she is saying. Her Urdu is a very simple, everyday style, interspersed with analogies, humor, and knowledge of current events. The everyday examples she draws on resonate with the lives of the specific classes she is catering to.

Farhat Hashmi gives her points authority by drawing on the verses of the Qur'an, the Sunnah, and other incidents from Islamic history, subsequently linking them with conditions in contemporary society. All of these strategies combine to make her actual message all the more appealing, illustrating the notion of language as a form of social action (Ahearn 2001). Other teachers attempt to emulate her and are appreciated by many of their students for their eloquence, knowledge, simplicity in style, and guidance. Their discourse is all the more effective when it gives practical tips in the course of the exegetical commentary and the discussion of the Sunnah, tips that directly feed into the lived reality of the students' lives, such as what verses of the Qur'an to recite to protect oneself from magic, how to increase one's level of faith, what prayers to recite to decrease marital conflict, or what beneficial properties various food items have.

Hence, Al-Huda fulfills its students on a number of levels, and its modus operandi plays a significant role in facilitating both ideological and behavioral changes within them. Most women remember the time they

spent at the school very fondly. As a former Al-Huda graduate shared, "I took to Al-Huda like a fish does to water. What I love most about Al-Huda is that it gave me back the Qur'an. They taught me how to read it in Arabic, what that Arabic meant, how beautiful it sounded, just like music. Al-Huda nurtured me emotionally and challenged me intellectually."

Transformation into "Pious" Subjects

Al-Huda's pedagogies of persuasion, when combined with students' faith in the authority of the discourse they are exposed to, have a significant impact on them and lead to a variety of ideological and behavioral changes. For instance, many women claim that Al-Huda is responsible for "giving them back the Qur'an" and for their developing a love for Allah, who, most of them made a point of mentioning by repeating a hadith popular at Al-Huda, loved them "more than seventy-two mothers." A connection with Allah, trust in Him, love for Him, thankfulness to Him, and consciousness of Him are some of the feelings Al-Huda is able to generate in many of its students as they take the one-year course or attend *dars* offered by its graduates. Natasha, an Al-Huda graduate who at one time was in charge of organizing the English summer courses at Al-Huda, explained that she is now conscious of Allah's presence and *akhrat*, or the hereafter, every waking moment of the day:

> Before it was just normal, you would think about death, about *akhrat*, but say that it's still far way. But they [Al-Huda] really emphasize how we don't know anything about when our life will end. Here today, gone tomorrow. So one really begins to think about one's actions all the time. . . . Before, whatever my approach to things was, no matter what I did, it was always for worldly benefits. I only used to remember Allah whenever I used to get worried. Now He is in every thought, every action. Before doing anything, saying anything, I think, what would Allah like me to do right now, what would make Him happy? . . . Death was feared because of the love I had for this world. Now death is feared because I know I will have to face Allah. So my whole way of thinking has changed.

Consciousness of Allah, in combination with a heightening fear of the Day of Judgment and a desire to earn rewards, both for this life and

the next, brought changes in the attitudes and behaviors of many women. Dr. Kanwal, an Al-Huda graduate who began the children's Islamic school Colors of Islam, shared the following:

> Materialism was always a prominent feature of my life. This was something I had never realized because that is something you grow up with, and therefore consider normal. If I used to wear an outfit to a party, I would never wear it again. It is only now that I look back that I can judge my behavior. I used to become impressed with people simply because they moved in high circles. I would buy branded things only, go to branded restaurants. . . . Now, after realizing how temporary this world is and how we must spend it preparing for the next one, I feel I've become more constructive. I think of the needs of society. I have changed my priorities, letting go of habits that seem frivolous to me now.

Another Al-Huda graduate tells a similar story:

> There were many things that were important to me before. Money, and having enough of it in the bank . . . security, whatever you want to call it. I always kept track of how much my husband spent on his family, or how much he gave to his other relatives. It bothered me. What are my children going to do if he's going to give it to so-and-so? I had a major turnaround in these things. I was like, I want to give, and I was constantly giving, which is something that shocked my husband, who, like I said earlier, was already very openhearted and generous with regards to other people. Now I've realized how happy Allah is with those who give generously, and how he has promised them rewards, if not in this life, then the next.

A heightened social consciousness is often accompanied by a change in personality for some, so that they claim to become more conscientious toward others, particularly their parents. They have begun to realize the value of maintaining relationships and realized the benefits of living an "Islamic" life. Naveeda, a housewife and mother of two teenagers, shared that "my relationships with others have changed. For instance, before, when my children used to misbehave, I used to start screaming at them, but now I try to make them understand things lovingly. Before when I used to

have a disagreement with my husband, none of us used to back down, but now I try to be quiet, and make my point later, when both of us have cooled down. . . . If some relative says something I don't like, I say 'Allah, grant me patience,' for Allah dislikes those who break or destroy relationships."

Internal changes, as witnessed above, often add meaning to women's lives. Shazia, a young mother of three who belonged to the lower middle class and had been attending Al-Huda as a listener for a few months at the time I met her, illustrates this point through her story: "I would get up every day, get my children ready for school, clean the house, cook, feed them when they came home . . . and repeat the process the next day, and again the next day . . . often wondering if there was perhaps not more to life than this routine. Now I've realized that when this work is done with the intention of pleasing Allah, it becomes a form of worship; it becomes meaningful."

Although no change occurs in the actual activities, the infusion of new meaning transforms the mundane into the sacred, turning dissatisfaction into contentment. An infusion of meaning also occurs in activities such as offering prayers or reading the Qur'an, because it is the first time, many women claim, that they are reciting the Arabic and also understanding what it means. Knowing what they are reciting goes a long way toward increasing the significance of the rituals.

All the students I spoke to at Al-Huda began praying five times a day within months of joining the school. Now that they knew what they were reciting, this religious ritual transformed into a "sacred performance" for them and served to heighten their faith (Asad 1993, 50). Women's language also underwent a change, as they were encouraged to remember Allah through the use of Arabic words, such as *Alhamdolillah* (Thanks be to Allah) or *Subhanallah* (Praise be to Allah). Language, in this context, becomes a manifestation of their consciousness of Allah and a tool that in turn heightens their consciousness of Allah, through which they attempt to construct themselves as pious subjects (Ahearn 2001).

Still others appreciated the fact that they only now realized how easy religion truly was. Al-Huda shifted the focus from the traditional *nafli 'iba-dat* to *farzi 'ibadat*. *'Ibadat* means worship. *Farzi 'ibadat* refers to obligatory worship, such as offering *salat*, or prayers, five times a day. *Nafli 'ibadat*

refers to a nonobligatory form of worship that is done following the Prophet's example or Sunnah once the obligatory worship has been performed. Many women claimed to appreciate learning that Allah does not ask them to perform more than the obligatory rituals, for to do so means taking time away from their worldly responsibilities, which Allah also deems important. The importance of *farzi 'ibadat*, however, such as offering prayers five times a day, or fasting in the month of Ramadan, is considered vital.

Many women confessed to feeling powerful and hopeful through the realization that Allah was near. They felt less despair because of the realization that their troubles were a test from Allah and must therefore mean something. Feeling *sukun*, or peace, through praying or conversing with Allah was perhaps one of the most frequent comments I heard. Although the problem itself often remained unresolved, women's feelings toward it altered, allowing them to feel some measure of peace. Sharmeen was a housewife in her midforties with grown children. She told me how stressful her life was before she began attending Al-Huda as a listener because of her bad relationship with her husband, who was much older. Now, she told me, she has realized that everything is Allah's will. Worrying about things will not make a difference. Whatever happens is because Allah wants it to happen. "I used to argue with my husband a lot, criticizing him, trying to get him to change. Now I pray to Allah to change him, and I feel at peace. I've adopted *sabar* [patience]. I no longer let things get to me."[6]

I received an e-mail from Rubina at the beginning of 2005 in which she told me that she had agreed to an "arranged" engagement within two days of her family's meeting another family:

> A family came to visit us on Wednesday. . . . The family was good. There was no reason for me to say no. . . . *Ammi* [Mother] and *Abu* [Father] went to visit them the next day and when they came back they told me that the engagement had been decided for the day after, Saturday. I was stunned. Somehow I had expected something to happen to turn

6. An example of what Karl Marx would refer to as religion becoming the opiate of the masses but one that disregards the attempts Sharmeen did initially make, in the space she felt she had, to bring about change.

things off, like it had happened in the past when I had okayed a couple of times. Two days passed in a daze, in which I did not have the guts to even call anyone, because I could not believe it. . . . Hence, I got engaged on Saturday evening.

The last few days have been of real anguish and harder was that I could not show it to my parents, although they sensed it a couple of times and questioned me. Their question and trauma is genuine too, that do I never plan to marry? . . . Two things made me stand up by the evening of the engagement.

Before 'id, I had attended a class of Colors of Islam at Al-Huda. . . . In that they showed a skit on the story of Prophet Ibrahim and how he went to sacrifice his son upon Allah SWT's[7] command. . . . The skit was so well done that I had tears in my eyes. The whole 'id I spent thinking how wrong we perceive the spirit of 'id-ul-adha. . . . [W]e think it is to eat and drink . . . see the media programmes . . . but the real purpose is to learn to sacrifice upon Allah SWT's command. By chance, I had even gotten to see a *qurbani* [animal sacrifice] being done in the neighbor's backyard. . . . [I]t had left an impact. . . . And the funny thing is, the other day I was telling someone that Allah SWT speaks to us not just through intuition but also through what he puts in the hearts of our parents, elders, etc., all those whom we are supposed to obey.

The day before the engagement, I had gone to attend another class of Colors of Islam, and in it they were telling the story of the creation of Adam and how Iblis [Satan] refused to bend down to him on Allah SWT's command, so he became an outcast, while he had been one of the highest ranked Jinns because he worshipped Allah so much. . . . As I was listening to the story, my heart became alert as I felt the message coming to me. I got terrorized lest I follow in Iblis's footsteps and lose my relationship with Allah SWT.

So I told myself, *Jo Rab ki raza, wohi bande ki raza* [Whatever Allah desires, a person must desire] . . . and I kept telling myself this until suddenly my heart came to peace. This was the evening of the engagement.

7. SWT is a common abbreviation denoting the following: (S) Subhanahu (Glory be to Allah), (W) *Wa*, and (T) Ta'la (the exalted).

Alhamdolillah [Praise be to Allah] I was able to go through the whole thing, which I never thought I would.

I am very okay now *Alhamdolillah*. . . . One of the great things about these days was that I felt some great heights of spirituality as I used to try to reach Allah SWT when I prayed very very very hard and in greatest of concentration.

Women's faith and their relationship with Allah clearly plays a critical role in their lives and brings them a lot of satisfaction, as is seen above. Such faith also facilitates acceptance. The potential danger of faith becomes visible when it is reduced to the function it is serving, that is, facilitating the acceptance of the status quo and the closure of one's mind to questioning or change. But the relationship women have with Allah and the peace they feel through communicating with Him are very meaningful and comforting for them and lie at the crux of their experiences. Tahira, a forty-year-old mother who works for an international development organization, shared that her recent divorce, and subsequent problems with her son, made her go into a phase of depression: "Islam became a source of solace for me. I used to pray to Allah to give me strength, and I would immediately feel at peace. Knowing Allah has listened to me, I let go of that worry, trusting Him to take care of me. It is out of your hands. You can let go of it. You give yourself up to Allah, surrender to Him, and feel relaxed and at peace that very instant."

Competing Cultural Codes

Al-Huda's success is clearly visible in the significant changes that can be observed among women who engage it on a regular basis for an extended period of time. One of the key reasons for its success is that it is functioning not in isolation but rather in a sociocultural landscape where preexisting values—related to both religion and societal norms—initially facilitate their entry and later their internal and external transformation. But whereas certain cultural codes may facilitate the movement's growth, other cultural codes can confine it. Social movements, after all, "belong to a broader social milieu and context characterized by shifting and fluid configurations of enablements *and constraints* that structure movement dynamics"

(Wiktorowicz 2004, 13; emphasis added). These constraints exist because "movement participants and potential adherents are not *tabulae rasae* upon which activists may draw any picture of reality they would like" (Benford 1993, 678). Intramovement divisions have been known to exist within the school because the actors making up the movement represent the larger society, and as such they come with varying backgrounds and levels of exposure to the larger world.

A Pakistani woman's experience and identity is based on myriad factors such as class, education, occupation, rural or urban setting, and regional affiliation (Rouse 1984; Shah 1986; Khan, Saigol, and Zia 1994), as well as how much she has traveled, what kinds of schools she has attended, and whether she has ever had a job. This difference in background plays out in a number of ways among both teachers and students, whether it is in conflict over pedagogical strategies or in creating tension owing to issues of language and class.

All the teachers and staff at Al-Huda are Al-Huda graduates themselves. Their ages vary from twenty to fifty, and they belong to classes ranging from the lower-middle to the upper classes. Their educational levels also vary, with some attaining only a high school education and others having earned master's degrees, whether in business administration, computer sciences, or the arts. Individuals with degrees in computer sciences manage the Al-Huda Web site and take care of basic office computing. Likewise, those staff with degrees in art take care of artwork within the school. Some teach, and others are in charge of small departments that consist of a number of cubicles in one section of the basement. Each cubicle is a minidepartment that handles activities such as networking with other branches, accounts, media, counseling, research, and so on. All the teachers and staff members are offered very modest pay, which some of them give back to Al-Huda as *sadqah-e-jariya*. (*Sadqah* refers to giving charity voluntarily, as opposed to *zakat*, or the more structured almsgiving. *Jariya* refers to something recurring or continuing. Hence, the term refers to alms that not only provide immediate good but continue to benefit people over time.)

Despite the fact that all the teachers have studied at Al-Huda, their differences can be a source of tension. One such tension often exists between

the teachers who teach in Urdu and the ones who teach in English. Haleema, a thirty-five-year-old Al-Huda graduate who taught at Colors of Islam at one point and had moved to Islamabad from the small town of Sargodha in Punjab in the mid-1990s, shared that she was not very fluent in English and that she and all the other Urdu-speaking teachers at Colors of Islam felt inferior: "Whenever I would recommend someone as a new teacher, they [the administration] said that no, she doesn't speak [English] well. I said that how will common people study then? We are so caught up in trying to impress others [that is, parents] that we will lose touch with our roots. But they were like, no, you should talk in English, because they are English-medium children. You should inspire them, impress them."[8]

There is some connection between the language that individuals, whether students or teachers, feel comfortable learning or teaching in and their class, exposure, and general background. For instance, while the teachers speaking Urdu covered all socioeconomic groups, more of them belonged to the lower-middle and middle classes, while those who taught in English came only from the middle and upper classes. Class in turn is related to whether one attends an English-medium school, which only the more affluent can afford. Students in privately run English-medium schools, particularly the ones who follow the "O"- and "A"-level route, are trained to critically engage with their subjects, as opposed to the rote method followed in most government-run Urdu-medium schools.[9] These and other related experiences have a bearing on how different women interact with a particular discourse, how much questioning they bring into the learning process, and, as I will illustrate below, how innovative they are in teaching.

8. Unlike classes at Colors of Islam, which are largely conducted in English, the majority of the students at Al-Huda take the course in Urdu, even many of those students who have gone to English-medium schools. For instance, only fifteen of the three hundred girls took the course in English in one of the diploma courses offered in 2003–2004.

9. Private English-medium schools in Pakistan offer their students the General Certificate of Education at the end of their sixteenth year of schooling (O [Ordinary] Levels) and their eighteenth year of schooling (A (Advanced] Levels). This is a British system of education. The O Levels are an alternative to the Matriculation degree that all public schools in Pakistan offer, and the A levels are an alternative to the Intermediate degree that public colleges award students at the end of their eighteen years of schooling.

Although I will present only a couple of examples, they are characteristic of the general differences I found among women based on the interconnectedness of these factors.

Some of the teachers who taught the English summer course, Reality Touch, at Al-Huda, shared that the teachers who taught in Urdu and were also in charge of administrative matters did not give them enough space to be innovative while teaching. Two of these teachers no longer teach these courses and do not like associating themselves with Al-Huda. Zarina is one of them. A young and vibrant person, Zarina teaches the Qur'an from her home in Islamabad and is very popular among young upper-class girls. Frequently invited to teach in different cities in Pakistan, as well as abroad, Zarina shared her experience of a time when she was invited to teach a summer course in Karachi and how disappointed she was by the rigidity of the structure:

> I had taken some badminton rackets with me so that the girls could take a break and enjoy themselves, but the other teachers shot down the idea. I also suggested that I take them to the beach for an outing one day, but did not get permission on the grounds that they only had limited time with the girls and they wanted to influence them as much as they could. The girls had a regimented routine, just like a cadet college. But what if you don't feel like praying? What if you're going through a phase and want out from praying for a month? You cannot enforce these things. You have to give girls space to think, to reflect.

Natasha, who also used to be involved with teaching the English summer course at Al-Huda, expressed similar views. These teachers spent a significant amount of time facilitating group discussions and trying out various experimental techniques, often using videos, in one instance making students watch *Malcolm X*, to the displeasure of the administration because the film has some "scenes" (read: sexual ones) in it. As Natasha strongly expressed, "Fine, so that was wrong Islamically, but the fact is that the girls who come to us are used to seeing much more in the films they watch. This is a transition. It's a level up. Sometimes you have to go down to their level to get to the top. . . . But Al-Huda follows a certain code of conduct, a certain methodology . . . and getting permission for

anything different is a big headache." By contrast, Haleema left Colors of Islam because she could not condone its innovative methods: "They [at Colors of Islam] had made Islam all fun and games. There would be skits in which children would act out historical scenes, and one in which a student acted the part of the devil. A lot of us were concerned about whether doing role-plays of these characters was correct Islamically."

So although all these individuals believe that "Islam is the solution . . . there are important divergences over specific tactics and strategies" (Wiktorowicz 2004,10 17), and these divergences become a source of tension on occasion.[10] My intent is not to create any artificial Urdu-medium versus English-medium divisions between women but simply to illustrate that a person's background has the potential to influence her modus operandi, her way of thinking. Zarina and Natasha grew tired of not having full control while teaching and chose to leave the school. So while one set of cultural codes, a desire to learn about their religion, brought them to this school as students, another set of codes, one related to their way of approaching things—a direct result of their backgrounds—made them leave.

Islamabad, like any other place, is made up of actors subscribing to different sets of ideologies. These ideologies cannot be simply put into the religious or secular camp, not only because there is an overlap between them but also because people are religious in a number of ways. Students who go to Al-Huda do so with preexisting ideologies, and they have their own ideas about what constitutes right and wrong behavior. Although most students were completely satisfied with their experience at Al-Huda, a very small number were not. They went because of their predisposition toward Islam but grew dissatisfied because the school propagated an ideology that clashed with some of their other preexisting cultural codes. They either left or chose to focus on what they considered its good points. Twenty-year-old Sadia was one of these students. Enrolled at the school at the time

10. It is important to remember that even though Zarina and Natasha chose not to teach at Al-Huda, they are still teaching and spreading a discourse that is not dissimilar to Al-Huda's. The primary difference lies in their innovative styles of teaching and the way they approach the notion of "change." Their methods are attracting girls who prefer their styles to Al-Huda's. Hence, the Islamic discourse continues to spread.

I interviewed her, she began crying while telling me of her experience. A standard of behavior is set as more and more Qur'anic verses are revealed daily, and those students who do not meet the standard are filled with dissonance. Dissonance is also felt among girls who are not changing their behavior or lifestyle at the rate their peers are. Although the dissonance caused by not meeting "Islamic" standards of behavior dispels over time as women either change themselves, as happens in most cases, or give importance to some *ehkamat,* or orders, over others, as happens less frequently, there are some students who seem to be caught between competing cultural codes, that is, what they feel is right and what they are told is right. Such was Sadia's experience. Her confusion about what is right and wrong came forth as she talked to me:

> They [Al-Huda] have a concept that if a girl and a boy are friends, then there is obviously something fishy going on. They have literally called such friendships *haram* [forbidden]. I know that it is *haram.* I agree. But I don't think that if you are talking to someone and if your intentions are pure that God will mind. . . . I'm not saying that I want to both keep the Qur'an and keep my friendships with male friends. But you decide that you will leave these things slowly. But they make is sound that if you are doing something like this, then you are literally doing something bad.

Sadia is a product of a culture that allows her the freedom to interact with the opposite sex but is also permeated with a hegemonic religious discourse that criticizes such freedom. While a person's selves may shift naturally in different contexts, drawing on various cultural strands when needed, without integrating them as happens in most cases, some instances, such as an interaction with Al-Huda, may bring this lack of integration to the forefront (Ewing 1990). Efforts are then usually made to achieve some kind of integrated wholeness, something Sadia was attempting to do. Nevertheless, despite her ongoing frustration and confusion, she told me that Al-Huda had allowed her to develop a bond with Allah, and for her that fact was the most important thing. Clarity on other issues, she claimed, would come with time.

Whereas Sadia had chosen to stay on at Al-Huda, Razia, who unlike Sadia, completely submerged herself in Al-Huda and its discourse, chose to

leave it and its teachings behind. Razia, who had been working in an international development agency for five years at the time we spoke, began going to Al-Huda as a listener. "I soon started feeling that every step of your life you're committing a sin . . . and the time came when I began thinking that I'm not going to join any job, I'm just going to stay at home and pray the whole time; otherwise I'll be corrupted." But she did begin a job on her family's urging where she was exposed to the human rights discourse that, she enthused, made so much sense to her: "Everyone gets equal importance in a secular environment, no matter what their religion." The new cultural codes Razia acquired proved to be stronger than her previous ones, particularly because they were, she shared, taught by vibrant role models and because her work brought her into contact with people in contexts where differences of religion took a backseat in the face of the basic human connection they shared.

For others, like Naz, a woman in her late fifties whom I met in one of the *dars*, it was simply a matter of Al-Huda's not resonating with her religious beliefs. Although she was interested enough to check it out, she left within weeks. Naz came from a Barailvi background in which saint shrines are visited and where special programs are held to celebrate the greatness of the Prophet Muhammad. As such, she could not condone going to a place where such practices were termed *biddat,* or religious innovation.

What we see is Al-Huda's success being tempered by people who are religious yet possess competing cultural codes that prevent them from associating with the school. Al-Huda faces even greater criticism from persons completely outside the movement, whether they are in the secular women's movement, leading human rights groups and nongovernmental organizations (NGOs), or religiously inclined people in general. The latter include individuals who believe students at Al-Huda are extremists or see the school as propagating an Islam that does not match their own. Tehzeeb, a twenty-eight-year-old schoolteacher who had been wearing the *hijab* for a couple of years when I interviewed her and had studied Islam personally, argued:

People are becoming very judgmental when they leave that place [Al-Huda]. I'm not going to associate Al-Huda with Dr. Farhat Hashmi

because she is not the only one there. There are many teachers. . . . You're supposed to be wise once you've studied religion. You are not supposed to stand up and start giving fatwas, that this is wrong and that is wrong. . . . The problem with Al-Huda is that it is catering to young inexperienced girls whose lives had been limited to Mills and Boons [romance novels]. They have not seen the world. They take what is taught as a matter of course and do not ask questions. . . . It is very isolated from the outside world; it does not inform you of debates on religion going on outside in other parts of the world. . . . The type of girls and the environment is a dangerous combination and is bound to lead to rigidity. . . . When you go after quantity, the quality is bound to go down.

The "religiously inclined" people also include some leading male clerics who, students claim, feel threatened by the school because they are afraid of losing the power they currently enjoy by holding all interpretations in their hands. Al-Huda reinforces a patriarchal system, highlights the idea that men and women have different natures and therefore variant gender roles, and claims that a man is the natural manager of a woman and that a woman must obey her husband unless he asks her to do something un-Islamic. Yet the school does not, unlike the propensity of many *maulvis*, ignore the rights that women do have in Islam, such as the right to divorce. Although it is something they strongly discourage, considering it a very undesirable alternative, they do not gloss over it or ignore it.

Despite the tensions both within and outside the school, Al-Huda has been quite successful in ensuring that by the time its students graduate, they will have internalized their hegemonic discourse. Hegemony is commonly seen as "a continuous process rather than a fixed state of affairs" that is always left somewhat incomplete (James 1996, 24). A particular danger for the school within this context, then, is that it may gradually lose its influence once students graduate, especially if they have no access to a support system. Aware of this danger, a group leader is given the additional duty of keeping in touch with her students even after they have graduated by calling them up and asking them if they have gotten together recently and keeping them informed of any guest speakers or special events and activities happening at Al-Huda.

It is imperative to be aware of the constantly shifting relationship that may exist between a hegemonic discourse propagating certain roles and values and the interpretive agency of subjects (Mankekar 1999). As Stephen Hart explains, a more useful analysis can occur when it includes the "culture-making practices and processes by which such codes [discourse] are created, transformed, communicated, applied, and given meaning" (1996, 90). According to this view, meanings arise when individuals interact with a particular body of knowledge, for they are "constructed and transformed in the course of action and interaction" (91). A case in point is Al-Huda's discourse on photography, which, simply put, is forbidden. A parallel is drawn between capturing images on film and idolatry. However, although all students listen to the same explanation by Farhat Hashmi, this prescription gets transformed in the process, so that it comes to mean different things among the students. Although most students truly stop taking or having their photographs taken and take down the ones displayed in their homes, some interpret the directive to mean that pictures can be taken but not displayed openly or that they can be taken if developed by a female or a *mehram*, a male relative a woman cannot marry, such as her father or brother. Still others argue that pictures can be displayed in a room as long as prayers are not offered in them. This example is a clear case of discourse transformation.

Some students also show some behavioral disruptions in discourse. Samira, a twenty-year-old Al-Huda graduate, for instance, says she knows it is wrong for her to talk to a *na mehram*[11] if there is no need, "but if I see a friend's brother on the street, and I've known him my whole life, ignoring him and not saying *salam* to him seems so rude. So that is still a challenge for me." She continues on a much lighter note, sharing laughingly, "My friends call me a nutcase. I call them up to chat, and after half an hour say, 'Oh, I shouldn't be wasting so much time on the phone,' and then continue talking for another half an hour." This disruption did not disturb her.

Although the instances of discourse transformation and disruption are present among Al-Huda graduates, they are not as common as one might

11. Since a *na mehram* is a male whom a woman can potentially marry, she must, Farhat Hashmi argues, maintain purdah in front of him.

expect. The intensity of the one-year course, the faith in the authority of the discourse, the development of a love for and relationship with Allah, a belief in the beauty and perfection of Islam, and the specific pedagogies employed to transform individuals into pious subjects, accompanied by an emerging fear of the Day of Judgment, all combine to ensure that disruptions become the exception and not the rule. Much of the disruption, when it does occur, is because these women are living in families where not all are religiously inclined in this particular manner or to this extent, which sometimes creates situations where following directives is simply not possible. Disruptions may also be a result of what women term their own personal weaknesses. It is important to note that in this context, a disruption in discourse cannot be equated with a disbelief in the discourse. Perhaps a more useful way to see this process is by looking at it *as a process*, where women are struggling to follow Islamic directives on a daily basis. Their struggle may be over getting up for the prayers at dawn or over controlling their gossip, but their desire is rooted in their faith, in their belief in what they have been taught. Farhat Hashmi is, after all, they claim, spreading Allah's word. You can try to understand it, but you cannot question it.

4 · The World of the *Dars*

"AN AL-HUDA WOMAN gave a *dars* in my neighborhood, and she said that the things we do, the way we do *guthlia*,[1] is un-Islamic," shared a fifty-year-old woman with a worried look on her face. "If you ever hear someone say anything like that again," replied Zulaykha, the sixty-eight-year-old *dars* teacher whose *dars* we were all attending, "*unkay sur pe juta marna* [hit them on the head with a shoe]!" Exchanges such as this one are a testament to the heterogeneity of Islam as a set of beliefs and practices in the social landscape of Islamabad, and I draw on the examples of five *dars*, only two of which are run by Al-Huda graduates, to illustrate this heterogeneity. Looking at *dars* exemplifying different strands of Islamic thought is critical to this work, as only a comparison between *dars* offered by Al-Huda graduates and other kinds of *dars*—with particular attention paid to their structure and discourse and the nature of exchanges between women making it up and their reasons for attending it—can shed light on why the former have become popular among so many women of the middle and upper classes of Islamabad, while the others, which have been around for much longer, have not. Also, it is only in the context of this Islamic diversity that the role *dars* play in contesting, propagating, reinforcing, and reaffirming these women's notions of Islam, as illustrated in the exchange above, can truly be appreciated.

A woman's decision to enter and reenter such a space may be motivated by a number of interrelated reasons that range from providing women with

1. *Guthlis* are pits, usually of dates or fruits like apricots. Some Qur'anic verses are generally recited over each *guthli*, and although they are not strung together like a *tasbih*, or prayer beads, they do serve the same purpose, that is, keeping track of the number of times a verse has been recited.

spaces to explore Islam as a system of particular beliefs and practices to engaging in activities such as networking and socializing; what reason a woman gives more importance to is interconnected with her own personal history, as she occupies a particular location within society, which also has an impact on whether discursive religious consciousness, when it does exist, translates into practical consciousness and whether it is even a goal.

Dars: Multiple Settings, Multiple Discourses

Wilfred Cantwell Smith, a scholar of religion, asserts that religion can be understood only once an individual stops asking the questions, "What is *true* Christianity? What is *real* Islam?" (1962, 12; emphasis added). Like other religions, Islam is not a monolithic entity (Armstrong 1992; Stowasser 1994; Esposito 1999) but rather a "complex composite—a heterogeneous set of historically and contextually variable practices and beliefs shaped by region, ethnicity, sect, and class, as well as by varying responses to local and transnational cultural and economic processes" (Saliba 2002, 1–2). The heterogeneity of Islam as a system of beliefs and practices is manifest in different *dars*.

The phenomenon of women getting together to read the Qur'an or hear a lecture on some Islamic topic to increase their knowledge and become better Muslims is a global one. Called *nadwa* in Yemen (Clark 2004) and *rowzeh* in Iran (Kamalkhani 1998), these gatherings usually take place in women's homes. Attended by women who live nearby, these weekly meetings have no formal membership, and women can attend them as much as or as little as they want, giving them a flexibility that they would not find in formal religious institutes. While some *dars* are affiliated with religious organizations or parties, others function independently. Two of the five *dars* I examine below are not affiliated with any institute or formal organization and follow, in varying degrees, a relatively more indigenous folk Islam that contains in it many elements of Barailvi Islam, such as appreciating the use of music in heightening spirituality and visiting the shrines of saints. Of the three other *dars*, however, one is offered by the religious organization Tehrik-i-Islam, and two are run by Al-Huda graduates. All three follow an Islam that closely resembles the Ahl-e-Hadith and Deobandi forms of Islam, with their adherence to a literal interpretation of

the Qur'an, giving the Sunnah a great deal of importance, upholding an idealized image of the Muslim community under the Prophet Muhammad and his companions, making attempts to remove cultural accretion and tradition from society, prescribing a certain dress code, and emphasizing ritual. Hence, all five *dars* are illustrative of and have been chosen to give insight into the diversity of practices and beliefs that take place under the umbrella of Islam and to which women subscribe in these settings. A brief overview of each of these *dars* is given below, followed by a more in-depth account of the activities that take place in these multiple sites.

Zulaykha gives a weekly *dars* in F-7, a quiet sector with middle- and upper-middle-class housing. The wife of a social scientist and mother of two grown children who work with international development organizations, Zulaykha calls herself a Naqshbandi Sufi. Her interest in Sufism is an old one. This interest led to her spending her entire life reading about Islam and also made her and a few other similarly inclined women do a *bait*, that is, become the disciples of a Sufi *ustad*, or teacher, some twenty years ago. They wanted to continue having contact with one another upon his death in the early 1990s and decided to meet for a weekly *dars* in the home of one of the women in their group. Zulaykha was asked to lead it. Other women who live nearby have joined them over the years. Since women from different sectors of Islamabad attend this *dars*, the ones who have drivers pick up those who do not have rides, and an average of twenty to twenty-five women attend every week. All of these women are at least fifty years old, and they belong to both the middle and upper classes. Many are retired college professors. A few had worked with different social welfare organizations when they were younger, a couple are doctors, and the rest have always solely been homemakers. Most have children who are either studying or settled abroad, usually in the United States.

The two-hour session begins every Thursday around 10:30 a.m. when the well-dressed women, wearing makeup and some jewelry, begin arriving. Their heads are covered with *dopattas*—long rectangular scarves worn with *shalwar kamiz*—that they remove and drape around their shoulders once outside the *dars* setting. The *dars* formally begins when the women take a handful of *guthlis* from the pile that is placed in the middle of a sheet-covered carpet in the drawing room, where all the *dars* take place.

Half of the women sit on this sheet-covered carpet, while the others take a seat on the sofas and armchairs that have been pushed toward the four walls of the room. The women usually recite the *Durud Sharif,* or Divine Blessings for the Prophet Muhammad, under their breath, and after each recitation drop one *guthli* from the bunch in their hand onto their lap or into a small bowl placed in front of them. Once they have gone through all the *guthlis* in their hand, they take more from the pile and keep doing so until it has been depleted. Reading the *Durud Sharif* is a way of expressing their love for the Prophet Muhammad, of showering blessings upon him, and, as some share, a means through which Allah will be pleased with them and forgive them their sins. Zulaykha reads from the Qur'an afterward, both in Arabic and its translation into Urdu, and the session ends with all the women closing their eyes to perform a silent *dhikr.*

In another part of town, in the lower-middle- and middle-class neighborhood of I-8, Azra Riaz, a seventy-two-year-old retired Islamic studies college professor, offers *dars* in her own home every Friday evening. It is attended by an average of twenty-five women from her neighborhood, all of whom walk to it. Unlike the women who attend Zulaykha's *dars,* these women do not wear makeup or jewelry, and are dressed in very simple cotton *shalwar kamizes.* Most of them use *dopattas* to cover their heads inside the *dars* setting as well as outside, but a few also wear *hijabs* and *abayas.* All the women are housewives, primarily in their fifties and sixties, with a few in their forties. Each two-hour session begins with women taking a *tasbih,* or prayer beads, from the center table in the living room and quietly reciting Arabic verses, as directed by Azra. These prayers include Qur'anic verses related to forgiveness, the *Durud Sharif,* or simply saying "La illaha illalah" (There is no God but God) or "Allah" over each bead. This ritual is followed by a session where a *ruku* of the Qur'an is read in Arabic and a translation and brief exegetical commentary are offered.

In another lower-middle- and middle-class neighborhood, this one in sector G-9, a group of women get together every Friday morning for two hours. They are attending a *dars* offered by Nadira, a member of the Tehrik-i-Islam. The *dars* takes place in another Tehrik-i-Islam member's house, and many women from that neighborhood attend it, walking to it each week. All the women are housewives between the ages of thirty and fifty. More than

half wear black or beige *abayas* and *hijabs,* and a few also wear a *niqab*—a style of purdah that covers women's faces, so only their eyes are visible—in public. The *dars* begins by Nadira randomly asking three or four of her students to read in Arabic the Qur'anic verses studied the week before in order to check their ability to do so. She follows by reciting the next *ruku* in Arabic and offers its translation. The exegetical commentary of Maw-lana Mawdudi—the Jama'at-i-Islami's founder—is next. The *dars* ends with Nadira reading a few lines about the Prophet Muhammad, his habits and likes and dislikes, from a collection of his Sunnah.

Amina Ellahi, one of Farhat Hashmi's early students whose lectures are available in English on audiotapes, offers *dars* in English in her large house in F-6. Amina's weekly *dars,* or Qur'an class, as it is called by the women who attend it, is made up of women belonging to the upper class.[2] All these women dress in very expensive clothing, and it is common to spot designer labels in these gatherings. About eight or nine women wear *hijabs* that match their clothes, while the rest cover their hair with a *dopatta* dur-ing the gathering and take it off as they drive away in their cars. All the cars are parked in the long driveway leading up to the house. Like Zulaykha's *dars,* women who attend this one do not necessarily live in that particular neighborhood but come to it from different parts of town, primarily because there is no *dars* being offered in English in their own locales. Unlike other

2. Although I have attended *dars* offered by Al-Huda graduates in socioeconomic backgrounds closer to the ones occupied by women belonging to the non-Al-Huda-re-lated *dars* I have mentioned in this chapter, I have chosen not to mention them here and instead focus on two Al-Huda-affiliated *dars* belonging to the upper class. The primary reason for my doing so is that despite slight variations in the modus operandi and religious discourses, the women belonging to the lower middle class who attend *dars* offered by Al-Huda graduates and the women of the same class who attend other *dars* are similar to each other, both in their backgrounds and in their reasons for engaging religion. Many of these women already come from religious backgrounds, more religious than their counter-parts in the upper classes. A focus on the latter will therefore bring forth a more diverse account of women's behavior and motivations as they engage religion, inadvertently also providing further insights that will help answer the larger question of this research: why are women belonging to the middle and upper classes engaging with the Islam propagated by Al-Huda?

groups that are usually primarily attended by housewives, this group, made up of an average of thirty women, is more mixed. Almost all of these women are in their thirties and forties and married, in most cases to diplomats, businessmen, and industrialists. Although some are solely housewives, others are also successful entrepreneurs. A unique aspect of Amina's group is that it also had a few foreigners in it. For instance, the group I attended included an American woman who had married a Pakistani man and desired to learn more about Islam. The *dars* itself dealt with the translation and exegetical commentary of a *ruku* of the Qur'an once a week, every week. This pattern is followed by all the *dars* offered by Al-Huda graduates, regardless of where or among which class they are offered.

Not too far away, in sector E-7, fifty-year-old practicing gynecologist Saleha hosts a similar *dars* for women in her neighborhood. Saleha and her family lived in the United States for fifteen years but moved back to Islamabad in the late 1990s because both she and her husband were concerned about the impact American culture would have on their teenage children. She opened her home to the women in her neighborhood, and about six or seven of them, all housewives in their forties and fifties, attend this weekly *dars*. It is offered by Hina, an energetic woman in her early fifties who worked as a television actress prior to joining Al-Huda as a student in 1999.

Table 1. Key characteristics of five *dars* groups

Dars[a]	Affiliation	Socioeconomic class	Age of attendees[b]	Profession
Zulaykha	Sufi/Folk Islam	Middle to upper middle	50 plus	Retired teachers, social workers, housewives
Azra	Blend	Lower middle to middle	50s–60s	Housewives
Nadira	Tehrik-i-Islam	Lower middle to middle	30s–50s	Housewives
Amina	Al-Huda graduate	Upper	30s–40s	Professionals and housewives
Hina	Al-Huda graduate	Upper	40s–50s	Housewives (except Saleha)

[a]By teacher's name.

[b]Forming the majority of the group.

She lives across town, and Saleha sends her driver to escort Hina back and forth every week. Although Hina wears an *abaya, hijab,* and *niqab* when outside the house, the women who attend her *dars* drape their *dopattas* around their shoulders only when outside and cover their heads with them during class.

Diversity of Islamic Beliefs and Practices

Although all women in all the *dars* engage "Islam," the way they do so varies from group to group. How they do so is a reflection of the Islam they subscribe to and propagate, and is also a reflection of their reason(s) for being there, as I illustrate through the discussion of various themes.

Ideology

One of the key differences among the *dars* groups lies in the religious ideology they embrace, something that comes up in the exegetical commentary of the Qur'an presented in them, and in the discussion among the group members, particularly as they comment on Islamic practices taking place in other groups in the city. Azra's *dars* in I-8, for instance, has some elements of a more indigenous Islam. It comes out in her and her group's favorable comments on *qawwalis* during their discussions, and in the way they do *dhikr* by reciting Allah's name on a *tasbih* every week. The emphasis is not as pronounced as it is in Zulaykha's gathering, and there is a clear division between them when it comes to the issue of purdah and going to the shrines of saints, issues on which Azra stands closer to Al-Huda's discourse. Although her tolerance for those who practice a different kind of Islam is higher than the tolerance found for difference at Al-Huda, it too has its boundaries, as I found out after Riffat Hasan, a Pakistani Islamic scholar residing in the United States, appeared on television. A few of my friends and I ended up becoming a part of the "audience" in the program, and upon seeing me on television, Azra wanted to know how I came to be there and what I thought of Riffat Hasan's views. Our subsequent discussion made it clear that Azra had no patience for Riffat Hasan's claim that the Qur'anic verses were time specific and historically bound. There was also much reaction in the larger group toward someone who talked about Islam yet did not cover her head while doing so. However, a lack of

tolerance, or a more rigid sense of righteousness, comes out most clearly in most Al-Huda-affiliated *dars*, as seen in Amina Ellahi's comment about a dinner she went to with her husband that turned out to be a musical event. As she put it, "Had I known that beforehand, had it been on the card, I would not have gone. And the sad part was that the people there did not even think that they were doing anything wrong." Music is un-Islamic according to the Islam Amina upholds, and this facet is one of the characteristics that differentiates the religious ideology found in *dars* offered by Al-Huda graduates from the beliefs found in Zulaykha's *dars*.

Zulaykha and the women who make up her *dars* appear to be the most tolerant toward different Islamic sects. While having one of their discussions, Salma, whose father is a Sunni and mother a Shiite, told the rest of the women that when she was young, she once asked her father which sect was the right one. He replied that they are all right because they all believe in the fundamentals: in Allah, in the Qur'an, and in the Prophet Muhammad. She told the group, "We must go to all kinds of gatherings, Sunni, Shiite, listen to what is being said in those gatherings, and make up our minds about what is right ourselves." Another woman supported her by sharing that her mother, a Sunni, had gone to Shiite gatherings her whole life. However, this acceptance falls short when it comes to Al-Huda.

The ideology propagated by Zulaykha's *dars* can be seen as standing in opposition to Al-Huda's ideology in a number of ways, whether it is with reference to music, dance, saint worship, or other practices undertaken in the name of Islam that Al-Huda terms *biddat*. Many women in Zulaykha's *dars* vented their anger toward the women affiliated with Al-Huda, who they claimed went to various *dars* to aggressively attack the practices engaged in. Take, for instance, the *dars* the week before *shabrat*. Occurring on the fifteenth night of the Muslim month of Shaban, *shabrat* is often spent in prayer and seeking Allah's forgiveness. Special foods are usually cooked, children often set off firecrackers in the streets, and some people even decorate their houses by stringing lights outside. It was a few days before *shabrat* when one of the women in Zulaykha's group informed the rest that she had watched a discussion program on television the night before on which "there were two people from our side, and one woman from Al-Huda." The woman from Al-Huda, apparently, negated the whole

idea of *shabrat* as *biddat*, particularly criticizing all the "nonreligious" activities, such as decorating houses and setting off firecrackers. All this denunciation greatly offended this woman in Zulaykha's group, as it did the rest of the women in the group. They made disapproving noises and remarks until one woman cut the discussion off by asserting, "Let's forget about them. You [Zulaykha] tell us what to do tonight, how to pray, what to read." Although different religious groups have more in common than not, such media programs or personal attacks in religious settings serve to highlight the differences between them, keeping them in the forefront, so that for many of these women those individuals engaging in different kinds of religious groups may become the "Other."

Interacting with the Qur'an

"Texts by themselves are silent; they become socially relevant through their enunciation, through citation, through acts of reading, reference, and interpretation" (Lambek 1990, 23). Although women in all the *dars* interact with the Qur'an, the way they do so varies from group to group. Perhaps the most useful way to look at the way different *dars* stand in relation to the Qur'an is by seeing them on a continuum, with the Al-Huda-affiliated *dars* on one end, Zulaykha's *dars* on the other, and the remaining ones falling in between. The way the Qur'an is recited by teachers is one entry point into the discussion. Over in F-7 we see Zulaykha glancing down at the Qur'an open in front of her with her eyes half-closed. She then closes them and begins reciting softly, in a low, singsongy voice, the words indistinct from one another, flowing into one another to create a melody. She has a slight smile on her face, and her whole body moves from side to side as she recites, her enjoyment visible to all. The other teachers, especially the ones affiliated with Al-Huda and Tehrik-i-Islam, on the other hand, make it a point to read loudly and clearly, so that the inflection of each word is heard and their students begin learning how Arabic words are pronounced.

The difference I illustrate is directly related to the purpose of the respective gatherings, as is another difference: the roles occupied by individuals making up the *dars*. For instance, the roles of students and teachers are clearly defined and delineated in all the *dars* except Zulaykha's, where the boundaries between the two often blur. Although Zulaykha is the key

spokesperson in her group and everyone defers to her, there are three other women who take her place whenever she is unable to attend or add to what she is saying when she is there, something she does not always appreciate, her frequent complaint to their interruptions being, "You make me forget what I was going to say." These other women, Fehmida, Maryam, and Salma—one a retired doctor, one a retired professor, and one currently the president of a women's health organization—have all studied the Qur'an on their own and have a deep interest in Islamic mysticism. Like most of the other women in the group, they come from a background where religion has always been a part of their lives. The emphasis is on Allah and His greatness, His mercy, His creation. Stories are related from Muslim history, and the greatness of the Qur'an is extolled. As Zulaykha informed the group one day, "When the British went to India, their preachers started their *tabligh* [missionary work], and that's when the Muslim consciousness awakened and schools like the Deobandi were formed. The British wanted to get rid of the Qur'an, but when one of their leaders went to a madrassa, he saw a number of individuals reciting it by heart. Destroying the book cannot destroy the Qur'an. There is a beautiful verse, 'Come let me tell you that a believer himself is the Qur'an.'" When she recites the first couple of words of the verse, a few of the women there rush to complete it with her, smiling and shaking their heads in enjoyment. There is often mention of different Sufis' verses sung in popular *qawwalis*, as well as frequent recitation of the Sufi poet Jalaluddin Rumi's verses in the course of these gatherings. Although Zulaykha occupies the leadership position, the primary focus of the group lies not in teaching or learning per se but in remembering the glory of Allah and the Qur'an.

Al-Huda-affiliated *dars* are on the other end of the spectrum. The purpose of these gatherings is religious education and the transfer of knowledge, and the focus is on bringing out the relevance of the Qur'an. Hence, Amina, following Al-Huda's pattern, relies on formal pedagogical tools in her class. She begins her class by testing each of her students on the proper Arabic recitation of the Qur'an. This lesson is followed by a word-for-word Arabic-English translation of a *ruku* of the Qur'an, an in-depth process she undergoes by presenting the rules of Arabic grammar active in the translated piece: "This is an abstract noun, derived from. . . . What is the root

word of . . . ? This is the plural of . . . Did we read this word before? Where? Yes, in the story of Hazrat Adam. Over there it meant . . . but it is used in a different context over here. It has a dual meaning over here."

The translation paves the way for the exegetical commentary. Amina's specialty, something particular to the *dars* offered by Al-Huda graduates, although also visible in Nadira's Tehrik-i-Islam *dars*, is the way that the Qur'an is made relevant to women's lives. The vague is made concrete. A case in point is Amina's exegetical commentary of the following two verses of *Surah Luqman:*

> 6: But there are, among men, those who purchase idle tales, without knowledge (or meaning), to mislead (men) from the Path of Allah and throw ridicule (on the Path): for such there will be humiliating penalty.
>
> 7: When Our Signs are rehearsed to such a one, he turns away in arrogance, as if he heard them not, as if there were deafness in both his ears: announce to him a grievous Penalty. (A. Y. Ali 1999)

Excerpts from her commentary on these verses are as follows:

> There can be different kinds of activities and speech, that for entertainment, and that related to Allah. . . . People say, "Oh, I went to the Holiday Inn for ice cream today. Oh, I took my children to KFC for lunch today." Allah says don't go after food so much that you lose your way. A believer only eats to stay alive; he does not stay alive to eat. . . . People spend so much to go to concerts so that they can be entertained. . . . Then you see how when we watch cricket matches, we forget everything else— our family, our responsibilities; if the phone is ringing, we let it ring. So there are some things that take us away from Allah. Ibn e Masoud referred to music, songs, musical instruments[3] . . . but these things also include novels, fiction, magazines, news shows.

3. The story of the last Great Mogul, Aurangzeb, who ruled the Indian subcontinent in the early eighteenth century and engaged in an orthodox Islam, comes to mind. He once asked "a lamenting crowd on its way to the graveyard whom they were burying. . . . [T]hey answered, 'Music.'" His disapproval of activities that take people away from Allah (which the crowd was critiquing) comes forth through his response: "Bury it deep so that it does not rise again" (A. Ahmed 2002, 201).

Someone watching *Baywatch* will not leave it to go and pray. . . . [A]s soon as we hear the *adhan* [call to prayer] on television we immediately switch the channel. . . . Both lie on our table, a Qur'an and a *TV Guide*. One is cherished and used frequently—no, not the Qur'an but the *TV Guide*. One is used to guide our lives—no, not the Qur'an but the *TV Guide*.

This consciousness of behavior is further reinforced, once again in the manner characterizing Al-Huda, through weekly assignments and group discussions. Amina facilitated a discussion on verse 74 of *Surah Baqra* that makes a reference to a hardened rock:

Then your hearts hardened after that, so that they were like rocks, rather worse in hardness. And surely there are some rocks from which streams burst forth: and there are some of them which split asunder so water flows from them; and there are some of them which fall down for the fear of Allah. And Allah is not heedless of what you do.

Amina told us, "This verse explains the consequences of our actions." After elaborating on how people's hearts are hardened through deposits of layers of sins and how a hardened heart prevents a person from listening to the Qur'an or taking it seriously, she asked the women to share what those sins might be. A lively discussion ensued. That week's assignment, aimed at heightening women's self-reflection and increasing their consciousness about their behavior within an Islamic framework, was making a personal list of the layers on their heart. A few weeks later, she read aloud some of the things the women had come up with, such as breaking promises, displaying arrogance, criticizing others, being selfish over one's time, a lack of remembrance of Allah, reading trashy novels, and so on.

Zulaykha's *dars* is somewhat unique among the others in that most of the women who take part in it prefer to talk about things on a different level, away from the issues of daily life. It was while I was attending one of Zulaykha's *dars* that Parveen, a medical doctor in her fifties, posed a question to the larger group: "The sharia[4] says that if a woman is raped,

4. A reference to the Hudood Ordinance in Pakistan, set in place by Gen. Zia-ul-Haq.

she must produce four witnesses, and if she cannot, she must be given a hundred lashes and stoned. Where is this in Islam? What is this?" Some of the more vocal women in the group immediately responded.

"This punishment is given in the Qur'an. The purpose for such requirements was to make proof difficult, so that people were not punished falsely," Salma explained.

Parveen shook her head and continued, "Let me tell you of a real case. I had to prepare a medical report for a raped woman who was blind in Quetta.[5] She was unable to produce four witnesses and was put in jail. How do you explain that?"

The rest of the group continued to put forth their opinions, trying to explain the wisdom of this law to her. "Just like a medicine can bring both relief and can also become a poison, the word of Allah can also be abused," Maryam spoke earnestly.

"Yes, the ruling is not wrong; it is being misinterpreted," another woman added.

"I'm not convinced," argued Parveen. "If something like this were to happen to me, what would I do? Where do I get four witnesses from?"

"That is why there is a Day of Judgment," exclaimed Salma.

Fehmida took the discussion in another direction: "The woman was blind in this case, and that is why we are feeling sorry for her. But what if she is lying? [The larger group makes assenting noises and remarks.] There should also be protection for a man!"

The group laughed. A woman began relating a story she had once read in a newspaper about a woman who had been raped in a cinema when it had emptied, to which another woman immediately responded by asking what she was doing alone in the cinema in the first place. The discussion soon dwindled, but Maryam quietly told Parveen the next time we met that some of the other women did not appreciate having such a discussion, as it took the focus away from what they were there to talk about: Allah.

Hence, there is a clear difference among *dars* groups regarding how the same text, the Qur'an, is engaged. For those women attending the *dars* by Al-Huda graduates, as well as for most of the women in the other *dars*, the

5. The capital of the province of Balochistan in Pakistan.

very value of the Qur'an lies in its being a code for life, and the way the classes are designed ensures that its relevance comes out so that individuals can begin working on transforming themselves accordingly. For most of the women in Zulaykha's *dars*, the Qur'an is primarily a means of connecting with Allah, and the entire session revolves around that goal. There is little space for the concrete, the physical, as Maryam's admonition indicates.

Witnessing discussions such as the one above also laid to rest my vague and clearly naive assumption that the women in this group—with their jobs and educations—were free from the influence of larger patriarchal forces. Although this discussion only touched on women's discursive consciousness, it does push forward the thesis that they are clearly products of their society and its often contradictory influences (M. Wolf 1992; Ewing 1997; Haeri 2002), something that should not be surprising considering that culture itself is not a neatly bound, static entity (Raheja and Gold 1994; Lamb 2000). As James Clifford articulates, "Once cultures are no longer prefigured visually—as objects, theatres, texts—it becomes possible to think of a cultural poetics that is an interplay of voices, of positioned utterances" (1986, 12).

Discourse Disruption

Being a product of one's society not only means being open to internalizing some of the larger patriarchal ideology that permeates society, as is seen above, but also means being open to other kinds of cultural discourses that also shape attitudes and beliefs. A teacher's job is easiest when what she is saying resonates with her students and fits into their preexisting belief system. She faces much more of a challenge when what she says goes against her students' beliefs and behavior. Hina faced this challenge while expanding upon some verses of *Surah Hujurat*. "Our enjoyment today lies in obnoxious things. Making decent jokes no longer remains a possibility for us. We cannot enjoy ourselves until we put each other down, hear sick jokes . . . and there are such dirty comedy programs, guaranteed to spoil children's manners. I don't watch much TV because I've become so upset and worried after watching such programs a few times. . . . There was this person in one show, burping away, and the other people in the show were laughing at him!"

Some women laughed, and immediately started contributing the names of other such programs, putting them down through their words but unable to hide their enjoyment of what were perceived to be entertaining programs. Such a dialogic interaction between women allows us to see them as individuals who are not bound to their discursive consciousness, helps us situate them "within sociocultural fields that are always fluid and in process," and locates "multiple socially embedded voices among and within individuals" (Ahearn 2001, 129). Hina responds to their lack of seriousness by harshly continuing, "Why is this a laughing matter? This is obnoxious! In a similar manner, if you look at our wedding functions, the mother-in-law, sisters-in-law are put down through songs. Girls begin practicing these songs days in advance. The height of rudeness is seen at times like this . . . and these are habits and mannerisms that a Muslim does not possess!"

Hina's goal, like many other *dars* teachers, is to aid her students in becoming pious beings through their transformation into "model Muslims." But just because a woman goes to a *dars* does not guarantee that her behavior emulates the discourse propagated in that setting. Although the intent is to create subjects informed with a unitary religious consciousness within the context of a hegemonic form of Islam as the truth—an endeavor at which the main Al-Huda branch is quite successful—"we must closely scrutinize the assumption that hegemony operates to support a dominant group by convincing people that the domination is legitimate because it is 'natural'" in the context of the *dars* (Ewing 1997, 18).

I was sitting with the women in Hina's *dars* before she arrived when Faiza, one of the elder women in the group, came in and told the rest of us that she had organized a *khatam-e-Qur'an* on her brother's death anniversary the day before. A folk Islamic practice considered *biddat* by the women at Al-Huda, a *khatam* (literally meaning "end") of the Qur'an refers to a function in which people get together and distribute the thirty *siparahs* of the Qur'an among themselves, and hence finish reading the Qur'an in one short sitting. It is an occasion that can be organized by anyone, anytime of the year, to mark any special occasion. The ones organized by people to mark the deaths of their relatives are done with the purpose of sending blessings to that person, the assumption being that the person who has

died will be given the blessings these women have accrued through read-
ing the Qur'an. Al-Huda is very firm in its assertion that these readings
by family members will make no difference because how a person fares in
the afterlife is solely dependent upon his or her deeds when alive. How-
ever, when Faiza shared that she organized a *khatam* for her brother every
year, another woman immediately commented that "these people" do not
approve of this practice in a tone that indicated that she did not agree with
them. A third woman agreed but pointed out that one cannot leave these
things and become too rigid, while other women nodded.

Discarding the concept of a "unitary consciousness," Purnima Mankekar
argues that "each person can be a contradictory subject 'traversed' by a vari-
ety of discursive practices" (1999, 17), and a nebulous relationship exists
between discourse and practice. A disruption of discourse may occur because
a woman, like Faiza, feels that some parts of the discourse are, as she asserts,
stamped by Al-Huda's extremism. She states that she loves going to *milads*
and thinks that functions like *chalisva* hold psychological value for family
members. *Milads* are events organized to celebrate the Prophet Muham-
mad's birthday and are largely condemned by Al-Huda, not only because
they claim that no one knows when he was exactly born but also because
celebrating birthdays is "un-Islamic." The Prophet Muhammad, they argue,
never celebrated his own or anyone else's birthday. If someone wants to
give thanks for their or someone else's life, they assert, they can simply do
so in a quiet prayer to Allah. Anything else is a waste of time and money.
They further argue that the manner in which *milads* are held often leads
to *shirk*, or what is believed to be the sin of ascribing partners to Allah, as
the Prophet Muhammad is often brought up to Allah's level. *Chalisva* are
another function against which Al-Huda graduates are very vocal. A func-
tion organized on the fortieth day of a family member's death, *chalisva* are
events where people traditionally read specific Arabic verses over *guthlis* in
order to shower blessings on the person who has died, believing that the
blessings gained from reciting the verses will be transferred to the person
who has died. Like *shabrat* and *milads*, Al-Huda also considers this practice
biddat. Women like Faiza, however, tend to disagree with Al-Huda's view of
all these rituals and practices and claim that they can all be held without
extravagance, engaging in *shirk*, or going to extremes.

Similarly, while sitting in a post-'id party at Saleha's house, Farheen, a housewife in her early forties who had been attending Hina's *dars* for a year, told me that she has been attending Farhat Hashmi's *dars* since she first started giving them in Islamabad, much before Al-Huda began. She said that she generally loved Farhat Hashmi's style and the manner in which she brought the Qur'an to life. Nevertheless, she did find some of the tenets propagated by the school to be a bit extremist, purdah being one of them. She covers her head in religious settings only. Both Farheen's and Faiza's accounts demonstrate the notion that "the experiencing subject is a nonunitary agent . . . who—in part through the experience of competing ideologies and alternative discourses—operates with a potential for criti-cal distance from any one discourse or subject position" (Ewing 1997, 5). We thus "begin to view culture not as a single totalizing discourse but as a universe of discourse and practice in which competing discourses may contend with and play off each other, compose ironic commentaries on or subvert one another, or reflexively interrogate a given text or tradition or power relation . . . [allowing us to] interpret experience and subjectivity not in terms of a single, incarcerating mode of thought, but in terms of multiply voiced, contextually shifting, and often strategically deployed readings of the social practices we seek to explicate" (Raheja and Gold 1994, 3).

Faiza and Farheen did not follow what they considered to be an extrem-ist reading of the text, only following that which made sense to them. Other women, however, were disrupting the discourse because a particular ruling seemed too difficult or novel. As Saleha's teenage daughter, Hajra, who regularly attended Hina's *dars*, candidly revealed:

Since you're doing research, I'm going to be honest and confess that sometimes I'm quite bored in these *dars*. Yet I also love them and learn-ing about Islam. I don't follow all the things Islam says, because I find them difficult to follow. I have not been blessed in that way yet. I still listen to music, watch movies, go to mixed gatherings, don't wear a scarf. . . . These are things I find difficult to give up because I have grown up with them and because they are a part of the life I and others around me have lived. Some things my parents ingrained in me from the begin-ning, like praying, but not others, and they have become a part of life.

To completely follow Islam would mean changing these things as well, adopting a completely different lifestyle, and many women have done that. They have been blessed. I accept that all these things are a part of Islam. I believe in effort, and I also believe that Allah is merciful.

In a similar manner, contextual situations also make a difference to a person's subjectivity, which can often change or alter given the situation (Marshy 2002). Such was Hafza's experience. A young mother of three who had been attending Nadira's *dars* regularly for a couple of years, she confessed that although she had undergone a number of changes over the years, such as wearing a *hijab* and *abaya* and praying regularly, she often forgot and joined her cousins in gossiping whenever they got together. Unlike Faiza and Farheen, Hajra and Hafza did believe in the absolute rightness of the Islamic discourse at their respective *dars*, thus making the nature of their disruption different from the disruption of the other two women, illustrating the different religious positions occupied by these women in the same society. This complexity not only disturbs the monolithic category of Muslim women but also indicates, as Hajra's account shows, that the process of change is an open, ongoing process.

This point is something Surraiya feels strongly about. A twenty-eight-year-old woman who taught business administration in a private local college, Surraiya attended Amina's *Daura-e-Qur'an* before beginning her job and told me:

> The most trouble I've had after I've started covering is that people have certain expectations from you. They expect you to be perfect, and I'm not. I make mistakes. I smoke a lot. . . . But people become upset when I don't fulfill their expectations. I believe whatever I do or don't do is between Allah and me. And whenever I am ready to change other behaviors, I will. It will take time. I can't change A–Z over night. But hey, people's reactions freak me out. Now I make an effort and don't smoke in public places. People would faint. People find it very hard to deal with a woman's smoking. It has all kinds of negative connotations in our culture. When she is covering and smoking, they just don't know how to deal with that.

Surraiya, with her smoking, does not fit the stereotypical image of a woman in a *hijab*, but as she herself articulates, it is all a process. The concept of hegemony is more useful when "grasped as a process, one that is typically uneven, heterogeneous, and incomplete" (James 1996, 25). To conceive of it in any other way results in the image of a subject informed with a unitary consciousness, who is either completely functioning from within a discourse or is placed completely outside that discourse (Ewing 1997). This one-dimensional view promotes a simplistic and dehumanizing image of people that serves to negate the complexities of their life and the manner in which they live it.

A disruption of discourse or selective use of teachings is much more common in the women who attend the *dars* offered by Al-Huda graduates, as compared to their counterparts who take the one-year diploma course. The difference in intensity and duration of exposure to the ideology in the two types of spaces plays a critical role here and also helps explain why the process of change is much slower in the former. Different learning settings are one factor that has an impact on the speed of an individual's learning, something Lynn Davidman (1991) attests to in her work on women turning toward Orthodox Judaism in the United States. By focusing on new recruits in two different types of Orthodox communities—the modern Orthodox synagogue in Lincoln Square, Manhattan, and the ultra-Orthodox live-in-school Bais Channa in St. Paul, Minnesota—she demonstrates that the process of change among women attending the synagogue is much slower than the ones who live at and attend the school.

Hence, the implication is not that women who go to *dars* do not change, just that the change is slower, as in the case of Amina's *dars*, or more selective, as in the case of Hina's. Factors such as type of setting, motivation for attending it, the kind of discourse being propagated, the age and occupation of participants, and the level of adjustment and satisfaction in women's lives all play a role in the process, as I will illustrate below.

The Space of *Dars*

The word "*dars*" literally means "lesson," and it refers to a space where individuals get together to learn. However the *dars* I attended provided

women space for a number of other activities as well, the importance of which varied from group to group.

Discussions

Having discussions and the space to ask questions and seek clarifications are a part of all *dars* groups, although how much of it happens varies from group to group. It happens the least in Zulaykha's *dars* because the way the Qur'an is engaged with does not inspire questioning or much discussion, and also because most of these women are already familiar with the text. Amina's group discussions are carefully guided, Hina gives only a limited time to questions and usually answers them abruptly, but other *dars* groups, particularly Azra's and Nadira's, give much space to women to share their problems, ask guidance from their teachers, and seek affirmation that what they are doing is indeed correct. Nadira was talking about *shirk*, the practice of ascribing partners to Allah, with reference to specific verses of the Qur'an one day: "We idealize people today, not Allah. We ask them for things. What we do today is what the *kufar* [nonbelievers] of Mecca used to do [that is, worship idols]. On the one hand, people who are alive can be sought for knowledge, but we cannot replace Allah with anyone. That is *biddat*. Touching people's feet, praying to others, worshiping others, whether it be idols, your children, your parents, your money . . . is forbidden."

A young woman in her early thirties interrupted Nadira and with a worried expression shared that her uncle had started calling her a Wahabi[6] ever since she had stopped going to shrines, and she did not know how to respond to him. "Tell your uncle that you don't know about being a Wahabi, but you are certainly a good Muslim," asserted Nadira.

Interestingly enough, unlike Mahmood's account (2005) of some Egyptian women who engaged in intense arguments and disagreements with their teachers, often quoting relevant religious literature to make their points, their counterparts in this context never argued with their teachers, perhaps because like Faiza and Farheen they took what seemed

6. This term is used in a derogatory way as a synonym for someone who is considered an extremist.

reasonable and ignored that which they thought was extremist, or perhaps because religious knowledge was something they were just beginning to acquire. Most questions posed were of the informative kind, in which women sought clarification, advice, and, as seen in the case above, reassurance around issues that came up in their day-to-day lives. A topic that usually raised much discussion was the rearing of children.

Saleha, in whose home Hina gave her *dars*, once asked her what she should do about her teenage sons, who showed a lack of interest in religion and often behaved in ways that she thought was wrong religiously. Hina used this question as a teaching opportunity and expanded upon how children ought to be brought up in order to avoid, or at least minimize, such problems. "Spend the first seven years of a child playing with them. The next seven is the time when you can train them as much as you can. Be their friend the seven years after that, so that they share all their feelings with you and feel they can come to you with anything. Spend time with them, be involved, and gently ask them—for instance, when they are watching inappropriate television programs—'What are you watching, how is what you are watching useful to you?'"

Shamim, a woman attending Nadira's *dars*, complained that her children did not listen to her until and unless scolded; she was raising a common concern. Another woman seated nearby quickly added that her children did not pray on their own and that she had to keep pushing them. Nadira responded by explaining that "an *azim* [honorable] mother cannot tolerate the idea of her children burning in the fire of hell, so pray to Allah that you can bring up your children right." She continued, "Today you see parents who do not care if their children pray or do not pray. Everyone is selfish, after material things, after money, after entertainment, and [they] do not care about their children's upbringing. They don't want more children so that they can spend more on themselves."

"Yes, but education is expensive for children today. We can't afford to have so many children," Shamim interrupted.

"But we don't spend all the money on education," Nadira fired back.

Another woman in the group added that they did spend money on other luxuries that could be reduced and took the discussion in another direction. Arguing that in order to have enough money to afford the

luxuries they have become used to women too have sought employment, she gave an example of a young boy whose parents were too busy working to give him any attention. One day he saw a puppy alone on the street and asked him if he too did not have a mother. The women immediately shook their heads in distress and disapproval. "So that is how children feel if their mothers work," she concluded.

"But sometimes mothers work because they have to. My mother had to help my father so that they had enough money to run the house, and this was her sacrifice," Shamim argued, clearly turning the lesson into a "joint production" through her continuing participation and questioning (Mahmood 2005, 91).

Nadira stepped in at this point and brought an end to the discussion by stating that "women can work. *Hazrat* Khadija [the Prophet Muhammad's first wife] had her own business. But we have to see that we work for a good reason, and in a good way, following Allah's commands. . . . My own mother had six children and she had to work, and we were always clean and well fed."

What we see happening in the discussion above is "the terrain of ideology [not being] constituted as a field of mutually exclusive and internally self-sustaining discursive chains." It is as women draw upon their experiences or share their opinions regarding the acceptability of smaller families or working women that we see these discursive chains come into play, "contest[ing] one another, often drawing on a common, shared repertoire of concepts, rearticulating and disarticulating them within different systems of difference or equivalence" (Hall 1985, 104).

The religious discourse on women and employment is broad enough for women to be able to justify their own experiences through it by emphasizing certain elements, as illustrated by the comments of Nadira and Shamim, who come from a socioeconomic background where their mothers had been forced to work because of financial need. On the other hand, we have women like Saleha, a gynecologist, or businesswomen and entrepreneurs who go to Amina Ellahi's *dars*. They have been working most of their adult lives, not because they have to but because they want to, and now they do not find anything in Islam that prohibits them from doing so.

Farhat Hashmi's take on women seeking employment is actually relatively more flexible than many of her students' outlook. On the one hand, she makes it clear that a woman's primary responsibility is her family and that her natural role is as wife and mother. On the other hand, she also states that a woman can seek employment, whether because of financial needs or because she wants to make a difference in society, if a number of conditions are met—for instance, if her husband gives her permission, if she does not ignore her family, if she has the ability or talent to do the job well, if she covers herself in the manner prescribed in the Qur'an, and if the workplace has other women working there as well. There is a need for women to join different professions, she states, as there is a need for women doctors, women teachers, and so on.

Hence, what Islam's position on various issues is, and the manner in which it is or ought to be intertwined in their lives, is something that women individually carve out from within the hegemonic discourse. It may also be something they choose to ignore. I came across a number of women who gave *dars*, ignoring their children, and hence their primary responsibility, according to the Islamic discourse they themselves propagate in their *dars*.

However, what Islam is or is not continues to be propagated at the level of discourse in all the *dars*, including Zulaykha's. The content of the discourse defining Islam is nevertheless different in this space. The session had just finished one day when Fehmida told the rest of us that she had gone to an acquaintance's house at her son's death the week before, and when she began reciting *Surah Fateha*, a former Al-Huda student present there told her that she must not raise her hands while reciting it. She was very upset and called the woman a Wahabi and continued to warn the rest of the group that "these women are very rigid. I just want to share this with you. They say they have taken pictures off their walls; they no longer watch TV. . . . 'How will you live?' I ask. Their thinking is so primitive. We are above them all. Our conversation is on a higher level. We focus on the Qur'an. . . . I am warning you about them so that you beware! The important thing is our relationship with Allah, not the things these women are caught up in. We must have a jihad against them."

Women in Zulaykha's group live an Islam that often puts them in opposition to women upholding an Islam that does not completely match theirs. They do share some common ground, and "some shared ground must exist . . . to make disagreement, contest, and resistance meaningful" (Lamb 2000, 5). But the climate in which they are functioning, in which they perceive their traditions to be under attack (women in Zulaykha's group) or in which they are reacting against what is perceived to be *biddat* (Amina, Hina, Nadira, and in some cases Azra), often keeps the focus on difference.

Networking and Socializing

The time before and after a *dars* is maximized by women who use their meeting space not only for increasing their religious knowledge and clarifying concepts through discussion but also for socializing, networking, and sharing information, "creating a tight community of overlapping, generally like-minded social circles" (Clark 2004, 175).[7] How much of this bonding occurs varies from group to group. Women in Amina's *dars* are usually found going over the lesson from the prior week before class begins. Al-Huda *dars* are relatively more formal than the others, and there is a very strong emphasis on learning there. One would never see an instance that often took place at Azra's *dars:* Her-four-year-old grandson frequently ran into the living room where the lesson was being held. The women cooed over him, remarked upon how much he had grown, and then automatically went back to their session once he had left. The women there were much less formal and more overtly caring toward each other. Yet the new networks women formed in *dars* such as Amina's were also playing an important role in their lives. This point is particularly relevant in the context of those women whose families did not support their journey, whose old friends may have left them, or who no longer felt comfortable with or trusted the people they used to spend time with. Maria, a married woman in her midthirties who attended Amina's *dars* regularly, related an emergency situation when she had to leave her children someplace overnight:

7. See Badran 1994, Eiesland 1997, Duval 1998, Kamalkhani 1998, and Raudvere 1998 for parallels in other parts of the world.

It was these people, these friends, who sprang into my mind immediately. And without hesitation I thought, "I can leave my kids with them." . . . I actually sat and cried when I realized that these are the real friends. And when I tried to think of my other friends, I couldn't think of anybody who I'd trust that much. . . . And what's binding us? It's the Qur'an. It's not as if our husbands worked together, or they have any business interests together or anything. In fact, I think our husbands have hardly met. And we hardly meet otherwise. Everyone is so busy, but you talk on the phone. And literally, the only thing binding us together is the Qur'an. And yet it's a strong thing that binds us. I could easily trust my children with them for two weeks. I could go for a hajj and leave them with them. Leaving them with my old friends, you'd worry—God knows what they'd show them on TV, God knows who'd be around . . . something as simple as the sort of movie they put on. I'm telling you, Sadaf, with these sorts of friends, you have no problems. And literally, their homes are thrown open for you. It's all the Qur'an.

Some detachment with old networks, whether family or friends, and the construction of new social networks sympathetic to their ideology, is a phenomenon that is visible in other parts of the world as well, in contexts where individuals engage a religious discourse that makes them alter their ideology and behavior (Clark 2004). New networks become especially important in such contexts, and a mutual love for one another in the name of Allah becomes the foundation of new relationships. Soroya Duval quotes one of her Egyptian informants declaring that loving one another in the name of God "is the purest and most sincere form of love, because I don't love you for being rich or beautiful, but because you share with me the love of God" (1998, 60). A sense of community is often found through a *dars*, which becomes comforting in the context of a larger environment that is not always supportive. This point holds true for women of other faith traditions also. For instance, women who have turned to Orthodox Judaism highly value religious community centers for similar reasons (Davidman 1991; Kaufman 1993). They no longer feel comfortable with the people they used to spend time with, and appreciate the opportunity to meet people with whom they have a "shared history,"

thus increasing their sense of belonging and also strengthening their own Jewish identity.

The space the *dars* provides for opportunities to socialize is most visible at Azra's, where all women bring a dish of food with them and spend up to an hour after class talking over food and tea. The women in this neighborhood are also part of a committee in which they each hand the head of the committee a certain amount of money every month; each month a different woman gets the total amount collected. Such committees, run completely by women, are a common feature in many low-income urban neighborhoods all over the country. Women often use the money they receive to buy something for the house or frequently spend it on their children's weddings. Turns may also be adjusted in emergency situations— for instance, if a woman suddenly needs money for an unexpected surgery of a family member. The head of the committee has to be a person who is good with numbers and highly organized, keeping track of women's payments and how much is due to whom and when. The woman occupying this position in this neighborhood always had her register open in front of her both before and after the actual *dars*, and a few women always surrounded her, either discussing their financial matters with her or handing in their money.

Informal chats at *dars* settings touch on a variety of topics, from women's health to their servants and from their children to their clothing. I even met a couple of women who had arranged a marriage between a girl from one's extended family with a boy in the other's. Glimpsing into different *dars* to get a feel for these conversations, we find one woman at Azra's *dars* telling another that she no longer cooks and her daughter-in-law does the cooking, while over at Zulaykha's a woman in her late sixties told the rest of the women that she had recently undergone angioplasty and warning that if they too were out of breath after walking from one room to another, then it was important to get a checkup. The other women nodded, and a discussion of top cardiologists ensued. Soon the daughter-in-law of the woman whose house we were in arrived, met everyone, and talked about how she planned to sell baked goods, at which point Salma offered to help her make brochures and gave her tips on how to get her small business started. Over at Hina's, Saleha informed one of her neighbors that her

shawl did not match her clothes. A woman at Nadira's *dars* spoke up and shared that she had brought a written *du'a* to show Nadira. Her daughter's Islamic studies teacher had given it to her and told her that if it was read during *sehri,* the time preceding dawn when Muslims eat before keeping a fast during the month in Ramadan, she would be given as many blessings as there are stars in the sky. The rest of the women began questioning her about whether it was just to be read on the first *sehri* or every one.

Sometimes conversations begun before the session in Zulaykha's *dars* continued into the time for reciting verses over *guthlis.* Some women would not let the ritual interfere with their conversation. They would recite the *Durud Sharif,* moving the *guthlis* from their hands accordingly, and at the same time listen to any low-voiced conversations going on around them. They would stop reciting and speak whenever they wanted to contribute to the conversation, and then pick up their recitation from where they had left it. Although conversation would be sporadic while the ritual took place, there were occasions when it took over the ritual and the woman in whose house the *dars* occurred had to tell the rest of them to stop talking and go back to the *Durud Sharif.* Zulaykha was always in her own world while recit-ing and never paid attention to the rest of the group during this time.

Space for Self

"I have four children, and we live in a flat. I cannot read at home. I cannot concentrate. Not the way I can when I am outside. At home it's one thing after another. But when I am out I can just lose myself in my prayers. I can concentrate. I can cry." This earnest statement uttered by a housewife was one with which a number of women I spoke to could relate. They highly valued the two to three hours they spent entirely on themselves. The num-ber of these hours increased during Ramadan, when women would get together for *taravia,* special collective prayers, every night of the month, often not returning home until ten or eleven o'clock at night. This time was especially valuable for the women who frequented Azra's and Nadira's *dars,* who did not have servants to help them out with their housework and children, and for whom time for themselves was a luxury. The kind of activities they engaged in while at the *dars* further increased the meaning-fulness of this time for them.

One of the most attractive parts of a *dars* for many women was the *du'a* offered by the *dars* teacher at the end of each *dars*. Amina's was always in Arabic, short and to the point: a few lines asking Allah's forgiveness and asking for His help in becoming better Muslims. Azra's and Fehmida's— who performed the *du'a* at Zulaykha's *dars* because everyone agreed hers were the best—would largely be in Urdu, and also be more personal. Apart from thanking Allah for looking out for them and for giving them His blessings, and seeking His forgiveness for the mistakes in conduct they made every day, Azra and Fehmida, and sometimes Hina as well, also made personal *du'as* for women in the group. For instance, praying that such-and-such woman's son got good grades in his exams or praying for women who had deaths in their families and asking Allah to give them strength. Sometimes women would request them to make a special *du'a* for them. Saleha once told Hina that her mother had called and told her she was not feeling well and requested that she pray for her at the end of the class. Another elderly lady who had had laser surgery told Azra that she still could not see clearly and requested that she pray for her. On my asking them, the women who made these personal requests told me that they believed that a *du'a* made in a *dars* setting where everyone had just read the Qur'an was more likely to be accepted.

Making general *du'as*, many women claimed, was a skill not all teachers had. Usually, the teachers who brought their students to tears were the most appreciated, and the place where this phenomenon was observed the most was at the *du'a* made by the teacher on the last day of Ramadan, after the last *siparah* of the Qur'an had been read as a part of a monthlong *Daura-e-Qur'an* experience. The ability to make an audience cry is something Charles Hirschkind touches on in his work on the creation of pious subjects via audiotaped sermons in Egypt. "Weeping has an important place within Islamic devotional practices, as a kind of emotional response appropriate for both men and women when, with humility, fear, and love, they turn to God" (2001, 630). *Du'as* offered at the completion of a *Daura-e-Qur'an* last for up to a half hour, and the women making *du'as* often have tears rolling down their faces by the end of it. Given below is an excerpt from Hina's *du'a*: "All praise is for you, Allah. You are the truth, and your saying is the truth, and the paradise and the heaven are the truth, and

your presence is the truth, and Muslims are the truth. . . . Allah, we have believed in you, we have placed our trust in you, we seek your guidance, your judgment. . . . Allah, forgive all our sins, whether secret or open; stop our excesses." Women cry "Amin" (Amen), overtly manifesting their faith in Allah, at the end of every small prayer that Hina utters. Great similarity is seen between her and women preachers who are frequently invited to give revival sermons in the United States. Folklorist Elaine Lawless calls these sermons "dramatic performances" in which the preacher "actively solicits the verbal participation of her audience" (1988, 90–91), using "verbal art" to revive their spirits (Hundt 2000). Hina continues:

> Oh, Allah, Lord of Gibrael, the Qur'an, creator of heaven and the earth, all our praises are for you. Allah, accept this effort from us. Allah, we have never appreciated you the way we should have. Allah, we have never loved you the way we should have. Allah, we have never obeyed you the way we should have. Allah, we have never revered you the way we should have, but you are *rab* [lord] of Ibrahim, *rab* of Isa, *rab* of Musa, *rab* of Muhammad. Oh my *rab*, you are so perfect, please accept these useless deeds from us. We are the ones in need of you. Allah, choose us, honor us, give us a share in this. We have made so many sins, made so many mistakes. If you do not forgive us, we will become losers. Allah, save us from ourselves, our *nafs*,[8] because our *nafs* can destroy us. . . . Allah, set right all our matters. Allah, you can give us everything. You gave Maryam out of season fruits, Hazrat Zakria a child when he was so old. . . . Allah, guide the Muslim *ummah* [global Muslim community] today. We are running towards hellfire. We cannot help ourselves if you cannot help us. Allah, save us from hellfire. Allah, you have promised that there is one door of paradise that never closes, the door of repentance. . . . Allah, grant the desires of all the people who have gathered here today. Those who are sick, grant them health; those who are issueless, grant them children. Accept our *salats* [obligatory praying]. Accept

8. Similar to Freud's id, *nafs* usually refers to that part of oneself that urges a person toward the instant gratification of pleasurable wants that are often considered immoral, evil, or harmful.

all the *sajdas* [prostrations] we did; accept all our fasts; cover our short-comings. Never let us be impressed by anyone but you. Allah, make our children follow your path. Let them become one of those who love you. Make the Qur'an the light of their hearts. . . . Allah, help those who are in need; take away the worries of those who have worries. Allah, accept our prayers and make our homes havens of peace. . . . Grant us confidence. Allah, these are the special moments of Ramadan, and they are almost over. Allah, guide us.

Hina's pace quickens, and the emotion in her voice deepens as she continues; there is complete silence when she is done, interrupted only by the sound of quiet crying. Some women have their heads bowed on their hands, while others are crying openly. This oral performance is an emotional climax at the end of a month of intense interaction with the Qur'an. As soon as the *dars* ends, Saleha goes up to Hina, who is also crying by that time, and hugs her. Others also get up to hug her, and Saleha's daughter begins distributing small packs of *mithai* (sweets) and copies of the Prophet Muhammad's *du'as* to the fifty or so women who have specially gathered in her living room to attend this last day of class. Another woman begins distributing a copy of Farhat Hashmi's tapes to everyone as a gift. The noise level steadily increases. Saleha and Hajra approach Hina and give her a wrapped gift as a sign of their appreciation.

Oftentimes women who are skilled in offering *du'as* are invited to *dars* in various parts of the city and are asked to make *du'as* at the end of those *dars*. Not all teachers are happy about this prospect, particularly one teacher affiliated with Al-Huda who complained that the women's main interest was in the *du'a*, and not the study of the Qur'an. She had begun refusing the invitations to go for a *du'a* alone. Her argument was similar to the assertion of a *khawtib*, or preacher, in Egypt, who claimed that "lots of people today just look forward to crying during sermons; they feel they are being cleansed, like Christians at baptism. But the sermon that just leads you to cry doesn't impinge upon the heart. It doesn't get people to change their actions. It is only through a careful engagement with the texts, reading the Qur'an and *hadith* literature, that knowledge gets rooted in the heart" (Hirschkind 2001, 630).

But many women took pride in their skill, as did Fehmida, who told me about the many places she was invited to that Ramadan. Women who lead *dars* occupy leadership roles and are praised for doing so, if from no one else, then certainly from the women they teach. One day when Zulaykha had finished reciting the Qur'an and reading its translation and there was still some time left over, a woman praised Maryam and requested that she speak for a bit. Clearly pleased, Maryam replied that "speaking after Zulaykha *apa*[9] has spoken is like showing the sun a lantern, but I'll do my best." Those women who do an exceptional job with a *dars* or *du'a* soon become well known in *dars* circles. They are invited to other women's homes and are highly appreciated and respected within those circles. *Tajvid,* or the art of Qur'anic recitation, is also held in high regard, and many women practice listening to audiotaped *tajvid* recitations from Saudi Arabia. A good reciter is subject to much appreciation and praise by the group, and often asked to recite in different settings on other occasions as well.

Other women who are praised in *dars* are the ones who have "changed" the most, and highlighting these women's experiences was a common phenomenon in Hina's and Nadira's *dars*. All the women in Hina's *dars* made it a point to tell me that Hina had once performed on television but that she had completely altered her life. Likewise, Sana, a young woman in her early twenties who used to be a presenter on a pop music show on television before she began attending Nadira's *dars*, was frequently used as an example of those women who have significantly changed their lives by giving up worldly pleasures and success. She was often asked to speak to the larger group about what she had found in Islam. Duval writes of such testimonials of well-known people in similar religious groups in Egypt, and shares that "these women are looked at with a sense of euphoria and are taken as symbols of how fame, beauty, wealth and power are not comparable to the beauty, wealth and power of Islam" (1998, 59).

Much has been written on the idea that participation in religious activities provides women with the opportunity to expand their gender roles and become mobile (Lawless 1988; Hegland 2002). One such example is that of Shiite women in the Pakistani city Peshawar who leave their homes to

9. A descriptive term denoting an elder sister.

travel to *majales* (mourning assemblies) in various parts of the city, often developing their talents and leadership and managerial skills through their participation in these gatherings (Hegland 2002). Such activity is what allows many of these otherwise sequestered women the freedom of mobility they would not necessarily enjoy in the repressive environment of this region. This description, however, does not apply to the women who participate in Zulaykha's, Amina's, or Hina's *dars*, who are already mobile, many of whom have or have had jobs. Those women who attend Azra's or Nadira's *dars*, on the other hand, are primarily housewives and relatively less mobile than the ones participating in the other three *dars*. But they are not taking up leadership roles or going outside of their neighborhoods to attend *dars* and, hence, not expanding their activities or increasing their mobility in the sense the Shiite women mentioned above are.[10] Nevertheless, the weekly *dars* do provide them with an organized means of meeting everyone regularly and an opportunity to spend their time in a constructive manner, that is, in learning. The women who attend Nadira's *dars* are more focused on learning and do not stay behind to chat once the *dars* is over. In Azra's *dars*, on the other hand, increasing one's Islamic knowledge is only one of the many attractions.

Breaking the Muslim Woman Monolith

Reacting to accounts in which authors assume that the Muslim women they are writing about are a monolithic, closed group, with similar motivations and interests, and that no differences on the basis of nationality, ethnicity, class, education, and other such factors exist (Mohanty 1991), many women, both Muslim and non-Muslim alike, have produced a number of works that carefully consider women's position vis-à-vis these factors (Ask and Tjomsland 1998). When scholars adopting such an epistemological approach study women's increasing engagement with religion, they illustrate that women turn toward religion in a variety of ways within a variety of contexts, and that multiple factors, both local and

10. This lack of growth is in contrast to some of their counterparts, also from the lower middle class, who expand their roles by working at the main Al-Huda branch or by offering *dars* in their own neighborhoods or other parts of town.

global, interact with each other and combine to shape their experiences. Ethnographic accounts of women's religious groups and activities in Iran (Hoodfar 1997; Kamalkhani 1998), Egypt (MacLeod 1991; L. Ahmed 1992; Badran 1994; Brink 1997; Duval 1998; Mahmood 2005), Turkey (Raudvere 1998), central Asia (Tadjbaksh 1998; Tohidi 1998), Africa (Jansen 1998), and the United States (Anway 1996; Bullock 2002) are some such examples. These accounts disrupt the Muslim woman monolith by shedding light on the different kinds of Islam that women interact with or propagate and the variety of religious rituals they engage in, also providing insights into the multiple reasons women have for participating in religious groups and activities. The significance of the reasons becomes apparent when we look at them within their specific contexts, reinforcing the importance of women's positionality and locality in any analysis (MacLeod 1991; L. Ahmed 1992; Wadley 1994; Ask and Tjomsland 1999). For instance, in her account of Muslim women in rural Egypt, Judy Brink (1997) explains that unlike their counterparts in urban areas who actively study and embrace a scriptural Islam via the mosque movement, these women, who practice folk Islamic rituals that are meaningful to them vis-à-vis their lives in a different cultural setting, are being forced to give them up because their male family members—who are influenced by urban Islamic revivalism—do not consider them to be Islamic. Brink claims that these rural women are now adopting Islamic practices imported from urban religious centers in order to maintain good relations with their male family members, particularly their brothers, upon whose support they largely depend for their entire lives.

In a similar manner, differences exist among women participating in different *dars* in Islamabad. Although they all adhere to "Islam," *dars* manifest differences in ideology (for instance, compare Zulaykha's *dars* with Amina's) and rituals that manifest that ideology (compare the use of *guth-lis* in Zulaykha's *dars* to the absence of such rituals in others). Differences also exist in the manner in which the space of *dars* is used by women, ranging from a primary consideration given to acquiring knowledge and subsequently transforming oneself into pious subjects in *dars* such as Amina's to others, like Azra's, that give equal importance to other considerations, such as using the space for networking and socializing.

Although differences exist among women across *dars* settings, signifi-
cant similarities usually exist among them in a particular *dars*. One of these
similarities is in the way Islam has or has not been a part of their lives prior
to their joining that particular *dars*. For instance, most women attending
Zulaykha's *dars* had grown up engaging with a variety of religious ritu-
als straddling a number of Islamic strands—such as fasting in Ramadan,
praying daily, visiting the shrines of saints, attending and holding *chalisva*
and *milads*—that they continued engaging with in their adult lives. Apart
from this similarity, they all had a fair to high level of religious knowledge
and a great interest in Sufi thought, either as a result of their family back-
grounds or because of their own personal interests. On the other hand,
most women attending the Al-Huda *dars* and belonging to the middle and
upper classes possessed only standard religious knowledge—such as infor-
mation pertaining to the birth and early spread of the religion, along with
some familiarity with the basic tenets of Sunni faith—acquired through
school. Although they came from backgrounds where their parents may
have prayed or they had to read the Qur'an in Arabic as children, their
scriptural knowledge was limited and their practice of rituals minimal.

We see further differences between, and similarities within, the *dars*
run by Al-Huda graduates. For instance, although they both belong to the
upper classes and share a lack of scriptural knowledge, we nevertheless
see differences in Amina's and Hina's students. The former group com-
prised younger women who took what they were learning much more seri-
ously than their slightly older counterparts. One of the main reasons was
that they were more concerned about how they were living their lives. For
instance, many of the women who went to Amina's *dars* had common
complaints, a direct manifestation of their lifestyle in their particular class.
As Maria explained:

> I go through the typical problems of a typical housewife of a well-to-do
> kind of person, where you don't have much to do. And your life is kind
> of empty. It is full of material things. But it does not have a value or an
> essence in it, "what you live for" kind of thing. And when you have lux-
> uries of life, then what happens is that you are never actually physically
> exhausted. When one works constantly, physically, then at least you're

drained. When you're not physically drained, when you're mentally not drained, when you don't have much to do, your life is a vacuum, and you don't know why you were created. I tried the routine things of coffee mornings, but inside me, it just didn't make me feel good. I didn't feel a part of them. So I went to one or two and then gave up. And generally I felt, in those days in particular, I wouldn't call it depressed, but I was in the mode of seeking something. I was a housewife with a very hollow kind of environment, in which I was meeting women who were partying and had nothing to do but paint their nails and backbite. And you go through it and go through it, but somehow it makes you sick from inside. And you just don't know if this is it. Either you live in that depression and in that soul-seeking mode and curtail yourself in it, or you go out and look for something else that gives you the correct answers to your questions.

Another one of Amina's students revealed that "there comes a time in a person's life when he or she feels coreless, when there is no purpose to their life. You feel like you're living in darkness. We get up in the morning, have breakfast, get our children ready, drop them off at school. . . . [T]here is this nagging empty feeling when you don't have a purpose in life, no real intent. That is what I found through the Qur'an, a purpose." Younger women in that group also expressed similar thoughts, such as Arshi, an eighteen-year-old "A"-level student, who shared that "all my life I've been very dissatisfied. . . . My life is normal, very much like other teenagers. . . . I've traveled. . . . I was always searching. I've searched for truth. Now I've realized the truth. I realized that this life we live is nothing but an illusion. It's just plain amusement, and time is short. *Surah 'asr* touched me. Time is short. Where are we going? How are we living?"

Such examples strongly suggest that one of the reasons religion has become attractive to these women in particular is that it is filling an emptiness in their lives. It is in this context that the fact that none of the women attending Zulaykha's *dars* informed me that they felt their existence was bereft of purpose or that religion filled a gap in their life is significant; most of them had worked as professors or engaged in social welfare work as they raised their families, and they spoke of the number of meaningful activities

they had been involved in their lives. Their emphasis on an ever-deepening love and remembrance of Allah as opposed to religion being a complete code of life is therefore not too surprising. I do not mean to present a reductionist account and do acknowledge that the aspects of religion that they vocally appreciated are not the sum total of their religious experience. But the religious factors they chose to highlight were intertwined with their lifestyles, and partially explain why they found religion meaningful and how it enriched their lives. In the case of many of Amina's students, the emphasis on religion as a code of life was connected to the emptiness they felt and the materialism that was failing to satisfy or had never satisfied. We see the same thing among one of Hina's students as well. Zaib, a twenty-seven-year-old mother of two children who lived with her in-laws and attended Hina's *dars* off and on, disclosed that she was "very tired of this life. . . . It is so superficial, so superficial. For instance, if we have guests. Now, Islam teaches us simplicity. The Sunnah teaches us that we make simple food. But what do these people [her in-laws] do? They make four or five dishes. The sweet dish is separate. There is so much tension at home, the children are ignored, and time is wasted as we prepare for the guests. A simple life is so convenient."

Many women in Amina's *dars* came from backgrounds where even if they or their families were not particularly religiously inclined in terms of following religious rituals, they did internalize a particular moral code, one that made them uncomfortable in their later married social life when they found themselves in an environment that was different from the one they had grown up in. Rabiya's story is illustrative of other women's experiences as well:

> I was married before I could begin my B.A. My husband is a good human being but not religious. He does not pray or anything. In fact, he is very modern. The scene after my marriage was very different from what I was used to. I come from a regular middle-class family. But I got a lot of freedom after marriage, and I have to confess that I began experimenting. I was never very regular in my prayers, and this continued. . . . This was a scene of sleeveless shirts, which I wore. There was drinking, which I didn't do, but everyone around me was doing it. I would be dancing with

my husband, and there would be men and women not married to each
other dancing together, and the married men would be looking at me
as they have no business looking at me. There were extramarital affairs
going on around me. I don't want to sound rude, but people in Islamabad
seem to live a very superficial lifestyle. I participated in that lifestyle, but
even as I used to be doing those things, a part of me, inside of me, was
never comfortable with it. I may have come across as very well adjusted
and "with" things to others, a social success, but inside I knew what I was
doing was wrong.

These women's reasons for attending *dars* made the subsequent impact
of what they were learning all the more ubiquitous in their lives. But
whereas many women attending Amina's *dars* were searching for a larger
purpose and meaning, dissatisfied as they were with the way they were
living on a number of grounds, the women attending Hina's *dars*, who
were also older, were comparatively well adjusted and not interested in
completely transforming their lives. They primarily came to the *dars* to
increase their Qur'anic knowledge and to spend their free time in a posi-
tive manner. They were not looking for a comprehensive way to live, and
although they did slowly incorporate many of the teachings into their daily
routine, they were relatively more selective in what they accepted. Amina's
students' motivation for being there, on the other hand, made their rela-
tionship with what they were learning different, and they were more ame-
nable to changing their behaviors and lifestyles.

Background factors, such as class, lifestyle, the strength and nature
of women's prior relationship with Islam, and what Islam means to them,
therefore play a critical role in determining what kind of *dars* women attend
and the extent to which those *dars* will have an impact on their lives in
terms of both ideology and behavior. It is therefore a mistake to assume
that all women who attend *dars* within a city do so for similar reasons and
get the same thing out of it. To do so would mean treating them as mono-
lithic, ahistorical subjects who are not products of the heterogeneous and
complex intertwining influences, both religious and otherwise, that make
up any culture. It would mean negating their diverse experiences and real-
ity as they occupy a particular place within that larger culture.

5 · Cultural Matters, Global Wars

THE FAITH WOMEN possess and bring to Al-Huda is strengthened through their growing love for and desire to please Allah, and it takes on a particular form through their belief in the authority of the discourse they are exposed to at the school via the unique pedagogies of persuasion employed by their teachers. The particular locations women occupy within society influence the multiple ways in which they find meaning in religion and religious spaces, which facilitates their engagement with religion, as does the larger sociopolitical environment within which they live. This larger sociopolitical environment is informed by the interaction of the local and global, and it is only through the exploration of women's experiences in this space that a more comprehensive understanding of their decision to transform themselves into pious subjects can be gained.

Many women's stories revealed some crosscutting concerns stemming from the larger sociopolitical environment. One set of concerns revolved around their perception of and reaction to "foreign" cultural values and trends in their society. Another set of concerns related to Muslims being persecuted and attacked in different parts of the world. Both sets of concerns produced feelings of anxiety and bewilderment among women, and many hoped that Al-Huda could help them deal with their feelings and answer their questions related to these larger issues. Al-Huda's response, among other things, propagated their adopting a pious lifestyle. However, as piety itself is informed by a specific version of Islam—so that the notion of "piety" that Al-Huda propagates is reflective of the Islam it upholds as the truth—what being pious or a good Muslim means is something these women (re)learn at Al-Huda. Hence, it is as they live their lives and encourage others to live their lives as Muslims within a particular

religious framework that they allay women's concerns and play an active role in the construction of a particular kind of culture in Pakistani.

"Foreign" Cultural Influences and Identity

The word "culture" has been described as one of the most complex words of the English language (Williams 1958), and different scholars have presented their own definitions of the word to capture what they mean when they refer to it. I limit the meaning of the word to its material and nonmaterial aspects and use it to refer to "an array of tangible materials that facilitate social interaction and discourse, delight, provide aesthetic pleasure and symbolize meaning" (Parezo 1996, 747), as well as the language, performing arts, values, beliefs, ideas, and norms of a particular geographical region. In light of this meaning of the word, Pakistani culture is often spoken of as a coherent entity with a number of distinctive cultural markers.

However, the notion of culture has moved beyond Bronislaw Malinowski's conception of it as a "coherent whole" in academic circles, and anthropologists now recognize a number of facets. One of them is that any geographical region is made up of not one but a number of different cultures. Pakistan, for instance, is home to the Balochi, Pukhtoon, Sindhi, and Punjabi cultures, each made up of a number of different languages and possessing unique musical instruments, dances, food items, clothes, and art forms. Furthermore, many cultural differences are also visible in the rural and urban settings within each of these four provincial regions. So the culture of a rural area in Sindh may be different from the culture of Karachi, an urban metropolis in the same province. Apart from rural-urban cultural difference, subcultures based on factors such as class, religion, and ethnicity also abound.

In a similar manner, although the people within each region are believed to demonstrate some characteristics and uphold certain values more than others, such that the Pathan are known for their bravery and hospitality and the Punjabis for their high spirits and zest for living, anthropologists also recognize the fact that any individual may be the product of a combination of experiences and influences and may not always uphold dominant or ideal cultural values. Hence, "what we do *not* find [in culture]

are neatly bounded and mutually exclusive bodies of thought and custom, perfectly shared by all who subscribe to them, and in which their lives and works are fully encapsulated. . . . The isolated culture has been revealed as a figment of the Western anthropological imagination" (Ingold 1994, 330; emphasis in the original).

Although different cultures do have a number of distinct characteristics, contact between them prevents their isolation. In the case of the region comprising Pakistan, the invasion of different cultural groups over the centuries—such as the Aryans, Persians, Afghans, and Turks—interaction with traders, travel, as well as the contact that different cultural groups within the area have had with each other have ensured that "culture" has not remained static. Furthermore, globalization today has ensured that cultures come in contact with each other as they never have before. Although a contentious word usually used to refer to expanding economic markets, "globalization" is used here to refer to "the growing frequency, volume, interconnectedness of movements of ideas, materials, goods, information, pollution, money and people across national boundaries and between regions of the world" (Beckford 2003, 118). Although it can also technically refer to the cultural flows that have been occurring in the world for centuries, I use the term to specifically refer to the flows of ideas and values that are occurring in the context of the communication systems and means of mobility available to people today.

It is within this framework of culture—one that is bound to a land but is not static or fossilized, one that has a number of characteristics making it unique but also a history of interconnections with different peoples both near and distant—that I begin talking about the culture of Islamabad. Like other places, Islamabad is an amalgam of trends and values both old and contemporary, and it is made up of people leading variant lifestyles, enjoying different leisure activities, and celebrating a number of festivals and events that they deem acceptable. However, what is acceptable to some is not acceptable to others, and what was once acceptable to some is not acceptable to them anymore. The latter include those women who are refashioning their Muslim identity through their engagement with Al-Huda in the larger context of exposure to a variety of alternative values and practices that they term "foreign." I elaborate on this view below.

The Globalization of Difference

Print and electronic media, as well as the Internet, have ensured that peo-
ple in one part of the world are exposed to and come face-to-face with
foreign ideas, values, and trends (Kurzman 2002). Perhaps one of the most
common means through which these elements enter Pakistan is through
electronic media. The two countries whose films are enjoyed the most
in Pakistan are the United States (Hollywood) and India (Bollywood),
and they are available, more so than Pakistani films, in all video rental
and DVD stores. Smuggled camera prints are also available so that highly
anticipated films can be privately viewed a mere day or two after they are
released in their country of origin. In addition, the advent of very cheap
cable television has also ensured that a large number of homes have access
to privately owned Pakistani channels (Hussain 2004), as well as those
networks that show programs from India and the United States. Although
the presence of foreign films and programs in the country is not a new
phenomenon, the way such a large number of people now have such ready
access to so many of them is a comparatively new one. These programs
and films bring forth not just simple entertainment but also certain images
and values. A source of concern for many, these images are then largely
used to construct an image of Indians[1] (read: Hindus) and the West (A.
Ahmed 2002).

Before moving forward, a clear distinction needs to be made between
"Westernization" and "modernization" (El-Solh and Mabro 1994). Western-
ization, a process whereby "Western" values are spread outside the "West,"
held negative connotations for the women I interacted with, for the West
was seen to embody both moral depravity and a spiritual void. The West,
in this context, becomes a synonym for the images and values women
associate with it. Hence, it is Westernization that these women and others
engaging with religious movements in general are denouncing. Moderniza-
tion, on the other hand, is acceptable (Schultze 1993; Tehranian 1993;
Moghadam 1994). By modernization, I simply refer to the technological

1. I must point out that the image of Hindus is also significantly constructed through
school textbooks, particularly the ones related to history.

advancement and developments that have taken place in the world and have become a tool of globalization.[2] When we look at the multiple ways Islamic knowledge is spread, not just through the media at Al-Huda but also through tapes of women's religious lectures in countries such as Egypt and Iran, we see that these individuals "actively accept and foster modernization . . . in a religious context that is in harmony with the indigenous culture" (Cooke 2001, 5). It is also in such contexts when we see the tools of globalization being used by "non-Western" countries that we see globalization itself in a more holistic way, where the cultural flow of goods and ideas moves not just from the "West to the rest" but in all directions (Beyer 1994, 9). This free flow of ideas does not, however, ease women's concerns over the values that they perceive the West to be contributing.

The images that are coming into Pakistani homes via television programs and films are, women tell me, all around the themes of sex, violence, and the breakup of families, which form a key social unit in Pakistan (A. Ahmed 2002). The "immorality" found in the West is a very common theme in their discourse. As a sixty-five-year-old retired army doctor who attended an Al-Huda *dars* regularly extrapolated on the West, "Over there neither does a sister have respect for her brother, nor children for their parents. There is obscenity and shamefulness, so that you live with whom you want, have children with whom you want, no home, no satisfaction." Other women claimed, "You don't have any relationships in the West; you only have sex," "Americans' brains work at an instinctive level, just like animals," and as someone who had watched an episode of *Baywatch*

2. I would also like to make a distinction between the words "modernization," as I am using it in this text, and "modernity," by which I refer to the sociopolitical transformation of Europe that occurred when religion was no longer used as a tool of political legitimacy and the separation of church and state occurred (McDaniel 2005; Sonn 2005). Modernity, in this context, becomes linked with certain concepts, such as secularism. The division between modernization and modernity is artificial at its roots, for technological advancements are themselves linked to the Enlightenment and the project of modernity in Europe. Nevertheless, my conversation with my informants revealed that they were not at all bothered by the Western underpinnings of many of these technological developments. Why should they not adopt something, they asked me, that would only help them spread the word of Allah?

observed, "They have even tried going around naked, yet they still feel no peace." Striking similarities are seen between these women's construction of Western morality and the beliefs of others in different parts of the world. An Egyptian woman involved in the mosque movement in Egypt, for instance, claimed that "there are [in the West] no rules or limits. Men and women go around almost naked in the streets, they kiss and touch each other in public . . . their people are lost amidst high crime rates, drugs, and sexual perversity" (Duval 1998, 61).

Entertainment programs are clearly perceived to pose a threat, as are other programs, such as foreign documentaries and news reports. As a glimpse into the potential future of one's own society, they become a source of concern. "The divorce rates, the drug abuse, the suicides, the revelations of pedophile rings and satanic rituals . . . the random violence" present a frightening picture of the West, argues scholar Akbar Ahmed. Hence the West, "especially the United States . . . represents moral and spiritual decadence. Sex, drugs and violence are what the West offers and Muslims must resist them with their piety and moral strength. . . . The VCR and some of its more vulgar exhibits are taken as exemplifying the West. . . . This is the obverse of Said's orientalism" (2002, 246, 196). This construction of the West negates the cultural diversity found in "the West." But regardless of how comprehensive or accurate the media images are of their countries of origin, the way people all over the world are reacting to what they do have access to is an illustration of their concerns amid particular global cultural flows.

It is as women share their theories regarding why they believe individuals are turning toward religion that some claim that it is a reaction to the West. Although a turn toward religion cannot solely be explained in terms of a "reaction," it does become a means to hold on to values that women believe are in danger of being lost or that they feel are being threatened. For instance, most of the mothers I met who had sent their teenage daughters to Al-Huda told me that they had enrolled them largely so that the girls could become cognizant of the difference between right and wrong, get a support system of similar-minded individuals, and not become influenced by foreign trends. Concerned over the values purported by media such as the television and the Internet, these women were concerned for their

children, who they claimed were attracted to Western culture. A mother of a seventeen-year-old shared her fears with me:

> The foreign media exposure is so much these days. I don't know what this generation will do when they grow up. So when I heard of the Al-Huda course, I requested my daughter to take it so that she will know how to live her life, and will be able to recognize right from wrong. After that, I told her, I will have full confidence in you, so that no matter where you go, no matter what university you choose, where you choose to work, you can take care of yourself. You will know how to carry yourself, how to talk to others, and realize what the religious limitations are, which you cannot cross.

Upon my asking, I was given details of what these "limitations" were and why they were necessary. Many women informed me that these limitations would help their daughters judge what dress and what kind of behavior would be appropriate in different situations and would enable them to keep men at a distance. Doing so was essential, I was told, because unmarried boys and girls often developed feelings for each other and began relationships if allowed to mingle with each other, and nothing good could ever come of such situations. According to the hegemonic Pakistani discourse, a woman's body embodies both her and her family's honor, and that honor is linked to her sexual purity. Hence, women who are sexually active outside the bonds of marriage are labeled "bad," a phenomenon not unknown in the West.[3] Spending time with a person of the opposite sex increases the chances of such labeling, and when it does girls are said to bring dishonor on themselves and their families.[4] As such, these women

3. Although the patriarchal system that divides women into "good" and "bad" based on their sexual activity currently exists in a very diluted form in many subcultures in the West, and gives people the space to have premarital sex without condemning them, it does exist, as exemplified through epithets such as "slut" that sexually active women may be given. This language is in marked contrast to the labels sexually active men are given.

4. It is important to remind ourselves that although this is the dominant discourse, a range of attitudes exists in practice, from a girl bringing dishonor on herself and her family through merely being seen with a na mehram to girls and boys having the freedom to be friends and spend time together.

shared, they lose their respect and can no longer marry a decent man, the logic being that no decent man would want to marry a woman of bad character. Other common arguments given to prevent young women from establishing close relationships with young men are that men never respect women they have relationships with, and when the time comes for them to get married, they never marry their girlfriends but instead marry those "respectable" girls who have never been in such relationships. A mother's concern for her daughter's reputation and eligibility for marriage is very real given that they function within a society within which the ubiquitous patriarchal ideology divides women into "good" and "bad" in order to control their sexuality and maintain a patrilineal system (Saeed 2001). The West, representing complete sexual freedom, becomes very threatening in such a context and motivates these women to turn toward a system where desirable values and behavioral limits are clearly specified.

Maria, one of Amina Ellahi's students, elaborates on this point: "We see much imperialism today, in the form of multinational companies, through NGOs, and through the media. I don't need to tell you the kind of values *The Jerry Springer Show* is bringing into our drawing rooms. . . . By studying Islam, people are going back to their roots, their own values, and resisting this immoral flux from outside."

The young girls whose mothers had sent them to Al-Huda soon began noticing the "immoral flux from outside" in their lives themselves. Misbah, whose mother forced her to attend Al-Huda (and whose mother later regretted doing so because she went to what her mother called a religious extreme), talked about her early days there, capturing the disparity between foreign behaviors and Islamic values: "I quickly, within a few days, reached a stage where I felt I had to make a decision. I felt a contrast between what I was being taught and my life in the outside world. I was taking an aerobics class in those days, in the evenings, and the disparity between it and what I was learning was great. They would have Indian music on, we would all wear shorts and T-shirts . . . and I would be attending Al-Huda during the day. Both came to epitomize two different paths, and I had to make a decision."

One of the striking commonalities that come up in women's comments on the level of morality in their society is how the "foreign" is

largely held responsible for influencing their society negatively. The fact that many people making up their society had not been living according to their ideal values, and had in fact been disrupting the ideal long before the media ever brought foreign images into people's homes, did not form part of their social critique. However, Zahida, a young mother who ran a "mini" Al-Huda branch in her home, was one of the few women whose critique did not target just the West. "I was shocked when I first saw the reruns of our television programs from the 1960s and '70s. The women were going around in sleeveless tops! Fine, I have never had proper Qur'anic knowledge, but I do have a concept of what a woman should be like, how she should appear, how she must behave in public."

Zahida was reacting to a generation that grew up in an environment that was different from hers. It was an environment in which the religio-nationalist discourse, linking the creation of Pakistan to Islam, was not imposed by the state via the media or school textbooks the way it has been since the 1980s. It was an environment in which the religious groups espousing a rigid and andocentric version of Islam did not enjoy as much power over the larger society as they do today. Urban women of that generation had much more space to be mobile in public and had greater freedom to dress as they pleased without being publicly stigmatized.[5] Zahida, however, who grew up in the 1980s, has internalized both the religio-nationalist discourse and the concept of an ideal woman that was highlighted and actively reinforced in mainstream society in a variety of ways by the state under General Zia in that period.[6] Eighteen-year-old Fatima had also internalized these cultural codes, and the ones related to the conception of the country manifested themselves in a popular slogan she quoted: "Pakistan *ka matlab kya? La illaha illalah*" (What does

5. I give specific examples of many of the opportunities they had in the 1970s being revoked under Gen. Zia-ul-Haq in chapter 2.

6. I am not claiming that the state, in the 1980s, is solely responsible for these ideas. They already existed to some degree in the larger society. But generally speaking they were not as strongly prevalent in the middle and upper classes in the 1960s and 1970s as they are today. As such, it seems likely that the active imposition of a particular discourse in an institutionalized manner has contributed to this larger shift.

Pakistan mean? There is no God but God). "There is no God but God" is the first half of the Muslim declaration of faith. Hence, this slogan is directly linked to the Two-Nation Theory that forms the basis of the ideology surrounding Pakistan's creation. Fatima referred to this ideology as she continued: "That is what they teach us in school, isn't it? But where do we see this visible today? Our first generation made many sacrifices to give us our country, but the next generation did nothing. However, our generation has realized that we must make our society into the kind Pakistan was created for."

Fatima's and Zahida's views make it easier to understand why they, along with other women, find Islam an attractive solution to their problems, and why they consider it to be primary framework that ought to inform their lives. Islam, they claim, is not only the foundation of their country but also a complete code of life whose clear-cut directives of right and wrong are comforting to them as they live in a society that is undergoing a threatening sociocultural change (A. Ahmed 2002). Any faith system that takes the responsibility of laying out what is right and what is wrong is bound to have appeal for many individuals who live in a society that is in a state of flux and in which the concept of right and wrong often becomes fuzzy. Much has been written about how societies that are undergoing fast-paced changes, are in transition, or feel they are being attacked begin to increasingly rely on their cultural, ethnic, or religious identity (Davidman 1991; Tehranian 1993; Moghadam 1994; A. Ahmed 2002). Rapid social change challenges the boundaries of a community, and individuals become motivated to reorganize their society into a consistent, acceptable guiding framework (Ewing 1988). This phenomenon can be observed in people engaging in other faith traditions elsewhere in the world as well. Mass Christian revivalism in the United States, for instance, has been shown to occur during times of great social disruption (Moghadam 1994). Similarly, according to the author of *Islam in America*, it seems that some women are attracted to an ordered existence where everyone's rights and responsibilities are clearly laid out, and there is no confusion regarding what the correct beliefs and behaviors are (Malhotra 2002). Although women's turn toward religion cannot solely be explained through this theory, and negates the beauty they claim to find in Islam,

their concerns, heightened by Farhat Hashmi and their other teachers, make the solution Al-Huda offers all the more attractive.

Farhat Hashmi brings forth behavioral rules based on a strict sense of right and wrong through her exegetical commentary and gives her students very specific guidelines regarding what is acceptable and unacceptable behavior in "Islam." These guidelines deal with the concerns they already have and also make them aware of new things to be concerned about. Such an awareness, for instance, had led Zahida to look at and assess her surroundings in a new way and conclude that "our current way of living is Western. The way we build our houses, the kind of furniture we have in them, the sofa styles, the decor. . . . We used to have courtyards where everyone used to be together, but now we are all closed in our rooms. Today our living rooms have so many decoration pieces that cleaning them is one problem, and the fear that the children will break them is another. . . . Islam, on the other hand, teaches us simplicity, togetherness."

Farhat Hashmi makes her students aware of the "Western" values of materialism and individualism, speaks of how to do "proper" purdah in order to prevent chaos in society, highlights the sanctity of the family, gives suggestions regarding how to bring up children so that they know the limits of suitable behavior, and identifies the negative consequences of practices such as listening to music, watching films, and spending time with or having male friends. She presents them with a coherent and comprehensive moral behavioral framework. This framework first builds on and heightens their already existing anxiety by making them aware of all the "un-Islamic" aspects of their lives and lifestyles that they were not cognizant of, and then serves to reduce it by providing them with the concrete means to do so.

However, not all women are equally enamored of Farhat Hashmi's discourse or feel threatened by the changes occurring in society. Salma, who attended Zulaykha's *dars* regularly, shared her opinion and claimed that "I've listened to Farhat Hashmi on a number of occasions, but I don't agree with her on a number of points. They talk too much of sinning. It is something they are panicky about. But their way is a safe way for those who lack a strong internal sense of right and wrong. If you have a strong sense of what is right or wrong, you can be put in any situation, any

environment [manifesting undesirable values and behaviors], and not fear being corrupted."

My conversation with Salma revealed that she did not support Farhat Hashmi's emphasis on sexual segregation or people depriving themselves of activities such as listening to music or watching entertaining programs on television; neither did she feel threatened by the societal change that was a source of concern for many. Her views are an example of the diversity of opinions found regarding cultural trends in the larger society. Nevertheless, the desire to get away from a "world gone mad" is certainly one of the factors that facilitates their increased engagement with religion, making the entire experience all the more meaningful for them (Moghadam 1994, 19). This idea does not suggest, as Salma's opinion implies, that fear and insecurity are the sole basis of women's behavior, for such a judgment negates the other reasons women have for embracing the guidelines put forth by Al-Huda. Perceived as the Word of God, the women who adopt the commands on proper attire, behavior, and so forth often manifest their love for Allah and their desire to become pious individuals. But functioning from a particular location and having the concerns they do, concerns that are heightened at Al-Huda, do increase the significance of following the commands.

Cultural Production and Identity Formation

One of the reasons for Al-Huda's success is its ability to present its discourse as the "truth." This "true" Islam is believed to transcend all cultural influences, and, hence, those women subscribing to it or functioning from this position critique and negate all folk Islamic practices for being heavily influenced by culture. Farhat Hashmi and her students would no doubt also take issue with those scholars who illustrate that Islam was a product of its sociopolitical environment, largely developing over a period of centuries as it entered and interacted with neighboring geographical regions (for instance, see Watt 1968, 1998). Yet the religious texts, exegetical commentaries, and ideas that Farhat Hashmi uses to demonstrate that her version of Islam is the "true" Islam, and that it transcends all cultural influences, are themselves products of a particular historical moment(s). Hence, although heavily rooted in culture, they continue to propagate the

idea of a pure, culture-free Islam. This belief directly leads to their attack on folk Islamic practices. Furthermore, their concept of a "Muslim society," one that is informed by this culture-free Islam, leaves no space for indigenous cultural traditions and events, such as the kite-flying festival of *basant* ("Festivals Under Fire" 2004), or values and practices that are deemed a Western or Indian import. All these "un-Islamic" activities and events are deemed unacceptable, and Farhat Hashmi and her students do their best to eradicate them from society.[7]

Even if the women who engaged with Al-Huda had not felt strongly about the influx of particular values and the existence of "un-Islamic" behaviors in society when they first joined the school, Farhat Hashmi's frequent reference to them, along with the remarks of the other teachers, would have made them conscious of them. She strives to enhance her students' awareness of these influences, as is seen in her elaboration of various verses in the fourteenth *siparah* of the Qur'an:

> The devil has said that I will influence your people so that they will try to alter the natural state of things. . . . [In the West] men are undergoing operations so that they can become women, and women are trying to become men. . . . They are involved in homosexuality and don't consider it anything to be ashamed of. They are propagating obscenity in the name of art, vulgarism in the name of fashion. . . . We have made the West our *ka'aba*,[8] and they, in turn, have confused us about what is right. So what do we do today? We celebrate our everyday happinesses, not in a Muslim way but in the way of others, by dancing and singing. We

7. The possibility and desirability of subscribing to "pure" Islamic values, devoid of cultural influences, are found among Muslims elsewhere in the world as well. A study done on American Muslim converts, for instance, tells us that these Muslims claim that because they are living in a non-Muslim majority country, it is easier for them to distinguish between religion and culture. This ability results in their following, as they put it, a "purer" Islam. This argument is, once again, based on the assumption that this pure Islam has not been shaped by culture at all. Examples of these Islamic practices, which in turn are creating a culture, are, in the words of a woman, "no shoes in the house, the manner of washing after using the toilet, answering the phone *asalamo'alaikum*" (Anway 1996, 127).

8. Muslims pray in the direction of the *ka'aba* in Mecca.

no longer feel bad interacting with men in mixed gatherings, or doing fashion . . . and celebrating *basant,* the function of *mehndi*[9] and *barat*[10] at weddings . . . [T]hese are not our customs.

When Farhat Hashmi uses the term "Muslim way," she first tells her students that there is only one way to be a Muslim and then elaborates on what activities a good Muslim must not engage in. *Basant* is a very old festival that marks the advent of spring. Indigenous to the province of Punjab, this festival is celebrated by people belonging to all the religious traditions in the region, who usually dress up in yellow clothing and gather on their rooftops to fly kites with their family and friends and engage in kite-flying competitions with groups gathered on neighboring rooftops. This event is often accompanied by music and dancing. Viewed by women at Al-Huda as a "cultural" event that promotes indecency and obscenity through the activities mentioned above, and erroneously linked with Hinduism, this festival is disowned as both un-Islamic and, ironically, foreign.[11] Farhat Hashmi clearly claims in the quote above that such customs are not "our customs" and inadvertently indicates that being Muslim, in a particular way, is her primary identity, one that leaves no space for other competing identities, be they region based or ethnicity based.

Perhaps one of the main reasons that Al-Huda students, upon urging, are able to disown old cultural practices and celebrations like *basant* and *mehndis* is because Al-Huda's discourse of these events is building on certain cultural codes these women already possess. In this case, these cultural codes exist in the form of the history lessons these women grew up hearing. Those individuals writing Pakistani textbooks under state

9. The henna ceremony making up the first day of the three-day Pakistani marriage.

10. The *barat* refers to the second day of the marriage ceremony, when the groom and his family come to the bride's home (or these days to a hotel or marriage hall). The *nikah* (Islamic marriage contract) usually takes place at this time, after which the bride leaves with the groom (and his family).

11. This connection exists simply because those individuals that practiced this event three thousand years ago—in other words, the ancestors of most Pakistanis in this region—were Hindus. The event is currently practiced by people of all religions in Punjab (in both India and Pakistan).

instruction (Aziz 1993) denote "their" history to have begun in 712 CE with Muhammad Bin Qasim, the first Muslim who came to the Indian subcontinent as a conqueror. People talk of that event as if it is when they first came into existence on the Indian subcontinent. However, as scholar Kamran Ahmad (2005) points out, "the notion of 'when we came to the subcontinent' or 'when we ruled the subcontinent' is almost as absurd as the Pakistani Christians referring to the British rule as a time when they ruled India. Although the descendants of a few Pakistanis today may have come with an army, the fact is that most of the people of Pakistan are descendants of the people who were already living on the subcontinent and only converted to Islam at some point in history. Moreover, these converted Indian Muslims were not considered part of the ruling class by the Arab, Persian, or Afghan rulers of the subcontinent."

Nevertheless, Al-Huda is building on these earlier lessons and glorifying the land's Muslim past, disowning the centuries-old civilization of which Pakistan is a part and of which remnants still exist today. At the same time, it is attempting to replicate many Middle Eastern countries that are generally believed to occupy the top slot in the hierarchy of "real Muslims." "Social hierarchy underscores the Arabia-centeredness of Islamic identity," and Muslims in the Middle East occupy a high position because of their proximity to Saudi Arabia, their earlier conversion to Islam, and their fluency in Arabic (Cooke 2002, 149). Because Arabic is the language the Qur'an was revealed in, it becomes infused with a sacredness, a sense of originality, and therefore an elitist sense of being above all other languages. It was during a Tehrik-i-Islam *dars* that a young woman asked the *dars* teacher, Nadira, whether she could learn *du'as* in Urdu, a language she spoke, instead of Arabic, a language she, like most Pakistanis, was unfamiliar with. Nadira replied that Allah knows all languages, but if one makes an effort and learns the *du'as* in Arabic, one will get greater rewards for it. Likewise, a young Pakistani woman who had lived in Switzerland her whole life but had moved to Islamabad after marrying into a family settled there shared her frustration on hearing her *dars* teacher tell her that she should not read the Qur'an in French but in Arabic.

Farhat Hashmi functions from this position as she critiques old cultural practices as well as more contemporary values and behaviors for which the

West and India are blamed and proposes the construction of a particular kind of culture in one of her classes at Al-Huda:

> Our children are not familiar with our history, our heroes—they don't even know their names—but you can ask them anything about Indian heroes. If you look at our newspapers, you'll see that along with Pakistani actors, there is also information on Indian stars, their personal lives, their scandals. This is undermining the whole notion of Pakistan, which was created for Islam, whose creation was based on the Two-Nation theory. . . . You look at Indian films, and you see saris with short blouses that are sleeveless or have short sleeves. We haven't had a trend of short sleeves for a while, but it is here again. Whose culture are we following? Whose culture are we attracted to at the cost of our own culture? These are all attempts to make us lose our way from the path Allah laid down for us.

When Farhat Hashmi uses the term "our culture," she is referring to her vision of Pakistani society as a Muslim society that is informed, or should be informed, by the Islam that she upholds as the truth. By propagating certain values and behaviors within this Islamic framework, she and her students are actively engaged in cultural production.

The changes that take place as a result of this cultural production are visible on a number of different levels. They are visible in women's changed attire, as they begin wearing *hijabs* and *abayas* in public. This style of dress is a form of purdah that is not indigenous to Pakistan but is an Arab import, yet shops have now begun selling ready-made *abayas* along with the more traditional chadors. Other examples of the production of cultural material include different kinds of decorative pieces that now occupy space in women's homes. Their ideological change at Al-Huda is clearly manifested in the way they have replaced the crystal figures and paintings depicting animal and human figures in their living rooms with landscapes and framed Qur'anic verses showing different calligraphic styles.

Ideological alterations are manifest not only in material changes but also in behavior, which also alters a culture. Many women, for instance, have stopped dancing at weddings. Teachers at Al-Huda liken the act of

dancing to prostitution[12] and critique the way a woman's body becomes prominent and the focus of attention in the process. But weddings have always provided women with a culturally appropriate place to dance, and giving it up was not easy for all of them, as Maria, one of Amina's students, shared: "The battle has been with myself. I used to be the first to get up at a *mehndi* and dance. I was that sort of a person. Leaving it, oh, it was so difficult, especially initially. Very, very difficult. I danced my heart out at my brother's wedding. This was before. . . . But my covering has helped. Because with the *hijab* you do look like an idiot if you do get up to dance, and nobody expects you to anymore."

Other changes in women's everyday lives were visible in the way many of them stopped watching films and television programs in order to protect themselves from the subject matter shown in these media. Listening to music was given up, as was attending functions and events like *chalisva* and *mehndis*. Misbah spoke of some such changes she went through as she took the Al-Huda course:

I used to love listening to music, so much so that when our driver used to turn down the volume of the songs playing in the car so he could concentrate on the traffic, I used to fight with him. But the Qur'an and music can't go together; the essence of both is different. If I know something is in the Qur'an, and proven by the Sunnah, there is no question of not to try and follow it. As far as *chalisva* and *mehndis* are concerned, all these activities are *biddat*, things the Prophet never did. No one did the *chalisva* for him when he died. If we look at the Prophet's companions, *Hazrat* [a term denoting respect] Umar did not do a *chalisva* for *Hazrat* Abu Bakr. . . . I no longer attend them. I only visit the bereaved family the first three days, the amount of time given for bereavement according to the Sunnah, but no more than that. . . . There was a big argument in my house over doing my *mehndi*. I told them I did not want to do it; it's not the Islamic way. . . . Even if I go for a simple *mehndi* for women

12. See Saeed 2001 for a detailed analysis of the association that dancing and singing have had with prostitution in South Asia.

only, how can I control the songs the girls will sing, their content? . . . I got engaged recently, and not a single picture was taken. My future mother-in-law is also an Al-Huda graduate, and she and her whole family are supporting me in my decisions, while my family is not. Some of the battles I have fought have been over the kind of clothes I will wear at my wedding. Cloth is so expensive these days that I did not want to wear a *lehnga*,[13] which needs a lot of cloth and work. Knowing my lifestyle now, I also know that I will not wear it ever again. So I will be wearing a *shalwar kamiz* without any embroidery for my wedding. . . . Birthdays are an issue that also come up. The Prophet never celebrated his birthday. For me, birthdays are occasions that tell me that I am a year closer to my death, to *akhrat*, for which we have to prepare. So how can I celebrate? What am I celebrating? Being a year closer to death? I no longer go to birthday parties, or wish my friends a happy birthday on the phone. And of course I do not celebrate my own. Neither do I wish my family members. It all seems so frivolous. Sometimes things become a bit tricky. For instance, my brother-in-law's birthday is on the twenty-fourth, and he is arriving here from Karachi that day. I will do my best to avoid wishing him [a happy birthday], but I may not be able to help it if an awkward situation arises. So small things like this crop up on a daily basis.

Women's stories clearly show their commitment toward ridding their lives of behaviors that they no longer consider acceptable. The condemnation of various cultural practices and "foreign" influences in society occurs within the larger framework of religion, and it is within this framework that women change their behaviors and lifestyle and engage in cultural production of their own.

Farhat Hashmi's denouncement of various cultural practices and disapproval of Westerners and Indians helps women redefine their own identity as Muslims. Stuart Hall explains that "identities are constructed through, not outside, difference. . . . [I]t is only through the relation to the Other,

13. The wedding dress traditionally worn by brides in the urban areas of Pakistan, consisting of a long top worn over a full-length skirtlike garment, accompanied by a large *dopatta*. Traditionally red or maroon in color, all three garments are full of rich embroidery.

the relation to what it is not, that the 'positive' meaning of any term—and thus its 'identity'—can be constructed" (1996, 4). In other words, identities form through "the emergence of difference [that] takes place through a complex interplay between the development of self-identity in opposition to an internally produced, and yet externally located, Other" (Dear et al. 1997, 461). Although identity construction is not limited to this process of "Othering" (Alcoff 2006), it is a process that the teachers at Al-Huda constantly engage in, as in the following elaboration of how there is no forgiveness for *shirk*, the practice of ascribing partners to Allah, in Islam:

> Hindus worship idols, and some groups even worship the devil. There is a satanic cult in America. They have an upside-down cross in their church, and they kidnap children and sacrifice them on it. . . . And even though it has not been confirmed, it is heard that Michael Jackson, Madonna, these people have evil powers. . . . They are the devil's disciples. . . . And their songs are satanic verses. Those who listen to these songs become involved in all the bad things mentioned in the songs. And there is a devilish atmosphere in their concerts, there is so much heat, and it promotes all kinds of evil activities.

This teacher at Al-Huda depicts Hindus and Westerners as Others by referring to them as idolaters and affiliating them with the devil. Similar instances of Othering are also widespread in the school.

Repeatedly being set up against a cultural or religious Other is likely to have an impact on women's self-construction as a Muslim, and especially as a particular kind of Muslim. Interestingly enough, however, although reference to the West is always made through examples such as the preceding quote, the fact that many of the students making up the classes at Al-Huda or the *dars* offered by their graduates are individuals who have traveled abroad has, upon occasion, led them to challenge their teachers. A case in point is the following excerpt from a discussion on cleanliness at Al-Huda. While discussing how cleanliness is a significant aspect of Islam and how the Prophet Muhammad once remarked that it is half the faith, the group leader of one of the smaller groups asserted, "Nonbelievers are dirty. . . . They aren't involved in cleanliness." One of the young girls in

that group immediately responded, "but people in the U.S., not so much the U.K., are very clean. They take a shower once a day." A bit taken aback, the group leader recovered quickly and responded, "Yes, but their cleanliness is not prescribed in their religion, like it is in ours." Although the class moved on to discussing other things, this exchange, and others like it, do suggest that how much exposure or what kind of exposure an individual has of another culture may have an impact on the extent to which she will accept this discourse of the Other. Some women who had traveled to the United States and England praised the citizens of these countries for being well mannered and commended them on their honesty, their friendliness, and their hard work in their respective fields. They followed their praise by commenting that the Americans and British were more Muslim than Muslims in their manners, in their commitment toward their work, and in their charity. It was unfortunate, they continued, that their good deeds would not be counted, as they did not do them with the intention of pleasing Allah. The most disturbing part of this assertion for me was the confidence with which they made it. Any doubts they had about this belief, I found out, existed before they came to Al-Huda, and it is through this comment that we see persons in "the West" placed in the category of "Others" yet again.

The process of seeing Hindus as Others is much older and forms the basis of the Two-Nation Theory surrounding Pakistan's creation. It is within this historical context that the opening up of the Pakistan-India border and the movement of people across it has become a source of concern for some women. As a former Al-Huda graduate exclaimed disgustedly, "Friendship doesn't mean that you get into each other's cultures. I was watching Geo [a private Pakistani television channel] yesterday, and they were wishing people a happy *holi*[14] on it. . . . I went to the Fatima Jinnah Park for my walk yesterday and saw a group of girls giggling and putting *bindis* [ornamental dots commonly worn by Hindu women] on their foreheads."

14. An indigenous festival of the Indian subcontinent that was later made a part of Hindu mythology, *holi* has taken on the connotations of being a Hindu event. It is celebrated by Pakistani Hindus, who probably appreciated its being marked, for the first time, on Pakistani television.

The Muslim fear of losing their identity by adopting Hindu customs and markers of identity is an old one, and Kamran Ahmad expands on it, referring to prepartition India. According to him, "Insecurity in minority groups, to some extents, is not uncommon. What made the Muslim situation in India much worse was that the Muslims had to survive in a predominantly Brahmanic, Vedic environment. . . . It is hard to find a more assimilative religious tradition in the world than Brahmanism that used various mechanisms to bring everything around it into its hierarchical fold" (2005, 7). It was in reaction to this fear of assimilation, he asserts, that the desire to hold on to a "true" religion arose at that historical moment. In a similar manner, women's stories today reveal their fears of Hindu traditions becoming a part of their society and losing the values and traditions that form a part of their identity as Muslims. Edward Said brings up the role of being threatened in his discourse of identity formation when he says that identities are constructed "out of a dialectic of self and other, the subject 'I' who is native, authentic, at home, and the object 'it' or 'you,' who is foreign, perhaps threatening, different, out there" (cited in Ashcroft and Ahluwalia 2001, 112–13). Although skeptical that these boundaries are the limits within which identity construction can occur, I do suggest that the presence of a threatening Other is one of the factors that facilitates Al-Huda students to redefine and strengthen their Muslim identity. It adds to the process they are already undergoing as they journey toward becoming pious individuals through their increasing engagement with and adoption of Islam via Al-Huda.

Although the Hindus and the West are the most common Others that teachers use, Christians, as happens less frequently, and Jews, as happens more frequently, are also occasionally portrayed as cultural and religious Others. Despite being respected as "People of the Book," their example is frequently given to illustrate how their religion is imperfect and, subsequently, how Islam is perfect by comparison. A frequently cited example is that Christians have a twenty-four-hour fast, and the very difficulty of keeping it has made many people turn away from Christianity. Islam, on the other hand, is all about maintaining a balance, they argue, and, hence, the fast is from sunrise to sunset.

Examples are also brought forth to illustrate how the Jews have and are continuing to play a role in the decline of Muslim morality. As an Al-Huda

graduate running a *dars* in her neighborhood once passionately exclaimed, "In whose hands is the media? The Jews. And if not the Jews, then those so-called Muslims who have nothing Muslim-like in them. Even today the Jews have the same plan, that obscenity be made so common that no person can escape it . . . even though they keep their children away from it. . . . They continue to work against Islam the way they did fourteen hundred years ago."

The Western media was also something that the women I spent time with unanimously condemned. As Natasha explained, "I think it's becoming extremely tough to follow and practice Islam because you're being constantly labeled as a terrorist, as the fundamentalist, as the people who are troublemakers. Any man with a beard, and any woman with a *hijab*, trouble!" Natasha's quote illustrates how she and others like her are reacting to the manner in which Muslims are being perceived and portrayed by the West. Akbar Ahmed argues, "Nothing in history has threatened Muslims like the Western media. . . . [It is] ever present and ubiquitous; never resting and never allowing respite" (2002, 223). Islam is marginalized and degraded, and stereotypes are projected, both of Muslims and of Islam (Said 1981; A. Ahmed 2002). Some women have responded to this ongoing negative portrayal in very concrete ways.

I visited the Islamic grammar school in Islamabad during my fieldwork in 2004. Opened soon after September 11, 2001, the primary aim of this school was to impart children with education according to "Islamic" guidelines. I interviewed the principal of this school, and she shared that her desire to open such an institute stemmed out of her reaction to the way Muslims have always been portrayed in Western institutions and books—for instance, as uncivilized barbarians in the Crusades. She was also very concerned about the anti-Islam discourse that had again become very active in the West and was reaching children via the media after September 11. Akbar Ahmed argues that September 11, 2001, was the day "the Grand Narrative [of Islam], which was assumed dead, if not buried, was back with a vengeance especially in the United States. God, Christianity and talk of the Crusades were back at centre stage" (2002, x). Agreeing with this opinion, the principal of the Islamic grammar school explained that her institution was an attempt to counter this discourse at a local

level by teaching children how remarkable Islam really is, presenting their "true" history, highlighting the contributions made by Muslim scientists, and teaching secular subjects based on Islamic guidelines so that, for instance, the theory of evolution, considered un-Islamic by mainstream religious scholars in Pakistan, is not taught in social studies.

Hence, women's heightened awareness and concerns regarding the inappropriateness of local and global cultural forms, and the manner in which they are consistently set up against cultural or religious Others, serve to add to the process whereby they redefine and strengthen their Muslim identities. The larger global arena where they are constantly persecuted and attacked further adds to this process.

Muslims under Attack

"Allah, Muslims are dying in Chechnya, Bosnia, Iraq, Kashmir. . . . Allah, help them. Allah, unite the Muslims in the world, unite their hearts, and make them a force to be reckoned with like you made them once before. . . . Allah, give the West wisdom, and if they don't take it make them suffer. . . . Allah, correct the way of the Muslims. They have strayed; show them the straight path." So went Fehmida's *du'a* in Zulaykha's *dars*, reflecting the sentiments of a large number of women, irrespective of their intrareligious affiliations. The attacks in Afghanistan and Iraq affected them deeply; Muslim civilians were dying, and sacred Muslim places were being bombed.

The lack of unity among Muslims in taking on the West to stop them from attacking was a sentiment many women shared. Some looked at what was happening and began thinking about why it was happening to Muslims. What were they doing wrong to deserve it, and how would they know what was wrong unless they knew what was right? Going to Al-Huda became one way for some of them to find out how they were supposed to live their lives and to understand why Muslims were undergoing such a fate. Others began wondering if there was any truth to the accusations made by the West. What *did* the Qur'an say about jihad? Was there something about Islam that led to the terrorist attacks on September 11, 2001? Hence, some women who joined the institute were motivated to overcome their lack of scriptural knowledge in order to find the answers to such questions. Others

confessed to feeling a heightened Muslim consciousness as a result of what was happening to Muslims all around the world. Eighteen-year-old Asma stated, "You don't really think about being a Muslim as you live your daily life, you know. You just live it. I keep thinking about how our patriotism is at its height during cricket matches with India. I guess these parts of ourselves come out the most during competitive situations, or perhaps in wars. . . . All of this has made me realize that I too am a Muslim, yet I don't know what that means. A friend of mine who lives in the States e-mailed me after 9/11 to ask me a question about Islam, and I was totally clueless."

For many women, some or all of the factors mentioned above motivated them to learn more about Islam. Al-Huda, resonating as it did with their particular socioeconomic class, became a feasible place to go to do so. I was a bit surprised to realize the extent to which most women who did bring up the current global situation did so with reference to their selves, their lack of knowledge, and their reaping what they had sown. Their self-reflection and self-critique heightened their desire to study Islam and follow Islamic prescriptions and were often accompanied by a longing for the past when they claimed Muslims had ruled much of the world. As Nadira elaborated in the course of her exegetical commentary in her Tehrik-i-Islam *dars:*

Muslims ruled for a thousand years after Islam came, i.e., Muslims opened the doors of development for the rest of the world. And today developed countries call people who follow Islam terrorists, and Muslims have become afraid of being attacked by America. We are intimidated by them. . . . So Allah, in this verse, told Muhammad, and is trying to tell us not to be taken in by other people. Don't think that they have everything and that you are weak. Who does a Muslim rely upon? Upon Allah. . . . Allah says be frightened of me, not them. But we have stopped doing that; we are afraid of them, afraid that we will get sanctions, investors will stop coming here. Are we of those people who had their backs burnt but refused to let go of Allah and His messenger?

However, a longing for the past, a self-reflexive and self-critical attitude, and a desire to join forces with other Muslims did not prevent many women from feeling and expressing anger toward the West, most particularly the United States. Maria refers to the time when the Muslims were

conquering different lands and states that "no destructive weapons were ever used while the Muslims were in charge. Innocent women and children were never killed. Look at the number of innocents killed in Iraq, people who were unaware of the politics between Saddam and America. . . . The Americans, people who work in the United Nations, different NGOs, all claim that we want to help people. Then they start killing thousands of them. The hypocrisy of the West is apparent now."

Although Edward Said's book *Covering Islam* (1981) was written nearly thirty years ago, it is as applicable today as it was then. A critique of the popular media's propensity to portray Islam in an unfavorable way by keeping the limelight on a few Muslims and a rigid form of Islam, it was a critique that the women I spent time with shared in equal measure. A few young girls claimed that being exposed to such negative takes on Islam and Muslims through the media, and listening to President Bush's speeches, had strengthened their faith and made them stronger from inside. Another of their classmates, with whom I was in touch for a while after finishing my fieldwork, contacted me via e-mail after President Bush was reelected in 2004. She sent me her congratulations on his win, which she claimed was an indirect win for Islam. In her words, "The more Muslims he attacks, the more people, Muslims and non-Muslims, will turn towards Islam, and the more Islam will spread." Yet another eighteen-year-old Al-Huda student spoke earnestly on the same theme but in a much more nuanced manner, verbalizing what often gets left out of the "turning to religion as a reaction" theory: "When Islam is attacked, people may turn to it as a form of reaction. But as they begin to read the Qur'an, they will realize what a beautiful religion Islam really is."

Hence, whether women feel threatened by values and behaviors deemed foreign, are upset over the manner in which Muslims are represented in the media, or are self-reflective as they question why Muslims are being persecuted, the end result is more often than not the same: a more meaningful engagement with religion as it serves to lessen their anxieties by giving them a concrete code of conduct and as it answers the queries they have about the condition of Muslims around the globe. The meaning that women therefore find in religion once at Al-Huda, and the subsequent time they spend engaging with it within a particular framework, heightens

their consciousness of being a Muslim and serves to strengthen both a redefined Muslim identity as well as notions of a pure and authentic Muslim culture. It is as Al-Huda students begin changing themselves and others around them within the religious framework that they have adopted, which informs them what is and is not Islamic, that they actively engage in cultural production of their own. Influenced by notions of an Other, including both non-Muslims and Muslims upholding variant ideologies alike, they end up becoming the Other in mainstream urban society.

6 · The Stories Behind the Veil

ALWAYS CLOSED, Al-Huda's black iron gates have a sign stating "men are forbidden to enter the premises." A part of the gate opens up as a door, and women enter and leave by opening it when they need to. On an occasion when a man, such as a handyman or a guest speaker has to enter, the guard outside the gate calls the front desk to inform them that a male is about to enter the space. This call gives the *hijab-* and *abaya-*clad teachers enough time to hide their faces with their *niqabs* before the man enters. Their behavior begins to be emulated by an increasing number of their students over time.

No matter how difficult it may be to make generalizations about the women who take the one-year course at Al-Huda, the one thing that holds true for all of them is that they begin covering their heads, usually with a *hijab*, outside the school premises by the time they complete their course. Most of them also wear an *abaya*, and some also hide their faces with a *niqab*. This change in women's dress has played a significant role in transforming the very social landscape of Islamabad where not a single *hijab-*clad woman was visible twenty years ago. The *hijab* and *abaya* are forms of purdah that are not indigenous to South Asia. Women affiliated with the Jama'at-i-Islami, for instance, commonly wear a burka, an enveloping head-to-toe garment for women, usually with a mesh grid over the eyes. Wearing the chador is another common way of doing purdah. The *hijab*, however, as part of the uniform at Al-Huda, has been institutionalized. It is not only worn by hundreds of Al-Huda students and graduates but also worn by women who are influenced by the *da'wa* of Al-Huda graduates. Furthermore, I also suggest that it is through its being worn by so many Al-Huda students that it has become "naturalized" in society, so that women who may not be affiliated with

the school in any way may decide to adopt this form of veiling when they begin doing so.

This change in women's dress has also actively contributed to their being derided as fundamentalists and written off as religious extremists by many in society. Such labels are dangerous because they are dehumanizing. I attempt to move beyond such labels by presenting different women's stories of why they choose to veil, examining the multiple reasons they have for doing so, and looking at the extent to which adopting it is a part of their attempt to transform themselves into pious subjects. Understanding middle- and upper-class women's reasons for veiling is particularly interesting because many of them also used to put down women who veiled before they turned to Islam via Al-Huda.

Women's commitment to transforming themselves within an "Islamic" framework also sheds light on their agency as they adopt a form of dress that often leads to varying degrees of resistance from their families and the larger society. However, their commitment can be understood only by first becoming familiar with Al-Huda's Islamic discourse on veiling, the techniques the school uses to facilitate women's comfort and familiarity with it, and the reasons women give for adopting it.

Veiling: The Discourse and Techniques

Although one of the things the students appreciated most about Al-Huda was the fact that they were not forced to do purdah, the fact that the *hijab* has been institutionalized by becoming part of the uniform and is worn by students for at least seven hours every day, plays a significant role in increasing their comfort with it. Many students also made it a point to mention that the first time they read the verses related to purdah in the Qur'an was after more than half of the Qur'an had been read.[1] They claimed to have been ready to hear and follow the commands by that time. The authority of the commentary, supported by hadith literature, also plays a critical role in the entire process. An example of a hadith that Farhat Hashmi and subsequently her students commonly quote is said to

1. The verses referred to in this context are verse 31 of *Surah Nur* and verses 53 and 59 of *Surah Ahzab*.

be narrated by Ayesha, one of the Prophet Muhammad's wives. In this hadith, Ayesha refers to an occasion when her sister, Asma, came in front of her and the Prophet, wearing thin clothes. Ayesha is claimed to have later said, "The Apostle of God turned his attention from her [Asma] and said, 'O Asma, when a woman reaches the age of menstruation, it does not suit her that she displays parts of her body except this and this,' and he pointed to her face and hands."

Farhat Hashmi not only illustrates that Allah requires women to cover their heads through an analysis of the Arabic words used in the relevant Qur'anic verses or through supporting hadith literature but also reinforces her argument by responding to popular critiques of the practice. For instance, according to one such critique, the Qur'an never uses the word "hair" but only requires women to hide their *zinat*, or beauty. Farhat Hashmi responds to this assertion by claiming that women's hair is a sign of their beauty: "If hair was not a sign of beauty, poets would not mention it in their poetry, and women would not spend thousands getting their hair dressed" (Hashmi n.d.c).

Farhat Hashmi's exegetical commentary, considered a word of Allah, is very detailed. She lays down the importance of veiling, elaborates on what kind should be done in front of whom, and expands on how "there are no accepted patterns for interactions between unrelated men and women" (Mernissi 2003, 489). The only accepted patterns for prolonged interaction take place in the context of meeting for purposes of education or illness, and that too only if there are no available alternatives. Sexual segregation is the ideal to work toward, even within one's extended family. When segregation is not possible, women are required to cover their entire bodies, except their eyes and hands, from all *na mehram*, that is, men they can potentially marry, which not only includes all unrelated men but also male cousins, their aunts' husbands, and so forth.[2]

Farhat Hashmi also increases the likelihood of women's adopting purdah by drawing on a number of cultural logics to highlight the wisdom of her interpretation of the verses. I will expand on these "logics" later on in the chapter, but, briefly, she illustrates how purdah prevents chaos

2. The list of potential marriage partners is laid out in *Surah Nisa*.

in society by keeping men from being sexually attracted to women other than their wives. Adultery, premarital sex, and sexual assault are some of the results of this attraction, she claims, and these evils can lead to others, such as the breakup of families, children being born out of wedlock, and abortions. Farhat Hashmi highlights women's responsibility for preventing this chaos (inadvertently heightening women's consciousness of themselves as sexualized beings)[3] through her commentary on purdah's importance at an individual and social level.

For instance, women are likened to pearls in Farhat Hashmi's exegetical commentary. As she puts it, "Does keeping a pearl within a cover or a diamond in a safe place decrease its value? It is when the woman's outer appearance is hidden from public display that her hidden qualities of intellect, wisdom, and knowledge shine through" (Hashmi n.d.c). Women's desire to change their attire and adopt purdah is not that surprising when this critique of their objectification as sexual objects is combined with their responsibility of preventing chaos in society within the context of the authority of the religious discourse they increasingly function within. They are, by the time the verses on purdah are revealed, aspiring to follow Allah's commands and changing themselves accordingly. Following Allah's commands was a goal that held increasing meaning for the women who attended Al-Huda and was intertwined with their desire to become good Muslims. A heightened awareness of how their lives did not reflect the "right path" as elaborated by this school created dissonance in them, and in most cases it was alleviated only when they changed their behavior so that it matched the desired ideal propagated by the school.

The pedagogical techniques employed by the teachers at Al-Huda further facilitated their transformation into pious individuals. I happened

3. Farhat Hashmi's exegetical commentary related to the body is likely to heighten women's consciousness of themselves and others as sexualized beings. For instance, highlighting some precautions women ought to take in their lives, she claims that "siblings above the age of ten, even same-sex siblings, must have separate beds, so that evil thoughts do not enter their minds . . . Avoid being naked, except when you wash yourself. . . . *Farishtay* [angels] leave you when you are naked, and Satan takes over. You can protect yourself by saying '*Bismillah*' [In the name of Allah] whenever you change clothes, take a shower. . . . The private parts of dead bodies must not be looked at" (Hashmi n.d.c).

to be at Al-Huda one day when a young student asked her teacher why they could not cover their heads with a *dopatta* at Al-Huda. The teacher responded by saying that technically it does not matter how you cover your head, but the difference lies in how what you cover yourself with makes you feel. She told the class to undo their *hijabs* and drape the cloth over their heads as they would a *dopatta* and to continue with their work. Ten minutes later she told them to go back to wearing a *hijab,* and then asked them if they felt any difference. The students' response—that they felt more active and alert wearing a *hijab* as compared to the *dopatta,* which kept slipping off and they kept having to adjust—made the teacher's point for her. Such a hands-on experience of the usefulness of the *hijab* was more effective than a three-hour lecture on it would have been.

In a similar manner, Zarina and Natasha spoke enthusiastically of an innovative way they made young girls feel comfortable with the idea of doing purdah in their English summer course at Al-Huda. They shared that the roots of a girl's reluctance to do purdah often lies in her fear of the unknown and in the idea that she will look bad doing it. So they brought in all of their brightly colored and patterned *hijabs* and *abayas,*[4] put up full-length mirrors in the hall in which they were conducting their course, and told the girls to experiment with them, to play with them, and see how they looked.

The desire to change oneself into a pious individual, the belief in the perfection of an "Islamic" way of life, the authority of the discourse, the reasons presented for it, along with such facilitating techniques—as well as the support and encouragement of fellow students and the pressure felt by those students whose classmates had "changed" while they had not—all combine to ensure that the adoption of veiling is the rule rather than the exception. The variation lies in what veiling means to women.

The Veil as a Sign

Veiling, or purdah, which literally means "curtain," has been the subject of much discourse all around the world. Some argue that it has placed

4. Zarina's inclination to wear *hijabs* in different colors and patterns made her the brunt of criticism by some Al-Huda teachers who believed that the colors brought atten-tion to her and, hence, defeated the whole purpose of doing purdah.

women in the center of the Orientalist discourse as desirable objects of the male (European) gaze (Yegenoglu 2003) and transformed women and men into sexualized beings (Mernissi 2003), as "all clothing is used to cover over desire—to repress it by putting it out of sight. But the covering also is always a reminder of what is covered, of the desire itself" (Eisenstein 2004, 170). Veiling is also an activity that has been closely linked to seclusion and oppression (Cooke 2002; Graham-Brown 2003; Eisenstein 2004). According to Leila Ahmed, the veil became linked to the oppression of Muslim women as a result of the development of the colonial narrative. Counternarratives by Muslims have thus used the veil to resist imperialism, whether colonial or postcolonial. Ahmed considers it ironic that "it is Western discourse that in the first place determined the new meanings of the veil and gave rise to its emergence as a symbol of resistance" (1992, 70).

A common pattern found in Muslim nation-states is how tradition—often created (Ahmed 1992)—is held on to and propagated as a means to resist colonialism. "Women's bodies symbolize the rejection of an alien culture by maintaining traditional customs" (Bodman 1998, 13; Stowasser 1994), and this tradition is then mapped onto their bodies, frequently in the form of a veil. Meyda Yegenoglu refers to the Algerian liberation struggle to illustrate this point, where "the affirmation of the veil in the anti-colonial struggle was a direct response to the colonial desire to unveil, reveal, and control the colonized country" (2003, 558). Mary Douglas asserts that whenever a group feels threatened, the body is used symbolically to define its boundaries (1966). As such, the veil has served a crucial role as a marker of Muslim identity and has been frequently donned by women to resist colonists (Cooper 1998). A change in one's style of dressing is also a phenomenon observed among individuals as they engage in religious revivalist movements (El Guindi 2003), and it has also been used as a symbol to show resistance to authoritarian regimes, as was seen in Iran during the revolution of 1979 (Cooke 2001). "In countries where the veil is not mandated, many women choose it . . . as a reaction to the failed bourgeois nationalist program of the post-independence era" (Majid 2002, 72), thus expressing dissatisfaction with a secular system in this situation

(M. Ahmad 1991).[5] The veil in these contexts "become[s] the embodiment of their will to act, their agency," as they function from within their own localized positions, employing particular discursive configurations that are at once both resistant and compliant (Yegenoglu 2003, 558).

Making an effort "to comprehend their motivations, rather than label them limited in their vision," ethnographic studies over the past couple of decades have shown that women all over the world are using the veil in a variety of ways (Gold 2000, 207; Eisenstein 2004). A close look at the sociohistorical context in which veiling occurs is essential to bring out the multiple meanings veiling has for the women who adopt it (Mohanty 1991). It is often used as a marker of status (Kandiyoti 1988; Wadley 1994; Graham-Brown 2003; Mernissi 2003) and as a ticket to increased participation in the public sphere (Hoodfar 1997; Charrad 1998; Bullock 2002; Cooke 2002). "Women may think of purdah . . . as a cover behind which they gain the freedom to follow their own lights, rather than as a form of bondage or subordination" (Raheja and Gold 1994, 167), and as such, it is often perceived as an "emblem of their political, economic, and cultural emancipation and as a means of asserting their multifaceted identities" (R. Hasan 1999, 274). It is also a measure of their morality and religiosity (Cooke 2002) and a manifestation of their Muslim identity. As such, to dress a particular way can be likened to performing an identity situated in a particular religious background or class (Lewis 2003). Some women who veil believe that it protects them against harassment (Woodhull 2003; Eisenstein 2004), and for others it becomes a way to hold on to "traditional" values when migrating to urban areas or whenever those values are believed to be under attack (MacLeod 1991; L. Ahmed 1992; El-Solh and Mabro 1994; Anway 1996). It also proves to be a means of not standing out among other veiled women (Jansen 1998). For some it is a fashion statement, and for some it is forced oppression (Eisenstein 2004). Clearly, it is no longer just a religious symbol, a point that some women feel very strongly about (Charrad 1998). It "imprisons and liberates. . . . [T]he veil is

5. The dissatisfaction with a secular system is not based on its being secular per se but on its failure to meet their needs, be they social or economic.

an item of clothing that each woman daily chooses, or is forced to choose, in awareness of the symbolic baggage it carries" and marks her body and herself in a particular manner (Cooke 2002, 154).

Hence, to simply infuse the veil with any one meaning denies the multiple meanings it may have for different women. Critiquing white mainstream feminists in the United States and their propensity to assume universal reasons—such as the gendered division of labor—for women's subordination, Chandra Mohanty (1991) argues that it is important not to automatically give values to phenomena but to look at the values given to them by the people. In a similar manner, veiling too is a phenomenon, and the veil is an object that is host to a variety of meanings. Women's stories of why they veil reveal the fallacy of the assumption that veiling can be solely explained through a simple theory of oppression, resistance, or even liberation, for the veil means a number of things to different women. The value a veil has for a woman is linked to her reasons for adopting it.

As a recent and very visible trend, veiling has been the subject of much public discourse. It is discussed on television programs, as well as in newspaper and magazine articles.[6] Yet a small number of the women I interviewed thought that the attention paid to their veiling was pointless and exaggerated. Sammiya, a young computer programmer who worked at Al-Huda, explained why she thought the attention given to veiling was overrated:

> Changing things on the outside is very easy. Leaving music, films, doing purdah, all this is easy once you come into this line. The challenge lies in maintaining your faith, maintaining both a love and fear of Allah, keeping your intentions pure, doing things for Allah's happiness, and thinking about why you're doing the religious things you're doing daily. Is it for Allah or is it to come across as a good person to others? There is a very frightening hadith that the first people to enter hell will include

6. For instance, an edition of the popular women's magazine *She* published an article (Alee-Adnan 2004) in which U.S.-based Pakistani Islamic scholar Riffat Hasan's views on purdah were placed in opposition to Farhat Hashmi's while I was doing my fieldwork. This article became the subject of some debate in a few *dars* I attended.

that person who gave his life in the name of Islam in order to appear brave to others; it will be that person who gained knowledge in order to be called an *'alim* [religious scholar]. . . . You may spend your whole life following Islamic acts, but if the intention behind those acts is not right, you have not gained anything. . . . Visible changes take minutes. But changing basic traits, being tolerant towards others, forgiving others, becoming selfless, making religion a priority, making Allah happy a priority, making a right decision at the right time and having the wisdom to know what that right decision is, maintaining a balance between your worldly responsibilities and your religious duties . . . this is where the daily challenge lies, and these are the monumental things. Looking back, things like doing purdah seem very easy.

Unlike Sammiya, however, most of the middle- and upper-class women with whom I conversed were quite proud of their adoption of the veil and spent a significant part of our time together talking about the process they went through that finally led to this change in their lives. For some women, adopting it was simply a matter of reading the relevant Qur'anic verses (and hearing their commentary) for the first time, and realizing that the issue was actually mentioned in the Qur'an. Veiling, therefore, became a manifestation of their faith and helped them take another step forward in their journey toward becoming pious individuals. It became a means of showing their love for Allah and being rewarded in the afterlife. This reason was illustrated in the comments of Mehreen—an Al-Huda student—as she told me that she thought she could not do it initially: "I kept thinking, what would people say? But in the end, it was down to whether I should keep Allah higher or people. You think, do I want to look beautiful to Allah, or to people. And then I thought fine, if people are going to talk, let them talk. I have to do what I have to do. Social approval no longer remains important." Once she realized this, she shared, adopting it became easy. Mehreen now wears the *hijab*, *abaya*, and niqab.

For another small group of women I interviewed, the reasons given for veiling were purely sociocultural. Tahira, whose sister is an Al-Huda graduate and whose *dars* she attends off and on, explained that her reasons for initially covering her head were not related to religion at all:

I began covering myself after my divorce. At first I just used to cover my head with a *dopatta*. I would be depressed, not take care of myself so much, not brush my hair, and when people used to come to visit me, I would hide my hair with a *dopatta*. Slowly that became a habit. It also comforted me whenever I used to go out, especially at work. I would feel that a *dopatta* was a signal to men that now that I am divorced I am not available to them. I felt protected. I also began wearing the gown. It allowed me freedom of movement. My work also involves making films, and I would have a hard time keeping my *dopatta* on my head, and maintaining modesty while bent over a video camera. A gown was a solution to that problem and allowed me flexibility of movement without having to worry about whether or not I am properly covered, and whether or not men are staring at me. And then when I later started learning about what the Qur'an says, I thought that I am also fulfilling a duty.

Tahira's reasons for initially veiling were more sociocultural than not, whereas Mehreen's were more heavily influenced by her faith. For most women, however, it was a matter of their faith in combination with other reasons, such as becoming impressed with and idealizing particular women who veiled, a change in their perception of their bodies, or in the case of some young women finding "romantic" the idea that only their husbands could see their beauty. Maria's reasons for wearing the *hijab*, for instance, were along these lines: "When I read the verses, I immediately realized that it was something I needed to do. I realized that something about my looks, my body, my hair, was very precious, to be shared only with my family, my husband. You feel very special. . . . Something as measly as your hair! So that helped me make the decision."

Despite women's belief in the necessity of veiling, the amount of time it took for them to adopt it varied. One of the patterns that came up in this regard was that all the women who took the diploma course at the main Al-Huda branch began wearing the *hijab* outside the school premises sometime during their one year there. In contrast, the women who attended the *dars* offered by Al-Huda graduates on a weekly basis showed more diversity. Their interaction with the religious discourse was not as intense as it was for their counterparts taking the one-year course, and

their reasons for being there also varied.[7] Even those women who did come to believe that veiling in a particular manner was a duty a Muslim woman had to fulfill often took much longer to adopt this change in their lives than those students taking the diploma course.

Another pattern that came up was that covering one's head or wearing an *abaya* was relatively easy for those women who already veiled in some manner, either in the way Al-Huda prescribed it, that is, veiling in front of *na mehram* regardless of the location, or in the traditional sense, that is, just in public. Most of these women belonged to the lower middle class and came from families that were affiliated with some religious group or believed that veiling was a necessary part of appearing modest and being protected from the male gaze or both. In contrast, covering one's head, or wearing an *abaya,* was a significant issue for many women belonging to the middle and upper classes, most of whom had never done it and used to think that it was not important. This group includes the women who attended *dars* offered by Al-Huda graduates, as well as the ones who took the diploma course at the main branch. They believed their *shalwar kamiz* to be modest enough. Many used to associate veiling with being backward, considered it unappealing, and wondered how women who did veil did so. Although their views regarding what modesty meant underwent a change and they began believing in the necessity of veiling, some women had still not been able to make it a part of their lives at the time I met them. Ayesha, a young medical student who attended a *dars* offered by an Al-Huda graduate, confessed:

> I think the biggest challenge for me right now is covering my head. I know it's right, in my heart, I know it's what I have to do. I've started it. But if there is a big wedding or party, it's a big struggle within myself. I wear the chador, but a little bit of hair is showing here and there, and in my heart I know that it's not proper. It's very hard, you know. If I go to a gathering in a chador, all the females are dressed up, their hair all out, and you say, "Oh, I want to do that, I want to do that," but then

7. A comparison of the women attending Amina's and Hina's *dars* in chapter 4 illustrates this point perfectly.

you're like, no. It's a struggle; it's a fight with my *nafs*. . . . If you open up the Qur'an and read it, you'll know what's in there. You can read it in Japanese, in Spanish, in English, it says you have to cover your hair and your chest both. It's in black-and-white. People who are denying it are just fooling themselves.

Ayesha's comments illustrate that a woman's journey is just that, a journey, a process. Her comments are also a testimony of the effectiveness of the exegetical commentary employed by the women leading *dars* or teaching at Al-Huda.

The Ideology Beyond the Sign

Besides revealing the different reasons women may have for veiling and the confidence they have in its being an Islamic injunction, women's stories can also be used to give us insight into the ideologies prevalent in society, many of which are reinforced through Al-Huda's religious discourse surrounding the veil. Although the veil is often a manifestation of a desire to follow Allah's commands and can be perceived as a symbol of their being good Muslim women, it is also a symbol they use to present themselves as "respectable" and "moral" to others, and to feel protected in public. This point sheds light on a society that, like others, both in the East and in the West, equates a woman's dress with her character. Tahira, whose story we heard above, shared that one of the reasons for covering her head was that it "was a signal to men" that she was not "available to them." The veil becomes a symbol of morality in this context.[8] Regardless of whether Tahira believes in this dominant discourse, she works from within it in order to feel more comfortable working among men; she consciously chooses a form of dress that she knows is imbued with particular meanings within her society. The end result of women simply functioning from within a discourse or actively propagating it in public may differ in

8. It must be noted, however, that since any culture is made up of people subscribing to a variety of ideologies, not all the people around Tahira may perceive her veil as a symbol of her modesty. For instance, some people I spoke to, and who criticized the veil in general, shared that they had heard of veiled women engaging in prostitution. The veil allowed them to maintain anonymity in public.

the breadth of its impact, but at the most simplistic level, the nature of the impact will be the same, that is, the reinforcement and increased association between dress and morality in society.

Related to the notion of the veil as a sign of morality and unavailability to men is the idea of its preventing chaos in society. The majority of the women who spoke to me about the necessity of veiling mentioned this theory to me. In the words of Tania:

> Many researches have been done that prove that men feel sexually excited when they simply see women, while women need to be touched to feel that way. This is men's nature. It's like you see a chocolate and want to grab it. They can't control themselves, so we are therefore responsible. It is our duty, our responsibility, to protect ourselves, and if we are harassed, it is our fault. Therefore, the concept of purdah is essential; otherwise there will be *fitna* [chaos] in society, and I do not want to be held responsible for creating *fitna*. These are the paths to *zina* [sex], and purdah is one way that shuts that path.

Fatima Mernissi describes a common perception of female sexuality present in the Islamic discourse that Tania and others like her are subscribing to when she states that "the Muslim woman is endowed with a fatal attraction which erodes the male's will to resist her and reduces him to a passive acquiescent role. He has no choice; he can only give in to her attraction, hence her identification with *fitna*" (2003, 496). A story that reinforces this image of the helpless male facing the dangerous sexualized female, which was frequently quoted to me by Al-Huda graduates, and which Mernissi also mentions, tells of the Prophet's seeing an attractive woman and returning home to have intercourse with his wife Zaynab. He is then said to have left his house and said, "When the woman comes towards you, it is Satan who is approaching you. When one of you sees a woman and he feels attracted to her, he should hurry to his wife. With her, it would be the same as with the other one" (497). Linked to Satan in this particular saying, women are believed to have the potential to disrupt society in general. I mentioned some common examples Farhat Hashmi gives of this disruption earlier. These disturbances include the breakup of the family as a married man goes after a woman he finds

attractive and men and women engaging in premarital sex, something that is considered a problem in itself and also leads to a number of other predicaments.

Farhat Hashmi spends a significant amount of time elaborating on the negative impact that adultery or premarital sex will have on society. For instance, having children out of wedlock, she explains, will prove to be harmful for both the child, who will live with the stigma his or her entire life, and the mother, who will have no basis to demand financial support from the father of the child. Even if the issue of children does not arise, she continues, a woman suffers from having a relationship outside the bonds of marriage, for she does not get any of the rights she is entitled to as a wife and is instead reduced to nothing but a sexual object. Women, Farhat Hashmi claims, can prevent themselves from being put in this powerless position by veiling, which automatically creates a barrier between men and women, and in the words of Tania shuts down the path to *zina*. They will be the ones to suffer if they do not, she continues, as they will be the ones held accountable because it was something they could have prevented.

I found that women were willing to take on the responsibility of preventing *fitna*, not only because they were concerned for the general good of society but also because they believed it was personally beneficial to them. The benefits that they shared with me are the same that Farhat Hashmi speaks of while making her students conscious of their behavior:

> Today we go around showing shopkeepers what our size is. We go around in rags at home, in front of our husbands, but get all dressed up when going out, giving the shopkeepers a treat. You should dress up for your husbands and hide yourself outside. What happens if you don't do that? Your husband goes after other butterflies, and then you cry when he leaves you. If women begin doing purdah, they have secured their husbands, because then they won't look here and there, and won't do the *zina* of the eyes, which is also forbidden. The actual physical act is the extreme, but it all begins through seeing, the eyes. . . . When a man sees women in purdah outside, he will love his own wife who is all dressed up for him at home. Why would he pay attention to her if he sees more beautiful women than her outside? (Hashmi n.d.c)

The ideology behind the veil that puts the responsibility of preventing *fitna* on women also gives them the responsibility for controlling men's behavior. Once again, this ideology already exists in Pakistan, as it does in other parts of the world. The common rejoinder that a woman "asked for it" because she was dressed in a certain way is as commonly heard among sexual offenders in the United States as it is in Pakistan.[9] The existence of this cultural code in Pakistani culture, in all likelihood, is bound to facilitate women's acceptance of it when it is presented to them at Al-Huda, and it will be further reinforced as they actively propagate it among others.

The larger emphasis of the religious discourse on women's bodies is on maintaining order and stability in the public and private spheres. As such, the notion of the active female body that is feared within the context mentioned above is subjugated in another. Farhat Hashmi, expanding on women and the appropriateness of their seeking employment, once shared an example of a woman who had confided in her that her husband had raped her. She addressed the class, amused:

A husband and rape? This is the root cause of family problems. Men have a right, and when women resist them, there are problems. Not surprisingly, if a woman is employed, she will be tired when she comes home. But it's not all about what you want, but about what your husband wants and what God wills. Even if you are not in the mood . . . still do it. . . . God will be pleased, and you will be rewarded in this lifetime. . . . [Sharing a hadith from Sahih Bukhari]:[10] When a husband invites his

9. The roots of an ideology that categorizes women as respectable or disreputable based on their sexual activity and clothing are very old. In fact, according to an Assyrian law from the year 1200 BCE, upper-class women's maids and female servants, as well as other working women from the lower classes and slaves, were not allowed to cover their heads. This rule allowed the men in society to ascertain which women were "fair game" and could therefore be marked for sexual activity. Women violating this rule were punished by the law (L. Ahmed 1992). We see an entire system being created for the convenience of men.

10. One of the scholars who compiled the hadith in the ninth century, Bukhari's collections are considered to be authentic and reliable and are difficult to challenge. There is a school of thought that considers most of the collected hadith to be fabrications, seeing

wife to his bed and she does not come, the *farishtay* [angels] will curse her till morning.

Whether preventing *fitna* outside by covering themselves or inside by uncovering themselves, women are required to manage their bodies and sexuality. Disciplining themselves in this manner is a part of the process through which they aim to become pious individuals, doing their best to create a just "Islamic" society in which everyone has particular responsibilities and rights.

Disciplining their bodies by veiling had a side effect that all the women I spoke to appreciated: the feeling of security and protection that veiling gave them. As one student at Al-Huda who wore the *hijab*, *abaya*, and *niqab* exclaimed, "The security, the comfort level, is amazing. I mean, you get freedom. You get liberated. I can walk anywhere, and no one can look at me. I can look at them." Although these women did not veil so that they could feel more secure and protected in public, they did enjoy this side effect of veiling. There was freedom in anonymity, I was told. Their comments give us a direct look into the larger society in which they live, in which sexual harassment is highly prevalent. All women learn how to walk in a particular way in crowded marketplaces and bus stations from a very young age in order to reduce the chances of being groped. Even if they are not physically harassed, they are often stared at and made very uncomfortable. Being veiled makes them feel free and liberated even as their act in no way alters the power structures within society, power structures that give men carte blanche over women's bodies and places the blame for the transgression directly on women's shoulders.

Remarkable similarities exist between these women's discourse of finding the veil liberating and the discourse of Muslim women in other parts of the world. Referring to her research on American Muslim converts, Carol Anway (1996) writes that many of these women asserted that rather than

them as a product of the cultures (often upholding misogynist ideas) in which Islam spread. Scholars supporting such a view do not believe that hadith should be given the weight that they are (see Berg 2000). Al-Huda does not subscribe to such a view and relies on hadith literature a great deal.

a symbol of oppression, the veil was a tool of liberation. They are, as Stu-art Hall would claim, engaged in an "ideological struggle" that involves attempts to "win some new set of meanings for an existing term, of dis-articulating it from its place in a signifying structure" (1985, 112).[11] This point is particularly important for them, as they consider veiling to be an inherent part of Islam. Elaborating on the veil's being liberating, one of Anway's informants explained that the "*hijab* removes the possibilities for men to 'ogle' and demands that they view women as people rather than objects" (1996, 78). These women argued that the veil signified their rejec-tion of an unacceptable system of values that debased women through their sexual objectification and commoditization.

Similarly, according to a woman quoted in an Internet article on Mus-lim converts, a woman's desire to go naked is not liberation but oppression because she just ends up doing what a man wants her to do (Malhotra 2002). Women whose reasons for veiling include a desire not to be objecti-fied as sexual objects enjoy the idea that their covering themselves in a par-ticular manner prevents this objectification, and they do not see that their veiling can also generate the idea or be construed as a reminder to others that they are sexualized beings who are in need of being hidden. Neverthe-less, this discourse of the veil does shed light on a society in which women are objectified. A young Al-Huda graduate criticized the way women have been turned into commodities in advertisements. She spoke sarcastically, "We can't do any work or become developed until and unless we undress a woman and place her next to an object. Whatever the new project, it can't take off until it is propped up by a woman." It is a valid critique; links between forms of dress and "development" do exist in popular discourse.

Zillah Eisenstein draws on the popular discourse on the linkages between forms of dress and development and explains that according to it, a woman who veils is considered to be "backward," and the "naked porn model" is considered to represent the modernization of the West (2004, 154). "Women's bodies are clothed to represent the status of the nation: *chadors, burqas, saris*, miniskirts, spiked heels, eye make-up, facelifts, and

11. Katherine Bullock's *Rethinking Muslim Women and the Veil: Challenging Historical and Modern Stereotypes* (2002), as the title makes evident, is one such attempt.

so on. Non-modern dress, read as non-Western, is seen as a sign of back-wardness or underdevelopment. Modernity exposes the woman's body; the more the body is revealed, the more modern the nation. The more that sexuality is spoken, the more modern the culture. Yet, both rich and poor nations, so-called modern and not, suffer domestic violence, rape, and unwanted pregnancies" (191). The reason, many feminists argue, is that the power imbalance that exists between men and women in patriar-chal societies all around the world remains unchallenged. Both veiling and unveiling, in this context, are deemed nothing more than two sides of the same patriarchal coin, so that the former becomes a means of controlling women's sexuality and the latter a means of exploiting it.

Adrienne Rich refers to a woman's body as "the terrain on which patriarchy is erected" (cited in Thornham 2000, 159), and it is in this context that it becomes what Foucault refers to as a "docile body" (Bordo 1989), that is, one that is a product of history (Alcoff 1993; Grosz 1994; Moore 1994; Thornham 2000).[12] Proponents of this view would explain a woman's decision to veil as being nothing more than a manifestation of her internalization of a larger patriarchal ideology through which her body is colonized by the hegemony of male honor and desire.[13] Accord-ing to this view, this manifestation occurs because people always function

12. Or as Foucault would have it, "Bodies have no 'sex' outside discourses in which they are designated as sexed," that is, they are neutral (Moore 1993, 197; Lamb 2000; Thornham 2000), a view other feminists adhere to as well. Monique Witting, for instance, does not consider sex and gender to be different in any significant way because according to her, both have cultural meanings associated with them. These meanings result in the formation of "males" and "females" with their own characteristics and personality traits. The purpose of assigning cultural meanings to sex, the argument goes, is that it "lends a naturalistic gloss to the institution of heterosexuality" (Butler 1990, 142). By seeing bodies as having a history, we can then attribute our gender-role expectations to them and in this way stay clear of the idea of biological essentialism (Gatens 1996).

13. See chapter 2 for a discourse on a Pakistani woman's body and the manner in which it embodies both the honor of the men in her family as well as the honor of the nation. Controlling women's bodies and sexualities therefore not only is considered essen-tial to ensure the paternity of children but also becomes a means of ensuring that their honor remains intact.

from within a particular ideological system (Hall 1985, 105),[14] a particular discourse that, as Foucault would argue, "intermesh[es] with bodies, with the lives and behavior of individuals, to constitute them as particular bodies" (Grosz 1994, 150) on which "forms of power are localized, inscribed on, and inflicted" upon (Lamb 2000, 10). Referred to as a "text" of culture, a "sign," and a "powerful symbolic form," the body provides a "surface on which the central rules, hierarchies, and even metaphysical commitments of a culture are inscribed" (Bordo 1989, 13). With the "real" body as it exists prior to interaction with a discourse considered meaningless (Dallery 1989), the layered body becomes a means of understanding its location in the larger sociopolitical fabric of society (Lamb 2000), influenced as it is by religious, "social, economic, medical, legal, and political structures" that produce meaning about it (Thornham 2000, 171).

It is in this larger context of the layered body that Mohanty asserts that women can "become the ground on which discourses of morality and nationalism are written. . . . [Such discourses] are also embodied in the normative policing of women's bodies" (2003, 133). Bodies are hence a cultural construct and become "the field on which the play of powers, knowledges and resistances is worked out" (Thornham 2000, 175). Although Uma Chakravarti refers to women's subordination in the religious text *Stridharmapaddhati*, her argument that social control is most effective when individuals "not only accept their condition but consider it a mark of distinction" takes Mohanty's assertion a step forward to illustrate the complicit role women may play in propagating a discourse of which they are a product (cited in Raheja and Gold 1994, 7).

By placing women and their behavior within the larger religious framework that they have adopted at Al-Huda, and by making links with a larger patriarchal discourse surrounding women's bodies in the society

14. This point of view, when taken to extremes, results in nominalism, a concept described by Linda Alcoff as "the idea that the very category 'woman' is a fiction" (1993, 104). Though important in the creation of a particular subjectivity and countering the essentialism propagated by cultural feminists, such poststructuralist deconstruction may end in nihilism, where there are no concrete politics left (Harvey 1990; Alcoff 1993).

within which they live, my purpose is to shed light on the socialization process that has made them, as we all are, products of a particular discursive consciousness. Yet it would be simplistic and inaccurate to see them as victims of a discourse. In fact, I want to move beyond the "liberation versus oppression" framework that usually characterizes accounts of women's veiling practices in academic works. Such a binary dualism, I claim, can be both politically reductive and analytically useless, for it fosters a simplistic, one-dimensional view of women's lives and the choices they make and promotes a unidirectional view of power in society, so that we begin thinking of them as empowered or disempowered or powerful or powerless as a result of their transformation, rather than simultaneously "subordinate, powerful, marginal, central, or otherwise, *vis-à-vis* particular social and power networks" (Mohanty 1991, 59).

The Veil as Agency

By veiling, women affiliated with Al-Huda are taking steps that often put them in opposition to people around them and create other kinds of challenges for them as well, and it is in their commitment to persevere that I claim that they show agency. The things that crop up on a daily basis are the most challenging for many women. A simple example of a common challenge facing *niqab*-wearing women was determining how to eat in public places without compromising their modesty. These women often dealt with this issue by choosing tables that allowed them to keep their backs toward the other diners present. They also learned how to eat by quickly lifting one side of their *niqab* each time they took a bite for those occasions when they did not get seats of their choice. Some women stopped eating out altogether to avoid this hassle. Other women highlighted other challenges. Natasha, for instance, shared her experience of working with her husband in his company: "There are so many things that you do before and never think about. We deal a lot with foreign companies, and so there are all these men you have to deal with. It seemed like a normal phenomenon to shake hands with them, and asking them about their wives, and talking and laughing with them. . . . But when you start covering up, you don't want to do those things. So I've been in those embarrassing moments when people who have met me two years back and meet me now, and

extend their hand, and I'm not going to shake it anymore, and I'm not going to sit around and talk with them."

In some cases, the challenges women faced as they attempted to transform themselves into pious subjects arose from within them. Ayesha, the young medical student who still had not been able to veil at the time I conversed with her, is a case in point, as is Saira, an Al-Huda graduate and a teacher at Colors of Islam. Saira told me of the challenge she faced when she decided to begin veiling:

> I've always enjoyed looking good, and my husband always supported my desire to look good. I streaked my hair, always made sure my shoes and jewelry matched my clothes whenever I went out. So when I decided to cover my head, I told myself that I would never look into the mirror, because if I did, I would never be able to continue doing so. So I used to take it off whenever going in front of a mirror. . . . I began by covering my head at home, so I could become used to it. Then I felt I had to do it in marketplaces because of the unknown people there. . . . I began by wearing a *dopatta*, moved on to a *hijab*, and now wear an *abaya* and *niqab*.

Maria shared the process she went through in detail:

> There were all these thoughts, thinking, "When do I start, where do I start, how do I start?" Being vain, I had to have that bit of glamour. I couldn't just take a plain black *hijab*. And where? I thought about it. It had to be with people who I knew would be okay with me, who would be encouraging, but would also tell me to my face that, "Hey, you look really awful in this." Or whatever. So I actually picked the time I did this. And I did it at a family friend's little tea party. It was only ladies. It was people I knew very well, so I knew it would be easier. Then I picked a very nice *shalwar kamiz*. A lovely color. Things that I knew suited me. And then I had someone to teach me how to fold the *dopatta* itself, and to put it on like that. Then I practiced and practiced in front of the mirror, how to handle it. Then I went, and that was it. I was very apprehensive as to what the reaction would be. But I kept saying to myself that I'm not going to whip it off right there and then. If I have to, I'll do it at home. But also, like I said, I had mixed thoughts. Because I also kept saying

that now that you've committed, you have to do this. You know you're a person who when you commit, you put your whole heart into it. So you can't go back on this one. Very, very mixed. Not confused, but mixed feelings. And bittersweet also, that after this you won't be showing off your hair, but then also reminding yourself that you're so precious, you can do what you want at home. . . . And so I went to that party. It was great. They were all so encouraging. . . . [T]hen during that week, before I could lose hope or faith or whatever, I went to a very good parlor to get my hair done, and the ladies' reaction there was, "Oh, my God, I spent a whole hour streaking your hair and blow drying it, and you've put on a *hijab*." And I said, "Don't worry, I'll take it off as soon as I get home, and my family will love it." And that's what I did. I streaked my hair. And I used to take special effort in the home, of not wearing the *hijab*, not covering, having my hair open. So getting best of both worlds, I felt. And that was important initially. Now it doesn't bother me so much. But initially it did bother me. . . . I was actually quite disappointed with the lack of reaction [to her *hijab*] from everyone. I thought I'd get a lot of reaction. And you know, from your inside, when you don't really want to do something, you feel that, oh, there will be so much opposition, it will be an easy way to get out of it. I'll simply say, "Oh, I tried, but it was so difficult with my family." But it was not at all difficult. . . . In a paradoxical way, it has helped to strengthen me as well. Because I then realized that the weakness is in me. I've got to gain that strength.

Unlike Maria, some women did face disapproval from their families and friends on their decision to veil. While the families of the students at Al-Huda appreciated the way that their daughters or wives were becoming more responsible and conscientious through their studies, many reacted to the changes that went against the social norms; their veiling was one such change. However, in many cases, it was their experience of growing up as a Muslim in Pakistan that prevented them from stopping their daughters even if they wanted to. As Maria told me, "Who would have the guts to say no to you if you tell them you want to study, adopt, or teach Islam? Allah actually shuts a lot of people up." But not everyone. Even the women whose decisions were accepted and supported by their families had to hear calls of

being *fundos* or "ninjas" on the street, and listen to comments—"Oh, your husband is forcing you to veil!"—and criticism from others while attending gatherings. One common critique was that the veil did nothing but arouse curiosity about who was veiled. Another common comment was that prostitutes often veiled to prevent people from recognizing them when looking for clients on roadsides.

Although many women faced some kind of criticism from the larger society, particularly when it was still a new practice in the 1990s, some also experienced it from their immediate families and friends. Fatima explained some of the challenges she faced as a result of veiling:

> Once when my father was really after me to stop doing *niqab*, I told him that "You can disown me but I cannot stop doing it." . . . The reaction to my changes has been intense. I am the first person in my family to do purdah. I feel like we are living in Meccan times, where there is only one believer in a household. There were only about a hundred or so people who migrated to Medina. I long to see the Medinan period in our society. So it has been very hard to remain strong in my beliefs in the face of so much opposition. My immediate family, my relatives . . . they say I have become rigid, fanatic, an extremist, but I do not care what they call me. But it has been a rough road, and I constantly ask Allah to keep me firm in my faith. Hurdles come every day, over small things. Whenever someone comes to our home, relatives and cousins my parents' age, I am always dressed the way I am right now [a simple *shalwar kamiz*, with a large black chador covering her head and three-fourths of her body]. My older cousins hug me, put their hands on my head, kiss my forehead, like the way it is done here, and they do not know how much I dislike this. Some people say that "It is okay—they are your cousins, like your brothers." But no, they are not my brothers. If the Qur'an says they are my *na mehram*, then they are, and I will do purdah from them. I dislike it when they touch me that way. And I know they do that considering me a young daughter—it's not as if I am saying that they have bad intentions—but it's just that I have changed now. Then when I started doing the *niqab*, there was this whole issue of how I would eat in public places. Some women go to places and sit with their backs to the people, and then eat by lowering their

niqabs. Or they go to darkened rooms. My family would urge me to take it off on these occasions, and every time we used to go out I used to pray before going that "Allah, give me strength to follow your commands." . . . I take off my *niqab* when there are not any people around. . . . But when I have taken a decision, I try very hard to carry it out properly and not look for shortcuts, or not make use of any given leeway.

Many women persevered in the face of the resistance that they faced from their families or the larger society. For one woman, the resistance came from her children who complained about her veiling, asking her why she could not be like other mothers. For another, it was her parents' general disappointment in her, something that tore her apart inside, she revealed. It took time for her to rebuild a relationship with them. Natasha's husband, when she sought his opinion on her decision to veil, told her that she could cover but should not wear black or go overboard:

So I started the scarf then, and within two months I was not happy with that by itself, and I wore the *abaya*. When I kept talking about it he seemed receptive to the idea, but when I actually wore it, he said it was a sack. I said that "Well, this is what it's supposed to be" [laughs]. It's been tough because if your partner doesn't think like you, isn't at the same level as you. . . . Perhaps I need to learn much more to be a better example for him to appreciate religion. So far, in many ways he feels that religion constricts you, and it narrows you down to something, rather than widens your horizons. And as usual, I also did all the mistakes that most people do when they get into Islam. You come by forbidding all the wrongs first. I'm not going to go to with parties with you, where there is alcohol served. I'm not going to go to mixed dinners, especially where people are this, that, and the other. I'm not going to dress up; I'm just going to wear this *abaya* stuff, whether you like it or not. So it was like a lot of I'm not going to do this. And this is not allowed. And going on and on by no, I'm not going to listen to music. I'm not going to watch movies. . . . He told me many times that "I got up finding a stranger in my bed." Because basically he has this thinking that I've just lost it somewhere. And his family is very secular. One of his sisters actually asked him, "What's going to happen, are you going to ditch her and get

another wife?" . . . My social circle totally changed, from what I had to
a stage of nobody ever inviting you. You go out socially, and you see the
way people react. When I walk into dinners where people accidentally
called Mr. and Mrs. Khan without realizing what Natasha Khan looks
like . . . you walk through the doors, and you see the shock on their face
when they see all the stuff you have on. And the first thought they have
is that she's gone. Put her aside. Because she's this *fundo*. So even for
business dinners that my husband was invited to, they started dropping
my name first, and solely calling him. And at a later stage even dropping
his name. . . . There is still, in my home, I feel, a certain divide between
Mum and Dad, which has an impact on my children. Because they don't
know which side to follow sometimes.

I was unable to talk to the men who resisted the women in their fami-
lies doing purdah. The time women gave me to visit them so that I could
interview them was usually during the day when their husbands were at
work and children at school. It was when they had the most time to them-
selves. There were also a couple of occasions when the men were at home,
but I was prevented from meeting them because I was not in "proper" pur-
dah. But based on what the women shared with me and my own famil-
iarity with the discourse against veiling in society, I suggest that those
families or family members who reacted to these women veiling largely did
so because veiling to this extent is considered to be a sign of extremism in
these classes. It represents "fundamentalism," conservatism, illiteracy, and
backwardness. Although modesty is valued in all classes, what modesty
means varies among people.

The women occupying Zulaykha's *dars* largely belong to the middle
and upper middle class, and their reasons for not supporting veiling in the
manner prescribed by Al-Huda can give further insight into people's reac-
tion to veiling. Women in Zulaykha's group covered their heads with their
dopattas while in the *dars* setting, as is traditional,[15] and uncovered them

15. I witnessed only one *dars*, led by an Al-Huda graduate who no longer associated
herself with the school, in which neither the teacher nor her students covered their heads
while reading the Qur'an, a very radical concept in the religious circles of Pakistan.

once it was over. They argued that the commands made in the Qur'an were limited to the Prophet's wives. Modest dress, however, was important, they claimed, and a *shalwar kamiz* fulfilled that requirement. Salma, one of the women present at this *dars*, informed the rest of the group that her daughter was studying in the United States, but no one ever approached her for dates. She then asked me whether I was approached for dates, and when I shook my head no, she said triumphantly, "You see?! It is the way we dress, and the way we behave, that characterizes us as Muslim. Our modesty lies in our mannerism. We don't need to be swathed in cloth to keep people at a distance. . . . Veiling is something Muslims got from the Byzantines, something not many people realize."

Farah, who attended a *dars* offered by an Al-Huda graduate for a few months but eventually left because of difference of opinion on many issues, held a similar view about what modesty means: "I tell you, when a woman stands in front of a mirror, she knows what she is dressing for. I know when I'm out there to attract, tantalize, and when I'm not. You know how to dress modestly, and what that means in different contexts, and you don't need to follow Al-Huda's path of doing purdah to do so."

The difference of opinion over the veil, what it means, and whether it is necessary or a requirement provides insights into a culture that is host to a number of different ideologies and subgroups. The kinds of challenges a woman faces or does not face depends a great deal on where she is located within it, and I claim that it is in the context of oppositional ideologies and constraining cultural codes that women's decision to veil can become a sign of their agency and their commitment to piety. The belief in and enactment of their commitment to a particular ideology make complete sense in the larger worldview that Al-Huda lays out for them and become problematic only to those of us who do not function from within that framework. Although spending time with various women affiliated with Al-Huda during my fieldwork in Islamabad allowed me to understand the practice as a manifestation of faith for many women, my own ideological positioning makes me continue to question the "logic" given for this practice.

7 · Reflections

As A PERSON'S IDENTITY usually embodies various selves and ideological strands that allow him or her to connect with others around some issues and in some contexts but not in others, it was with no great surprise that I found myself feeling like an insider in some research-related moments and an outsider in others. It is from this space of shifting boundaries that I elaborate on how, by building on women's existing faith in Allah and the Qur'an as the word of Allah, Al-Huda aims to give their faith a concrete form and, hence, create pious subjects informed by a unitary form of religious consciousness.

My insider status within the larger culture my informants came from, in conjunction with my basing my work on the stories they told me—in which they themselves identified many of the factors that facilitated their active and conscious turn toward an increasing engagement with Islam via Al-Huda—means that they are likely to agree with the reasons I have highlighted for their engagement and internalization of particular Islamic beliefs and practices. Yet the different positions we occupy—with them largely inside a particular religious framework, a space that I do not occupy—also increase the likelihood of us looking at and giving variant overarching meanings to their journeys. Despite an agreement on the factors facilitating their engagement with Islam through Al-Huda, many of the women thought of their journey toward piety as the result of God stepping closer to them and helping them on the path leading to Him once they had taken the first steps by opening their hearts to Him. My informants' ideological positioning translates into situated knowledge (Haraway 1991), as does my choice of a variant analytical frame that highlights their experiences but does not give those experiences a similar overarching meaning that comes from within the religious tradition they

uphold. It is from this location of partiality and situatedness, interspersed with moments of connections and chasms, that I speak of women's desire to become better Muslims or pious individuals through making attempts to infuse their entire lives, and later the lives of others, with a particular kind of Islamic ideology.

Women's Engagement with Al-Huda

Women affiliated with Al-Huda have been working toward spreading this institution's Islamic ideology into mainstream society through a variety of forms of *da'wa* since the first Al-Huda branch was established in Islamabad in 1994. Most women did not possess the desire to significantly alter their lives when they first went to this school. Although the reason(s) that led women to first set foot in the Al-Huda premises varied, ranging from their wanting to make sense of a personal tragedy in their lives to a simple desire to check it out based on a friend's urging, the one thing that most of them had in common was that they possessed faith. They believed in one God, in the Prophet Muhammad as the messenger of God, and in the Qur'an as the word of God. The faith that women developed in an Islamic discourse at a young age in their homes was further strengthened in an environment in which the hegemonic religio-nationalist discourse propagated by different governments through the media and textbooks has increasingly linked Pakistan's creation with Islam and emphasized the country's Muslim identity. Although the presence of competing ideologies had prevented religion from becoming the primary framework informing women's lives, their faith played a critical role in their initial contact with, and later subscription to, Al-Huda's Islamic ideology.

Faith in itself was not enough to motivate women to increase their scriptural Islamic knowledge; none of the women belonging to the middle and upper classes that I spoke to had ever attended any *dars* offered by other religious groups. I suggest that the authority of the discourse and the pedagogies of transformation that women were exposed to at Al-Huda built on their faith in Allah and the Qur'an as the word of Allah, and played a critical role in helping them in disciplining themselves into becoming pious subjects infused with a unitary consciousness. Women's lack of scriptural knowledge, in combination with a lack of access to an

alternative discourse, one that is being presented the way it is at Al-Huda, as well as the various ways in which they found their experience there meaningful, facilitated the school's impact on women and gave their faith a concrete form. All this transformation happened over time, as women spent an increasing amount of time at Al-Huda.

One of the changes women went through as they took a diploma course at an Al-Huda branch or attended *dars* offered by Al-Huda graduates was that they developed a love for Allah and a deepening desire to please Him through following His commands. A strong belief in the perfection of an Islamic way of life developed, along with a longing for heaven and a fear of hell. All these beliefs motivated them to alter their life so that it resonated with what they learned were Islamic prescriptions. The changes that they then made in their lives were rooted in their desire to become pious individuals who lived their lives in the way they believed Allah wanted them to. Although some of these changes were accepted more readily by people around them, such as their regularly praying five times a day, others, such as their adopting purdah or their critique of a variety of cultural practices, inspired more of a reaction. The fact that many of them continued their journey in the face of much resistance from people around them is a testimony of how important and central Islam had become to their lives and how deep their faith was.

The meaning women found through engaging with Islam via Al-Huda was not limited to their relationship with Allah. Islam also gave many of them a purpose in life and presented them with a way of living that made more sense to them than the lives they were leading until then, full of, I was told, materialism, greed, and meaningless chitchat. Many women were also concerned about the morality of society in general, particularly in the face of a media invasion in which they were bombarded with alternative values and lifestyles. The Qur'an, perceived as a complete code of life, became very attractive in this context. The various ways their journey became meaningful to them served to reinforce their perception of the rightness of their path and, as such, facilitated the journey itself.

The stories that women related of the process they went through, and were continuing to go through as they made attempts to make religion the primary framework informing their lives, revealed the sincerity

and commitment many of them had toward becoming better Muslims. Women's individual actions to transform themselves and others have turned Al-Huda into a social movement, and the changes they have made in themselves and continue to facilitate in others are changing society itself.

Although the impact of these changes at a societal level will become visible only with time, I find some emerging patterns and trends within the movement worthy of consideration, for they bring up issues of identity construction, power structures, and interpersonal relations within society. I have no intention of negating the meaning Islam has for my informants, but I am going to take a step back from their lives and share some personal reflections on these issues, issues that I find myself increasingly thinking about since completing my research.

Al-Huda: Musings on the Long-Term Impact

One aspect of Al-Huda's discourse that has become the subject of increasing contemplation for me is the systematized valorization of gender roles. Women are considered to be naturally nurturing, emotional, and empathetic; their primary duty is therefore raising a family, a job best suited to them, given their nature. The reinforcement of an essentialist notion of womanhood that already exists in various degrees in society, and creates a positive value for their roles as wives and mothers and a negative value for a number of other occupations, leaves very little space for those women who want other options in life. Furthermore, the well-defined characteristics that make up a "good woman" put down those women who are different, either directly or by default. Not all women judge, but many do, and they do so on the basis of the model of desirable behavior provided by the discourse they engage. The criticism is not really geared toward the overt differences of lifestyle, behavior, or dress per se but toward what those differences represent in terms of the piety, morality, and character of women and the impact their choices and behaviors are believed to have on society.

The ideal woman as propagated by Al-Huda is one who, among other things, takes on the responsibility of keeping her family intact, and by extension the larger social order as well. One of the ways of maintaining

order in the larger society is through the adoption of purdah. I mentioned earlier that the women affiliated with Al-Huda, through their discourse on purdah, play an active role in reinforcing an idea that already exists in the larger society, that is, that women are responsible for leading men astray. This belief not only puts the responsibility for any sexual crime against women on their own shoulders—as we see in the rest of the world—but also becomes an excuse for the control of their mobility and sexuality (Graham-Brown 2003). Although many women veil simply to manifest their faith and to please Allah, this reasoning does not prevent the ideology surrounding veiling from spreading into society.

When Al-Huda graduates do *da'wa*, they do not just make attempts to convince women to adopt purdah by claiming that it is a duty prescribed by Allah. They also draw on theories of *fitna* and women's role in preventing it in order to explain why it is a duty prescribed by Allah. Many women's stories of their adopting purdah clearly reveal that they were influenced by such reasoning. Although the fact that such an ideology already exists in the country facilitates the ease with which they accept it, those women who internalize it and spread it further are reinforcing it in the larger society. This point raises a number of questions: How does veiling challenge the larger system in which men feel they have a right to touch women's bodies as they please? What impact does such a discourse—men are naturally aggressive, unable to control their impulses, and therefore not responsible for their actions—have on the construction of the notion of manhood, and subsequently on men in the larger society? To what extent can they develop an internal locus of control if they are not held accountable for their behavior? Also, does veiling truly protect women from sexual assault and rape? It certainly does not protect the many purdah-observing women from getting raped in their villages and towns (Harrison 2002).[1] That women find purdah meaningful, that it is often a manifestation of their faith, and that it fulfills them is not under question. But to ignore the fact that the veil is often a symbol of a

1. The fact that the roots of sexual violence lie more in a need to exert power and control and less in sexual desire has been long established in literature through a study of actual rape cases.

particular ideology leads us to romanticize it and ignores the way power operates in society (Abu-Lughod 1990). Also, any negative judgment that takes place concerning "women who wear sleeveless clothes," "women who have male friends," and so forth objectifies them and serves to promote and reinforce harmful stereotypes, a process Al-Huda graduates take exception to when it is directed toward themselves.

The adoption of purdah is just one transformation women undergo in their journey to attain piety that is collectively contributing toward a transformation of the culture within which they live. One set of changes is related to their actively ridding their lives of elements that they deem un-Islamic. These facets include rituals associated with forms of Islam that are different from theirs, a number of everyday practices such as listening to music, and festivals and celebrations such as *basant* and *mehndis*. The elimination of these practices on the basis of their being "un-Islamic" or "foreign" or both is a reflection of women's adherence to a redefined Muslim identity that has developed through their affiliation with a particular interpretation of Islam. People upholding this interpretation as the truth are negating not only the religious experience of different kinds of Muslims but also the history of the land, in the process, ironically, creating a culture based on beliefs and practices that originate from outside the land.

Although all these activities clearly reveal how the women I studied positioned and identified themselves, they also force the larger question of what a Pakistani identity or Pakistani culture is. Is Pakistani culture rooted in a multireligious, multidynastic, and multicivilization South Asian experience, or is it an expression of a monolithic, relatively arid Middle Eastern culture? Is it an exclusive articulation of predefined and preconceived "Islamic" values, or is it an amalgam of ancient pre-Islamic rites and non-Islamic rituals, Islamic values, modern secular-colonial practices, and postmodern globalizing tendencies (Sethi 2004)? What is it that is keeping us from seeing the advent of Islam on the Indian subcontinent as a foreign import, an act of imperialism, merely our own position of being inside the hegemonic religio-nationalist discourse? These questions are the subject of much debate among intellectuals and social scientists in Pakistan. As Najam Sethi (2004), senior editor of the well-known weekly the *Friday Times* writes, "The crisis of identity and ideology refers to the fact that

after fifty years, Pakistanis are still unable to collectively agree upon who are we as a nation, where we belong, what we believe in and where we want to go. In terms of our identity . . . are we Pakistanis first and then Punjabis, Sindhis, Baloch, Pathan or Mohajir[2] or vice versa? Do we belong—in the sense of our future bearings and anchors—to South Asia or do we belong to the Middle East?"

The government of Pakistan has, over the years, strengthened Pakistan's Muslim identity through its active propagation of a hegemonic religio-nationalist discourse that ties Pakistan's creation to Islam. The internalization of this discourse by many people making up the urban middle class facilitates their acceptance of Al-Huda's Islamic ideology that highlights their Muslim identity so that when they speak of "our history" they usually mean Muslim history, and when they refer to "our people" they usually mean fellow Muslims in various parts of the world. It is within this context that the land's history prior to the first Muslim conquest in 712 CE can be referred to but not owned as one's own and that many practices are criticized for being "un-Islamic," "foreign," and therefore unacceptable. Such an ideological positioning can often run counter to what is upheld by other Pakistanis who own their pre-Islamic history and take pride in the fact that Pakistan was once a part of the Indus Valley, Gandhara, and Mehergarh civilizations and that even today it is the home of many different kinds of cultures.[3] I do not wish to create artificial boundaries here. People who belong to this latter group usually also feel connected to other Muslims around the world, and may define themselves as such. But their definition of their society and history, and subsequently their identity, is much more expansive and inclusive.

I came across a school that was opened by one such individual in Islamabad around the year 2000, and visited it while I was there doing fieldwork. Called Mazmoon-e-Shauq, this school caters to upper-middle- and upper-

2. The people who migrated from India at the time of partition (and continue to be called Mohajir even after sixty-plus years).

3. This statement does not imply that they accept "culture" indiscriminately or that they do not criticize harmful aspects of Pakistani subcultures, like child marriages, "honor" killings, and the like.

class children between the ages of three and ten, and its entire approach is influenced by its guiding principle of connecting children with their culture, that is, the culture of the land. Hence, unlike other Pakistani schools, religious studies rather than Islamic studies is taught. Teachers talk to their young students about the different religions practiced in the region, celebrate or mark both Muslim and non-Muslim religious occasions, and organize trips to places like Taxila, a small town that used to be the seat of the twenty-five-hundred-year-old Buddhist Gandhara civilization, an hour's drive from Islamabad. Dance and music also form a part of the curriculum. English is spoken for only a limited time during school hours, so that children learn to speak in Urdu without interspersing it with English words in every other sentence, as individuals belonging to this class are bound to do. Birthday cakes at school are first accompanied by children singing "Happy Birthday" in English, as has become customary in these socioeconomic groups, but it is then immediately followed by teachers leading students into *"Mubarik tumhain, khushi ka ye samah,"* an Urdu song that is full of different kinds of best wishes for a person and sung on an occasion of happiness. The children now continue this practice at each other's birthday parties at home. The woman who began this school is as concerned over the trend that Al-Huda is bringing in as she is over the infiltration of Western culture. Both *hijabs* and jeans are foreign imports, she argues, and must go. Therefore, whereas the influx or the presence of the "foreign" is a source of concern for many people, where they are positioned in society, what ideologies they subscribe to, how they define their identity, and what being a Pakistani means to them all play important roles in determining what they define as foreign and how they then deal with it.

Al-Huda has been very successful in redefining and highlighting women's Muslim identity and associating their Pakistani identity with it. As such, it aims to create a larger monolithic culture infused with particular values and behaviors. How successful it will be in this project will depend on how successful it is in creating subjects infused with a unitary "Islamic" consciousness. Although this success is largely dependent on the strength and nature of women's prior religious beliefs, the strength of alternative ideologies in their life, and their motives for engaging this religious discourse,

Al-Huda's success is already visible in its national and international expansion and in the manner in which women transform their ideology, their behavior, and their lifestyle and, later, the lives of others. The transformation they undergo within the religious framework the school offers them is important not only for what the change means to them on a personal level but also because of the impact such a change has had and will have on the culture of the larger society—significant, given that women affiliated with Al-Huda number in the thousands and given the enthusiasm with which they work toward spreading the school's religious ideology into mainstream society through a variety of forms of *da'wa* or religious outreach. As such, they are playing a critical role in constructing a particular kind of culture in Pakistan. This culture gives no space to Muslims who are or wish to be Muslim in a way different from theirs. Propagating the "truth" and the "true path" automatically negates other people's truth, be they Muslim or non-Muslim.

Pakistani social scientist Kamran Ahmad argues that "this tendency, where every group maintains that theirs must be the only true interpretation, leads away from tolerance of other perspectives within Islam and certainly of those outside of the religion" (2000, 4). Religious intolerance generally ends in violence when taken to extremes. Ahmadi Muslims in Pakistan, as well as the Shiites, are regular victims of violent attacks by Sunnis who claim monopoly over the truth. Other religions are not spared, either.

A recent example of religious intolerance in Islamabad is the burning by madrassa students of a banyan tree that was a few hundred years old. Buddhists believe that Buddha, in one of his travels, sat under this banyan tree and rested there for a while. As such, it is revered as sacred by the local Buddhist community. The small community of Buddhists in the twin cities of Islamabad and Rawalpindi used to meet under the tree to observe their rites. Over time, they built a small altar next to the tree where they put a few statues of Buddha. After some time, however, they found the altar broken by the students of the nearby madrassa. They tried to rebuild it a few times, but every time they did, people would come and break it down again. In the end, they even tried to build a small shed with iron-bar gates within which they placed a statue of Buddha. That too was broken

into. Eventually, they moved the altar and their activities within the closed walls of a small temple in the diplomatic enclave. This move, however, did not stop the madrassa students; they decided to burn the whole tree down. But one cannot burn a huge banyan tree all at once, especially when it is in the middle of a forest that also surrounds one's school. So they set some small part of it on fire and let it smolder slowly. This way, it took years to finally kill the entire tree. It was while I was doing my fieldwork in Islamabad in 2004 and visiting the tree that I saw some madrassa students set fire to parts of it. My uncle, who was with me at that time, reminded them that according to the constitution of our country Buddhists have the freedom to practice and even preach their religion openly. At this statement, one of them, who seemed to be the eldest, spoke: "We are *but-shikan* [idol breakers] and this is in line with what our Prophet did, destroying the idols of all other religions when he reentered Mecca. We will break down anything that anyone sees as sacred, whoever they may be. They are all *kafirs* [nonbelievers]!" Clearly, no ethical dilemma was felt, only a great sense of righteousness. My uncle later wrote about this incident in the local newspaper, relating how his trip to the police station to report the burning produced no results. He concluded by stating that "being a Muslim, and being a Pakistani and, above all, being a human being, it fills me with deep sadness and it fills me with shame as I sit in front of the ashes of this Banyan tree, witnessing the end of an ancient, pluralistic and tolerant civilization. I take my four-year-old son to this charred stump now, to give him a concrete image of what we are fast becoming and to give him a sense of the challenges that lie ahead for his generation" (K. Ahmad 2006).

People like these madrassa students make up only a very small percentage of the Muslims in Pakistan. The majority continue to be tolerant of other religions. In addition, there are a number of initiatives introduced in society by individuals such as the woman who began Mazmoon-e-Shauq, different community-based organizations, or very popular Pakistani singers like Abrar-ul-Haq or pop groups like Junoon who blend Sufi poetry with contemporary music and are actively working toward creating a more pluralistic and tolerant society in the face of a larger religious trend sweeping the nation that claims to offer the only true path leading toward the divine. Yet the extent of their success is more difficult to measure, which

makes it problematic to assess future trends, particularly since such trends are also interconnected to global politics.

As far as Al-Huda's role in having an impact on future trends is concerned, I must confess that philosophies such as the ones permeating Al-Huda, which leave no space for multiple truths, make me very nervous. Even if Al-Huda students do not condone activities like the burning of the banyan tree, they do glorify their Muslim heroes, invaders like Muhammad Bin Qasim and Mahmud Ghaznavi, who broke temples and replaced them with mosques (Rapson 1987). While such glorification already exists in school textbooks, their discourse justifies, naturalizes, and subsequently reinforces the acceptability of such practices. Their exclusionary politics negate all other forms of the truth, and an increasing chasm and increased intolerance are already clearly visible between women affiliated with Al-Huda and those individuals who practice Islam differently. Their intolerance toward people of other religions, at least at the level of discourse, also comes out in their comments about them, whether it is in their referring to them as *kafirs* (nonbelievers) or in their desire to convert them so that they leave the wrong path they are following. This sense of righteousness is connected to the shape their faith has taken, and it is in this context that faith has the potential to become dehumanizing, dangerous, and harmful for others.

Given the rapidly changing sociopolitical scene in Pakistan, I do not think any one of us has the luxury of merely debating the impact of people who consider themselves the custodians of truth at a purely theoretical level anymore. Issues related to intolerance that dehumanize others touch our lives on a daily basis, in various contexts. They touch my life every time I turn on the television and hear of hate crimes against Muslims belonging to minority sects in the country, and every time I hear a suicide bomb go off in the city. I get a disturbing taste of the sense of righteousness that can exist only when one is confident about the nature of truth, every time a Muslim student in my Anthropology of Islam course finds it difficult to take seriously the beliefs and practices of Muslims who practice Islam in a manner different from theirs. Al-Huda's specific role in this context is also very real for me, actualized in my changing relationship with my friend Rubina, who took the one-year diploma course during the time I did my fieldwork in Islamabad.

My friendship with Rubina goes back almost twenty years. But I felt that we had very little left to talk about by the time I completed my research and she her diploma course. I did not visit her the first summer I went home to Islamabad from the States, a year after I had completed my fieldwork. One of the reasons was the fear of once again being in a situation where it seemed that the only things that were highlighted were our differences—differences in the language we spoke, in how we dressed, in the activities that formed a large part of our respective lives that we could not share with each other, and in our divergent thoughts revolving around various issues, ranging from politics to what piety entails, thoughts that stemmed from our variant worldviews. Added to this fear were a number of specific instances that magnified what I was beginning to think were insurmountable differences. One of these moments took place in my grandparents' home in Islamabad. Rubina was visiting them at a time when one of my brothers, who was sixteen at that time and had been living in the United States since he was nine, was also visiting. He used to be very close to her as a child and had not seen her since then. However, his excitement over meeting her after such a long time quickly gave way to amazement, and then bewilderment, when he realized that she would not uncover her face in front of him. Her explanation that he was a *na mehram* to her fell on deaf ears, and he kept arguing that he was like her younger brother, reminding her of occasions when she used to go around carrying him on her shoulders when he was young. Her response hurt him a great deal. A few years have passed since then, but he continues to get upset whenever her name is spoken in front of him. The other men in my family, ranging from my grandfather who is in his eighties to my uncle, also feel bewildered whenever their paths cross Rubina's, wondering aloud what she thought would happen if they saw her face. Understanding where she was coming from ideologically did not prevent me from becoming upset on my family's behalf. Added to this feeling was a keen sense of loss. Yet I was not ready to throw in the towel, not after everything we had shared over the years, and kept in touch with her.

I completed my Ph.D. and moved back to Pakistan in the fall of 2006, and have since then had greater opportunities to interact with Rubina. I forced myself to share my feelings of discomfort with her on one occasion

when she brought up an old childhood issue that had been bothering her recently. This conversation allowed us to resolve a few things. I doubt that Rubina will be a frequent visitor at my grandparents' house anymore, and I know that there will always be issues that we cannot resolve with each other. But in my heart I also know that I can always count on Rubina to be there for me, just as I hope I can always be there for her. The nature of the friendship may have changed, but the connection exists, and I keep reminding myself of that fact.

When I think back to the emotional ups and downs I have had while conducting this research, I often find myself remembering my research proposal with amusement. In the section outlining the significance of this research, I had confidently written something along the lines of this research increasing our understanding of those individuals who seem different from us. I then went on to claim that such an understanding would foster acceptance and tolerance. It is only now that I realize what a simplistic assumption that pronouncement was. Conducting this research led me to interact with a number of Al-Huda graduates whom I found to be very intolerant and judgmental toward people who were different from them. Yet I also met a number of genuinely nice people whom I will always remember for their sincerity. The lesson I take away from all this research is that it is important to make a distinction between an institution and its philosophy, on the one hand, and the people who are affiliated with the institute, on the other. I continue to find the institute and elements of its discourse problematic on a number of grounds, and I have become well aware of the limits of my tolerance. But I cannot make any kind of blanket statement about Al-Huda's adherents. Whether veiled or unveiled, judgments—be they positive, negative, or a combination therewith—must move beyond people's outward trappings and be made only on the basis of a one-on-one interaction or visible behavior. The alternative is truly frightening.

Al-Huda: The Future of the Movement

Assessing how the Al-Huda movement will influence the larger society over the long term is difficult for a number of reasons, one of which is that "impacts" can be assessed only if generalizations about a current trend

can be made. The goal of this research was never to make generalizations but to present patterns and to use them as a means of gaining insight into this trend. In any case, to what extent can generalizations be made when the subject matter under study is "change"? Since the women engaging with Islam via Al-Huda were on a journey, so to speak, their accounts of themselves and of their relationship with Islam were colored by where they were in that journey. On whose accounts do we make generalizations? Those women who had completed their course more recently and were usually highly motivated to incorporate everything they had learned into their lives, those who had taken the course ten years ago, or those still students at the time I met them and had not yet been completely exposed to all the directives they would be exposed to by the end of their respective courses?

Furthermore, would a larger sample reveal any differences between those women who learned from Farhat Hashmi herself and those who learned from her audiotaped lectures, posing any questions they had to the other teachers? What impact does the manner of engagement with the Al-Huda movement have on the extent to which women make its ideology a part of their lives? I mentioned some differences between women who take the one-year diploma course versus those who take the *dars* offered by Al-Huda graduates. But what of those students who take the correspondence courses or listen to Farhat Hashmi's tapes in a personal capacity? What tapes are they choosing to listen to, and what impact do they have on their lives?

Another aspect that makes it difficult to generalize and predict future trends, and also requires reflection, is related to the depth of people's transformation and the impact that depth will have on them and others over the years. I was able to, on some occasions, get a very strong sense of how some women's experience with Al-Huda had brought about a significant inner transformation, where they had truly questioned what they were doing with their lives and where they were able to, over time, develop a very meaningful and satisfying relationship with Allah. The inner transformations these women had gone through made them kinder, motivated them to cut down on the materialism in their lives, and made them socially conscious. But with others, it seemed as if the changes had occurred at a

very superficial level, where the new outer trappings had been adopted but the deeper inner work had been neglected. Of all the women I interacted with, these latter women were the most judgmental and intolerant of "difference." As for the rest, how can one truly judge? How will the positive values of love, kindness, simplicity, and spending time constructively, which are also a part of Al-Huda's discourse and visible in a number of women, play off against the intolerance and rigidity that are visible in others after they take the course? Which of these values will be more visible in society over time?

Differences among women also existed in the manner in which they dealt with the changes occurring in their lives. Some women retained their joy in life and assimilated what they were learning into it. Others became quiet, lost weight, no longer felt joy in everyday activities, stopped smiling, alienated others around them, and focused on following "the right path" at the expense of everything else. It is also difficult to assess whether women who believe in an ideology will continue to believe in it as strongly a few years in the future, or continue to follow all its tenets the way they usually do upon graduating from the school. The environment they live in and the kind of people they are exposed to over the years are just some examples of factors that may influence how strongly they hold on to the tenets.

Yet another factor that must be considered is the nature of Al-Huda itself. Religious education is no longer the sole activity of this school. This school, which was registered as a nongovernmental organization in 1994, has now made social welfare a part of its operation. In addition, it has also begun special outreach programs for special needs groups, such as women in jails and urban slums.[4] All of this activity is in keeping with their new objective of "to plan, and work for the welfare of the deprived classes (i.e. the needy, and calamity-stricken people) of society" (Al-Huda 2005), and makes them similar to other religious groups around the world, such as the Muslim Brotherhood in Egypt or the Hindu Nationalist movement in India, who also engage in welfare work. Kalyani Menon (2002), who studied women's participation in the latter, proposes that the movement's

4. Up-to-date information on the school's activities is available on its Web site, http://www.alhudapk.com.

ability to speak to and take within its fold a diverse group of people has led to its widening base and success in India. There is a distinct likelihood that by expanding its base, and providing means to do social work, Al-Huda may also be able to attract those people to it who would not necessarily associate with it otherwise.

A movement changes its nature over time. Al-Huda as it exists today is not the same as it was when it began more than a decade ago, neither in terms of its audience base nor in its activities. Further research is needed to understand what role its expansion will play for those women who come there as students and for those who are more engaged in its other activities, and whether class is playing a role in terms of who is participating where. Likewise, further research is also needed to understand the impact that Al-Huda graduates are making in rural areas where a folk Islam is largely practiced and the extent to which it is having an impact on men in urban society.

The Al-Huda movement is no longer limited to Pakistan, and as such it is influencing Muslims all over the world. Al-Huda graduates have opened up Al-Huda branches around the world, although most of them are concentrated in the United States, Canada, England, and Dubai. A list of these branches and their contact information can be obtained through the main Al-Huda branch in Islamabad. These branches have become very popular among Muslims living in these countries, although there are also Muslims living there who are very concerned about the kind of Islam being brought into their communities. Farhat Hashmi herself moved to Canada in 2005,[5] and apparently there are a number of Muslims there who want her to leave. They react strongly to her statements, such as her claim that the eighty thousand Pakistanis who died in the 2005 earthquake did so because they were involved in "immoral" activities and had left the path of Islam, and fear that her brand of "extremist" Islam will further marginalize their communities within the country (Kohler 2006).

Farhat Hashmi's move to Canada may also have some effect on Al-Huda's development in Pakistan. Although she makes frequent visits to

5. If Internet articles are to be believed, Farhat Hashmi has been residing illegally in Canada since the year 2005, when her work permit was denied and she was told to leave by the Canadian immigration authorities (see K. Hasan 2006 and Kohler 2006).

Pakistan, she will no longer be able to keep as close an eye on the main branches in Pakistan as she used to when she resided in the country. Once again, the impact of both her relocation and the leadership she has left behind can be understood only over time and through further research.

Women continue to attend Al-Huda, and the extent to which they will continue to do so is also closely connected to global politics. The knowledge that Muslims are being persecuted and that Islam is often attacked is increasing the motivation of Muslims, both in Pakistan and elsewhere, to learn more about their religion and to make it an increasing part of their life. What kind of Islam they end up learning is largely dependent on what kind of Islam they have access to. In the case of the women I studied, it was the Islam that was taught at Al-Huda that was the most accessible and gave their faith a concrete shape. It is as they engage with this form of religion that they contribute to a global "Islamic" resurgence, in which being a Muslim often means (because of the particular way a certain kind of Islamic knowledge is being spread globally) dressing in a particular manner, following specific rituals, and adhering to a certain kind of ideology and lifestyle.

Women affiliated with Al-Huda are increasing their own religious knowledge, and also doing as much as they can to infuse society with particular Islamic values. Even if they do not offer *dars*, they all do their best to influence their families and friends. Most women found it easiest to influence their younger children, but with time even the most resistant elder children and other family members began showing change, whether it was in terms of following mainstream Islamic rituals, changing their dress, going to the mosque to pray, or lessening the amount of time they listened to music or watched television. Women from the middle and upper classes were usually married to men who did not follow Islamic rituals, but I heard one story after another of how with patience, tact, and prayer, they were able to convince their husbands to begin offering their prayers and read the Qur'an. It is in this manner, by transforming themselves and influencing others around them within a particular Islamic framework, that they play an active role in attempting to change the very culture of society.

Glossary

•

References

•

Index

Glossary

abaya: A loose cloaklike garment, worn on top of clothes.

akhrat: The hereafter; afterlife.

Alhamdolillah: Thanks be to Allah.

'alim: Religious scholar.

Assalamo'alaikum: Muslim greeting meaning "Peace/blessings be upon you."

basant: A kite-flying festival that marks the beginning of spring.

biddat: Religious innovation.

chador: Similar to a shawl, a chador is a large rectangular cloth that women drape around their body, on top of their clothes. How much of the body it covers, and whether it covers a woman's head and face, depends on the manner in which and reason a chador is worn.

chalisva: A function organized on the fortieth day of a family member's death.

dars: Literally meaning "lesson," a *dars* is a religious lecture or lesson that usually takes place in a residential neighborhood setting, often in someone's home.

Daura-e-Qur'an: Literally meaning a "journey through the Qur'an," this practice is undertaken in the month of Ramadan, when a teacher gives the translation and brief exegetical commentary of one *siparah* or section of the Qur'an per day. Hence, the thirty *siparahs* that constitute the Qur'an are completed in this month. (The Islamic calendar is a lunar one. Hence, the first *siparah* is usually begun a day or two before Ramadan in order to prevent the thirtieth *siparah* from clashing with *'id-ul-fitr* in the event that Ramadan is twenty-nine days long.)

da'wa: Religious outreach or the call to Islam.

dhikr: The remembrance of Allah, commonly taking place through the ritual utterance of His name or His praise.

dopatta: A long, thin rectangular scarf, worn with a *shalwar kamiz.*

du'a: Supplicatory prayer.

Durud Sharif: Invocations made to God to shower blessings upon the Prophet Muhammad.

farishtay: Angels.

fatwa: A religious decree or decision made by a Muslim scholar.

fiqh: Islamic jurisprudence.

fitna: Chaos.

guthli: guthlis are pits, usually of dates or fruits like apricots. They are commonly used in religious rituals where they serve the same purpose as prayer beads, that is, keeping track of the number of times something has been recited.

Hadith: A report of the sayings attributed to the Prophet Muhammad.

hajj: Annual pilgrimage to Mecca in the Muslim month of Dhilhaj.

hijab: Literally meaning "curtain," "partition," or "screen," the word *"hijab"* popularly refers to the head scarf worn by women. It covers the hair and neck.

'id: Literally meaning "celebration," *'id-ul-fitr* takes place at the end of Ramadan, the month of fasting, whereas *'id-ul-adha'* marks the completion of hajj.

imam: A religious leader who is responsible for running a mosque, leading the prayers, and giving sermons.

jihad: Jihad means to strive, whether against weaknesses in oneself or in the larger society.

khatam or *khatam-e-Qur'an:* A *khatam* (literal meaning "end") of the Qur'an refers to a gathering in which the thirty *siparahs* of the Qur'an are distributed among a group of people. With everyone reading different sections of the Qur'an, the entire book is read in one short sitting. Such gatherings can be organized by anyone, anytime of the year, to mark special occasions in their lives.

madrassa: A school for religious study.

maulvi: A religious cleric who is allowed to preach and officiate at religious rituals and functions.

mehndi: Literally meaning "henna," a *mehndi* in the context of this work refers to the henna ceremony that makes up the first day of the three-day wedding in Pakistan. It is an occasion marked with singing, dancing, and a number of rituals blessing the couple.

mehram: A male relative whom a woman cannot marry, such as a father, brother, or nephew.

milad: An event organized to celebrate the Prophet Muhammad's birthday on the twelfth day of the Muslim month of Rabi-ul-Awal.

na mehram: A man whom a woman can potentially marry, and therefore refers to men who are not her father, brothers, and so on.

nazima: The female leader of the women's branch of religious organizations such as the Jama'at-i-Islami and Tehrik-i-Islam. Each town or city has its own *nazima*, who heads the women's branch in that locality.

nikah: Islamic marriage contract.

niqab: A style of veiling that covers a woman's face so only her eyes are visible.

pir: Spiritual guide or faith healer.

purdah: Literally meaning "curtain," purdah also commonly refers to veiling.

qawwali: A musical genre based on devotional Sufi poetry that aims to guide its listeners, especially the ones who understand the poetry, into an ecstatic trance.

ruku: A way of dividing the Qur'an into smaller portions for contemplation. Each *ruku* is made up of about ten or so Qur'anic verses.

shabrat: The fifteenth night of the Muslim month of Shaban that is often spent in prayer and seeking Allah's forgiveness. Special foods are usually cooked, firecrackers are set off in the streets, and some people even decorate their houses by stringing lights outside.

shalwar kamiz: The national dress of Pakistan, made up of baggy pants and a long shirt, worn by both men and women.

sharia: Islamic canonical law.

siparah: A section of the Qur'an. The Qur'an is commonly divided into thirty such sections of more or less equal length. The purpose of this division is to aid the reading process, especially for those individuals wishing to read the entire book in a month.

Sirah: Biography of the Prophet Muhammad.

Sunnah: The collection of sayings and deeds attributed to the Prophet Muhammad.

surah: A chapter of the Qur'an.

tafsir: Exegetical commentary of the Qur'an.

tajvid: The art of Qur'anic recitation.

tasbih: Prayer beads.

ulema: Religious scholars (plural of *'alim*).

zakat: Zakat, like fasting in the month of Ramadan, is considered to be one of the Five Pillars of Islam, and refers to obligatory almsgiving.

zina: An Arabic word referring to extramarital or premarital sex.

References

Abbas, Azmat. 2002. *Sectarianism: The Players and the Game*. Pakistan: South Asia Partnership.

Abbot, Freeland. 1968. *Islam and Pakistan*. Ithaca: Cornell Univ. Press.

Abu-Lughod, Lila. 1990. "Can There Be a Feminist Ethnography?" *Women and Performance* 5, no. 1: 7–27.

———. 1998. "Introduction: Feminist Longings and Postcolonial Conditions." In *Remaking Women*, edited by Lila Abu-Lughod, 3–25. Princeton: Princeton Univ. Press.

Ahearn, Laura. M. 2001. "Language and Agency." *Annual Review of Anthropology* 30: 109–37.

Ahmad, Kamran. 2000. *Exploring Dimensions and Challenges of Pluralism in Pakistan*. Islamabad: Centre for Peace and Pluralism.

———. 2005. "Mental Blocks." *The News* (Islamabad), Apr. 3.

———. 2006. "How They Are Burning Down the Best in Us." *The News* (Islamabad), Jan. 29.

Ahmad, Mumtaz. 1991. "Islamic Fundamentalism in South Asia." In *Fundamentalisms Observed*, edited by Martin Marty and Scott Appleby, 457–530. Chicago: Univ. of Chicago Press.

Ahmed, Akbar S. 1997. *Jinnah, Pakistan, and Islamic Identity*. New York: Routledge.

———. 2002. *Postmodernism and Islam: Predicament and Promise*. New York: Routledge.

Ahmed, Ishtiaq. 1991. *The Concept of an Islamic State in Pakistan*. Lahore: Vanguard.

———. 1999. "South Asia." In *Islam Outside the Arab World*, edited by David Westerlund and Ingvar Svanberg, 212–52. New York: St. Martin's Press.

Ahmed, Leila. 1992. *Women and Gender in Islam*. New Haven: Yale Univ. Press.

Alcoff, Linda. 1993. "Cultural Feminism Versus Post-Structuralism: The Identity Crisis in Feminist Theory." In *Culture/Power/History*, edited by Nicholas B.

Dirks, Geoff Eley, and Sherry Ortner, 96–122. Princeton: Princeton Univ. Press.

———. 2006. *Visible Identities: Race, Gender, and the Self.* New York: Oxford Univ. Press.

Alee-Adnan, Erum. 2004. "Hijab: The Big Debate." *She* (Karachi), Mar.

Al-Huda. 2003. http://alhudapk.com.

———. 2005. "Objectives." http://alhudapk.com//home/about-us/.

Ali, Abdullah Yusuf. 1999. *The Qur'an: Translation.* n.p.: Tahrike Tarsile Qur'an.

Ali, Amena A. 1997. "The Role of Faith Healers in Resolving the Socio-medical Problems of the Village Naniyan." Master's thesis, Quaid-e-Azam Univ.

Ali, Sahar. 2003. "Pakistani Women Socialites Embrace Islam." BBC News, Nov. 6. http://news.bbc.co.uk/2/hi/south_asia/3211131.stm.

Al-Munajjed, Mona. 1997. *Women in Saudi Arabia Today.* New York: St. Martin's Press.

Alvi, Sajida S. 1996. "Islam in South Asia." In *The Muslim Almanac: A Reference Work on the History, Faith, Culture, and Peoples of Islam,* edited by Azim A. Nanji, 55–72. New York: Gale Research.

Anway, Carol L. 1996. *Daughters of Another Path: Experiences of American Women Choosing Islam.* Lee's Summit, Mo.: Yawna Publications.

Armstrong, Karen. 1992. *Muhammad: A Biography of the Prophet.* San Francisco: HarperCollins.

Asad, Talal. 1993. *Genealogies of Religion.* Baltimore: John Hopkins Univ. Press.

Ashcroft, Bill, and Pal Ahluwalia. 2001. *Edward Said.* New York: Routledge.

Ask, Karin, and Marit Tjomsland. 1998. Introduction to *Women and Islamization,* edited by Karin Ask and Marit Tjomsland, 1–16. New York: Berg.

Avis, Hannah. 2002. "Whose Voice Is That? Making Space for Subjectivities in Interviews." In *Subjectivities, Knowledges, and Feminist Geographies,* edited by Liz Bondi et al., 191–207. Lanham, Md.: Rowman and Littlefield.

Aziz, Khursheed K. 1993. *The Murder of History in Pakistan.* Lahore: Vanguard.

Badran, Margot. 1994. "Gender Activism: Feminists and Islamists in Egypt." In *Identity, Politics, and Women,* edited by Valentine Moghadam, 202–27. Boulder: Westview Press.

Beckford, James. 2003. *Social Theory and Religion.* Cambridge: Cambridge Univ. Press.

Benford, Rob. 1993. "Frame Disputes Within the Nuclear Disarmament Movement." *Social Forces* 71, no. 3: 677–701.

Benford, Rob, and David Snow. 2000. "Framing Processes and Social Movements." *Annual Review of Sociology* 26: 611–39.

Berg, Herbert. 2000. *The Development of Exegesis in Early Islam*. Richmond: Curzon Press.

Beyer, Peter. 1994. *Religion and Globalization*. London: Sage.

Bodman, Herbert L. 1998. Introduction to *Women in Muslim Societies: Diversity Within Unity*, edited by Herbert L. Bodman and Nayereh Tohidi. Boulder: Lynne Rienner.

Bordo, Susan. 1989. "The Body and the Reproduction of Femininity: A Feminist Appropriation of Foucault." In *Gender/Body/Knowledge*, edited by Alison Jaggar and Susan Bordo, 13–33. New Brunswick: Rutgers Univ. Press.

Brink, Judy. 1997. "Lost Rituals: Sunni Muslim Women in Rural Egypt." In *Mixed Blessings: Gender and Religious Fundamentalism Cross Culturally*, edited by Judy Brink and Joan Mencher, 199–208. New York: Routledge.

Bruce, Steve. 2000. *Fundamentalism*. Malden, Mass.: Polity Press.

Brysk, Alison. 1995. "'Hearts and Minds': Bringing Symbolic Politics Back In." *Polity* 27, no. 4: 559–85.

Bullock, Katherine. 2002. *Rethinking Muslim Women and the Veil: Challenging Historical and Modern Stereotypes*. Herndon, Va.: International Institute of Islamic Thought.

Burki, Shahid J. 1998. *A Revisionist History of Pakistan*. Lahore: Vanguard.

Burney, Naushaba. 2007. "Covered-Up Fashions." *Dawn*, Nov. 24.

Butler, Judith. 1990. *Body Trouble: Feminism and the Subversion of Identity*. New York: Routledge.

Caplan, Pat. 1993. "Learning Gender: Fieldwork in a Tanzanian Coastal Village, 1965–85." In *Gendered Fields: Women, Men, and Ethnography*, edited by Diane Bell, Pat Caplan, and Wazir Jahan Karim, 168–81. New York: Routledge.

Charrad, Mounira M. 1998. "Cultural Diversity Within Islam: Veils and Laws in Tunisia." In *Women in Muslim Societies: Diversity Within Unity*, edited by Herbert L. Bodman and Nayereh Tohidi. Boulder: Lynne Rienner.

Chatterjee, Partha. 2001. "The Nationalist Resolution of the Women's Question." In *Postcolonial Discourses: An Anthology*, edited by Gregory Castle, 151–65. Malden, Mass.: Blackwell.

Clark, Janine A. 2004. "Islamist Women in Yemen: Informal Nodes of Activism." In *Islamic Activism: A Social Theory Movement Approach*, edited by Quintan Wiktorowicz, 164–84. Bloomington: Indiana Univ. Press.

Clifford, James. 1986. Introduction to *Writing Culture: The Poetics and Politics of Ethnography*, edited by James Clifford and George Marcus, 1–26. Berkeley and Los Angeles: Univ. of California Press.

Comaroff, Jean, and John Comaroff. 1991. *Of Revelation and Revolution: Christianity, Colonialism, and Consciousness in South Africa*. Chicago: Univ. of Chicago Press.

Cooke, Miriam. 2001. *Women Claim Islam*. New York: Routledge.

———. 2002. "Multiple Critique: Islamic Feminist Rhetorical Strategies." In *Postcolonialism, Feminism, and Religious Discourse*, edited by Laura E. Donaldson and Kwok Pui-Lan, 142–60. New York: Routledge.

Cooper, Barbara M. 1998. "Gender and Religion in Hausaland: Variations in Islamic Practice in Niger and Nigeria." In *Women in Muslim Societies: Diversity Within Unity*, edited by Herbert L. Bodman and Nayereh Tohidi. Boulder: Lynne Rienner.

Crapanzano, Vincent. 1986. "Hermes' Dilemma." In *Writing Culture: The Poetics and Politics of Ethnography*, edited by James Clifford and George Marcus, 51–76. Berkeley and Los Angeles: Univ. of California Press.

Dallery, Arleen B. 1989. "The Politics of Writing (the) Body: *Ecriture Feminine*." In *Gender/Body/Knowledge*, edited by Alison Jaggar and Susan Bordo, 52–67. New Brunswick: Rutgers Univ. Press.

Davidman, Lynn. 1991. *Tradition in a Rootless World: Women Turn to Orthodox Judaism*. Berkeley and Los Angeles: Univ. of California Press.

Dear, Michael, Robert Wilton, Sharon Gaber, and Lois Takahashi. 1997. "Seeing People Differently: The Socio-spatial Construction of Disability." *Environment and Planning D: Society and Space* 15: 455–80.

Douglas, Mary. 1966. *Purity and Danger*. New York: Routledge.

Downs, Roger. 1977. *Maps in Minds*. New York: Harper and Row.

Durrani, Atifa. 1991. "Role of Shrine in Solving Psychological Problems among Females." Master's thesis, Quaid-e-Azam Univ.

Duval, Soroya. 1998. "New Veils and New Voices: Islamist Women's Groups in Egypt." In *Women and Islamization*, edited by Karin Ask and Marit Tjomsland, 45–72. New York: Berg.

Eiesland, Nancy L. 1997. "A Strange Road Home: Adult Female Converts to Classical Pentecostalism." In *Mixed Blessings: Gender and Religious Fundamentalism Cross Culturally*, edited by Judy Brink and Joan Mencher, 91–116. New York: Routledge.

Einagel, Victoria I. 2002. "Telling Stories, Making Selves." In *Subjectivities, Knowledges, and Feminist Geographies*, edited by Liz Bondi et al., 223–35. Lanham, Md.: Rowman and Littlefield.

Eisenstein, Zillah. 2004. *Against Empire: Feminisms, Racism, and the West*. New York: Zed Books.

El-Solh, Camillia, and Judy Mabro. 1994. Introduction to *Muslim Women's Choices: Religious Belief and Social Reality*, edited by Camillia El-Solh and Judy Mabro, 1–32. Oxford: Berg.

El-Zein, Abdul Hamid. 1977. "Beyond Ideology and Theology: The Search for an Anthropology of Islam." *Annual Review of Anthropology* 6: 227–54.

Esposito, John L. 1999. "Contemporary Islam: Reformation or Revolution?" In *The Oxford History of Islam*, edited by John L. Esposito, 643–90. Oxford: Oxford Univ. Press.

Ewing, Katherine. 1988. "Introduction: Ambiguity and Shariah." In *Shari'at and Ambiguity in South Asian Islam*, edited by Katherine Ewing, 1–24. Berkeley and Los Angeles: Univ. of California Press.

———. 1990. "The Illusion of Wholeness: Culture, Self, and the Experience of Inconsistency." *Ethos* 18, no. 3: 251–78.

———. 1997. *Arguing Sainthood: Modernity, Psychoanalysis, and Islam*. Durham: Duke Univ. Press.

Fair, Christine. 2004. "Islam and Politics in Pakistan." In *The Muslim World after 9/11*, edited by Angel M. Rabasa et al., 247–96. Santa Monica: RAND Corporation.

Ferree, Myra, and David Merrill. 2000. "Hot Movements, Cold Cognition: Thinking about Social Movements in Gendered Frames." *Contemporary Sociology* 29: 454–62.

"Festivals under Fire." 2004. *She* (Karachi), Mar.

Fontana, Benedetto. 1993. *Hegemony and Power: On the Relation Between Gramsci and Machiavelli*. Minneapolis: Univ. of Minnesota Press.

Foucault, Michel. 1988. "Technologies of the Self." In *Technologies of the Self*, edited by Luther H. Martin, Huck Gutman, and Patrick H. Hutton, 16–49. Amherst: Univ. of Massachusetts Press.

———. 1995. *Discipline and Punishment: The Birth of the Prison*. New York: Vintage Books.

———. 1997. *Ethics: Subjectivity and Truth*, edited by Paul Rabinow. New York: New Press.

Fox, Richard. 1990. Introduction to *Nationalist Ideologies and the Production of National Cultures*, edited by Richard Fox, 1–14. American Ethnological Society Monograph Series, no. 2. Washington, D.C.: American Anthropological Association.

Gatens, Moira. 1996. *Imaginary Bodies*. New York: Routledge.

Geertz, Clifford. 1973. *The Interpretation of Cultures*. New York: Basic Books.

———. 1983. *Local Knowledge: Further Essays in Interpretive Anthropology*. New York: Basic Books.

Gellner, Ernest. 1992. *Postmodernism, Reason, and Religion*. New York: Routledge.

Gilmartin, David. 1998. "A Magnificent Gift: Muslim Nationalism and the Election Process in Colonial Punjab." *Comparative Studies in Society and History* 40, no. 3: 415–36.

Glasse, Cyril. 2002. *The New Encyclopaedia of Islam*. Walnut Creek, Calif.: Alta Mira Press.

Gold, Ann G. 2000. "From Demon Aunt to Gorgeous Bride: Women Portray Female Power in a North Indian Festival Cycle." In *Invented Identities*, edited by Julia Leslie and Mary McGee, 203–30. New York: Oxford Univ. Press.

———. 2001. "Shared Blessings as Ethnographic Practice." *Method and Theory in the Study of Religion* 13: 34–50.

Gourgouris, Stathis. 1996. *Dream Nation: Enlightenment, Colonization, and the Institution of Modern Greece*. Stanford: Stanford Univ. Press.

Graham-Brown, Sarah. 2003. "The Seen, the Unseen, and the Imagined: Private and Public Lives." In *Feminist Postcolonial Theory: A Reader*, edited by Reina Lewis and Sara Mills, 502–19. New York: Routledge.

Grosz, Elizabeth. 1994. *Volatile Bodies: Toward a Corporeal Feminism*. Bloomington: Indiana Univ. Press.

El Guindi, Fadwa. 2003. "Veiling Resistance." In *Feminist Postcolonial Theory: A Reader*, edited by Reina Lewis and Sara Mills, 586–609. New York: Routledge.

Haeri, Shahla. 2002. *No Shame for the Sun: Lives of Professional Pakistani Women*. Syracuse: Syracuse Univ. Press.

Hall, Stuart. 1985. "Signification, Representation, Ideology: Althusser and the Post-Structuralist Debates." *Critical Studies in Mass Communication* 2, no. 2: 91–114.

———. 1989. "Cultural Identity and Cinematic Representation." *Framework* 36: 68–81.

———. 1996. "Introduction: Who Needs 'Identity'?" In *Cultural Identity*, edited by Stuart Hall and Paul du Guy, 1–17. London: Sage.

Hannigan, John. 1991. "Social Movement Theory and the Sociology of Religion: Toward a New Synthesis." *Sociological Analysis* 52, no. 4: 311–31.

Haq, Farhat. 1995. "Women, Islam, and the State in Pakistan." *Muslim World* 86: 159–75.

Haraway, Donna. 1991. "Situated Knowledge: The Science Question in Feminism and the Privilege of Partial Perspective." In *Simians, Cyborgs, and Women*, 183–202. London: Free Association Books.

Harding, Sandra. 1987. "Introduction: Is There a Feminist Method?" In *Feminism and Methodology*, edited by Sandra Harding, 1–14. Bloomington: Indiana Univ. Press.

Harding, Susan F. 2001. *The Book of Jerry Falwell: Fundamentalist Language and Politics*. Princeton: Princeton Univ. Press.

Haroon, Anis. 2002. "Women's Participation in the Muttahida Qaumi Movement." In *South Asia*, vol. 2 of *Muslim Feminism and Feminist Movement: South Asia*, edited by Abida Samiuddin and R. Khanam, 83–120. Delhi: Global Vision.

Harrison, Frances. 2002. "Pakistan Woman Tells of Rape Ordeal." BBC News, Aug. 3. http://news.bbc.co.uk/2/hi/south_asia/2170586.stm.

Hart, Stephen. 1996. "The Cultural Dimensions of Social Movements: A Theoretical Assessment and Literature Review." *Sociology of Religion* 57: 87–100.

Harvey, David. 1990. *The Condition of Postmodernity*. Oxford: Blackwell.

Hasan, Khalid. 2006. "Farhat Hashmi Told to Leave Canada." *Daily Times*, July 18. http://www.dailytimes.com.pk/print.asp?page=2006%5C07%5C18%5C story_18-7-2006_pg1_7.

Hasan, Riffat. 1999. "Feminism in Islam." In *Feminism and World Religions*, edited by Arvind Sharma and Katherine Young, 248–78. Albany: State Univ. of New York Press.

Hashmi, Farhat. n.d.a. *Sacrifice or Valentine*. Audiocassette. Islamabad: Al-Huda Audio Vision.

———. n.d.b. *Islam Main Gaana Bajaana* [Music in Islam]. Audiocassette. Islamabad: Al-Huda Audio Vision.

———. n.d.c. *Purdah*. Audiocassette. Islamabad: Al-Huda Audio Vision.

Hashmi, Taj-ul-Islam. 1992. *Pakistan as a Peasant Utopia: The Communalization of Class Politics in East Bengal, 1920–1947*. Boulder: Westview Press.

Hegland, Mary. 2002. "The Power Paradox in Muslim Women's *Majales:* North-West Pakistani Mourning Rituals as Sites of Contestation over Religious

Politics, Ethnicity, and Gender." In *Gender, Politics, and Islam*, edited by Therese Saliba, Carolyn Allen, and Judith A. Howard, 95–132. Chicago: Univ. of Chicago Press.

Hirschkind, Charles. 2001. "The Ethics of Listening: Cassette-Sermon Audition in Contemporary Egypt." *American Ethnologist* 28, no. 3: 623–49.

Hobsbawm, Eric. 1984. "Introduction: Inventing Traditions." In *The Invention of Tradition*, edited by Eric Hobsbawm and Terence Ranger, 1–14. Cambridge: Cambridge Univ. Press.

Hodgson, Marshall. 1974. *The Venture of Islam*. Chicago: Chicago Univ. Press.

Hoodbhoy, Parvez. 2004. "Schools or Zealot Factories?" *Friday Times*, June 25–July 1.

Hoodfar, Homa. 1997. "The Veil in Their Minds and on Our Heads: Veiling Practices and Muslim Women." In *Women, Gender, Religion: A Reader*, edited by Elizabeth Castelli, 420–46. New York: Palgrave.

Horvatich, Patricia. 1994. "Ways of Knowing Islam." *American Ethnologist* 21, no. 4: 811–26.

Human Rights Commission of Pakistan. 2006. *Annual Human Rights Report for 2005*. Lahore: Human Rights Commission of Pakistan.

Hundt, Gillian. 2000. "Multiple Scripts and Contested Discourse." *Social Policy and Administration* 34, no. 4: 419–33.

Hussain, Zanab. 2004. "Pakistani Channels Push New Boundaries." *Syracuse Post Standard*, Aug. 8.

Ingold, Tim. 1994. "Introduction to Culture." In *Companion Encyclopaedia of Anthropology*, edited by Tim Gold, 329–49. London: Routledge.

International Crisis Group. 2002. *Pakistan: Madrasas, Extremism, and the Military*. n.p.: Asia Report no. 36.

Jalal, Ayesha. 1991. "The Convenience of Subservience: Women and the State of Pakistan." In *Women, Islam, and the State*, edited by Deniz Kandiyoti, 77–114. Philadelphia: Temple Univ. Press.

———. 2001. *Self and Sovereignty: Individual and Community in South Asian Islam since 1850*. New York: Routledge.

James, B. 1996. *Demons and Development: The Struggle for Community in a Sri Lankan Village*. Tucson: Univ. of Arizona Press.

Jansen, Wilhelmina. 1998. "Contested Identities: Women and Religion in Algeria and Jordan." In *Women and Islamization*, edited by Karin Ask and Marit Tjomsland, 73–102. New York: Berg.

Kamalkhani, Zahra. 1998. *Women's Islam: Religious Practice among Women in Today's Iran*. London: Kegan Paul International.

Kandiyoti, Deniz. 1988. "Bargaining with Patriarchy." *Gender and Society* 2, no. 3: 274–90.

————. 1991. Introduction to *Women, Islam, and the State*, edited by Deniz Kandiyoti, 1–21. Philadelphia: Temple Univ. Press.

Kaufman, Debra. 1993. *Rachel's Daughters*. New Brunswick: Rutgers Univ. Press.

Keddie, Nikki. 1999. "The New Religious Politics and Women Worldwide: A Comparative Study." *Journal of Women's History* 10, no. 4: 11–25.

Khan, Nighat S., Rubina Saigol, and Afiya S. Zia. 1994. Introduction to *Locating the Self: Perspectives on Women and Multiple Identities*, edited by Nighat S. Khan, Rubina Saigol, and Afiya S. Zia, 1–19. Lahore: ASR Publications.

Klandermans, Bert, and Dirk Oegema. 1987. "Potentials, Networks, Motivations, and Barriers: Steps Towards Participation in Social Movements." *American Sociological Review* 52: 519–31.

Kohler, Nicholas. 2006. "Good Morning Mrs. Hashmi." *Canada*. http://www.macleans.ca/topstories/canada/article.jsp?content=20060724_130714_130714.

Kurzman, Charles. 2002. "The Globalisation of Rights in Islamic Discourse." In *Islam Encountering Globalisation*, edited by Ali Mohammadi, 131–55. New York: RoutledgeCurzon.

Lal, Jayati. 1996. "Situating Locations: The Politics of Self, Identity, and 'Other' in Living and Writing the Text." In *Feminist Dilemmas in Fieldwork*, edited by Diane L. Wolf, 185–214. Boulder: Westview Press.

Lamb, Sarah. 2000. *White Saris and Sweet Mangoes: Aging, Gender, and Body in North India*. Berkeley and Los Angeles: Univ. of California Press.

Lambek, Michael. 1990. "Certain Knowledge, Contestable Authority: Power and Practice on the Islamic Periphery." *American Ethnologist* 17, no. 1: 23–40.

Larana, Enrique, Hank Johnston, and Joseph Gusfield. 1994. "Identities, Grievances, and New Social Movements." In *New Social Movements: From Ideology to Identity*, edited by Enrique Larana, Hank Johnston, and Joseph Gusfield, 3–35. Philadelphia: Temple Univ. Press.

Lawless, Elaine. 1988. *Handmaidens of the Lord*. Philadelphia: Univ. of Pennsylvania Press.

Lewis, Reina. 2003. "On Veiling, Vision, and Voyage: Cross-Cultural Dressing and Narratives of Identity." In *Feminist Postcolonial Theory: A Reader*, edited by Reina Lewis and Sara Mills, 520–41. New York: Routledge.

MacLeod, Arlene. 1991. *Accommodating Protest: Working Women, the New Veiling, and Change in Cairo*. New York: Columbia Univ. Press.

Maggi, Wynne. 2001. *Our Women Are Free: Gender and Ethnicity in the Hindukush*. Ann Arbor: Univ. of Michigan Press.

Mahmood, Saba. 2003. "Anthropology." In *Encyclopaedia of Women and Islamic Cultures: Methodologies, Paradigms, and Sources*, edited by Suad Joseph, 307–14. Boston: Brill.

———. 2005. *Politics of Piety: The Islamic Revival and the Feminist Subject*. Princeton: Princeton Univ. Press.

Majid, Anouar. 2002. "The Politics of Feminism in Islam." In *Gender, Politics, and Islam*, edited by Therese Saliba, Carolyn Allen, and Judith A. Howard, 53–94. Chicago: Univ. of Chicago Press.

Malhotra, Priya. 2002. "Islam's Female Converts." Allaahuakbar.net. http://www.allaahuakbar.net/womens/islams_female_converts.htm.

Mankekar, Purnima. 1999. *Screening Culture, Viewing Politics*. Durham: Duke Univ. Press.

Marshy, Mona. 2002. "Performing Art and Identities: Artists of Palestinian Origin in Canada." In *Subjectivities, Knowledges, and Feminist Geographies*, edited by Liz Bondi et al., 123–39. Lanham, Md.: Rowman and Littlefield.

Mascia-Lees, Frances E., Patricia Sharpe, and Colleen Cohen. 1989. "The Postmodernist Turn in Anthropology: Cautions from a Feminist Perspective." *Signs* 15, no. 11: 7–33.

McAdam, Douglas. 1994. "Culture and Social Movements." In *New Social Movements: From Ideology to Identity*, edited by Enrique Larana, Hank Johnston, and Joseph Gusfield, 36–57. Philadelphia: Temple Univ. Press.

McDaniel, Timothy. 2005. "Responses to Modernization: Muslim Experience in a Comparative Perspective." In *Modernization, Democracy, and Islam*, edited by Shireen Hunter and Huma Malik, 35–51. Westport: Praeger.

McKenna, Terence. 2006. "Land, Gold, and Women." CBC News, Feb. 28. http://www.cbc.ca/news/background/pakistan/mckenna_pakistan.html.

Mendelsohn, Everett. 1993. "Religious Fundamentalism and the Sciences." In *Fundamentalisms and Society*, edited by Martin Marty and Scott Appleby, 23–41. Chicago: Univ. of Chicago Press.

Menon, Kalyani. 2002. "Dissonant Subjects: Women in the Hindu Nationalist Movement in India." Ph.D. diss., Syracuse Univ.

Menon, Ritu, and Kamla Bhasin. 1998. "Borders and Boundaries: Recovering Women in the Interests of the Nation." In *Borders and Boundaries: Women in India's Partition*. New Delhi: Kali for Women.

Mernissi, Fatima. 2003. "The Meaning of Spatial Boundaries." In *Feminist Postcolonial Theory: A Reader*, edited by Reina Lewis and Sara Mills, 489–501. New York: Routledge.

Metcalf, Barbara. 1984. "Islamic Reform and Islamic Women: Maulana Thanawi's *Jewellery of Paradise*." In *Moral Conduct and Authority: The Place of "Adab" in South Asian Islam*, edited by Barbara Metcalf, 184–95. Berkeley and Los Angeles: Univ. of California Press.

Michaels, Paula. 1998. "Kazak Women: Living the Heritage of a Unique Past." In *Women in Muslim Societies: Diversity Within Unity*, edited by Herbert L. Bodman and Nayereh Tohidi. Boulder: Lynne Rienner.

Moghadam, Valentine. 1994. "Introduction: Women and Identity Politics in Theoretical and Comparative Perspective." In *Identity, Politics, and Women*, edited by Valentine Moghadam, 3–26. Boulder: Westview Press.

Mohanty, Chandra. 1991. "Under Western Eyes: Feminist Scholarship and Colonial Discourse." In *Third World Women and the Politics of Feminism*, edited by Chandra Mohanty, Ann Russo, and Lourdes Torres, 51–80. Bloomington: Indiana Univ. Press.

———. 2003. *Feminism Without Borders: Decolonizing Theory, Practicing Solidarity*. Durham: Duke Univ. Press.

Moore, Henrietta. 1993. "The Differences Within and the Differences Between." In *Gendered Anthropology*, edited by Teresa del Valle, 193–206. London: Routledge.

———. 1994. *A Passion for Difference*. Cambridge: Polity Press.

Mumtaz, Khawar. 1994. "Identity Politics and Women: 'Fundamentalism' and Women in Pakistan." In *Identity, Politics, and Women*, edited by Valentine Moghadam, 228–42. Boulder: Westview Press.

Mumtaz, Khawar, and Farida Shaheed. 1987. *Women of Pakistan: Two Steps Forward, One Step Back?* Lahore: Vanguard Books.

Munir, Mohammad. 1980. *From Jinnah to Zia*. Lahore: Vanguard Books.

Munson, Henry. 1988. *Islam and Revolution in the Middle East*. New Haven: Yale Univ. Press.

Narayan, Kirin. 1993. "How Native Is a 'Native' Anthropologist?" *American Anthropologist* 95: 671–86.

Nasr, Seyyed Vali R. 1994. *The Vanguard of the Islamic Revolution: The Jama'at-i-Islami of Pakistan.* Berkeley and Los Angeles: Univ. of California Press.

———. 1999. "European Colonialism and the Emergence of Modern Muslim States." In *The Oxford History of Islam,* edited by John L. Esposito, 549–99. New York: Oxford Univ. Press.

Parezo, Nancy. 1996. "Material Culture." In *Encyclopaedia of Cultural Anthropology,* edited by David Levinson and Melvin Ember, 747–52. New York: Henry Holt.

Pinault, David. 1992. *The Shiites: Ritual and Popular Piety in a Muslim Community.* New York: St. Martin's Press.

Qureshi, Attiya. 1990. "Women's Spirit Possession in Multan." Master's thesis, Quaid-e-Azam Univ.

Raheja, Gloria, and Ann Gold. 1994. *Listen to the Heron's Words: Reimagining Gender and Kinship in North India.* Berkeley and Los Angeles: Univ. of California Press.

Rapson, Edward James. 1987. *The Cambridge History of India.* New Delhi: S. Chand.

Rashid, Ahmed. 2000. *Taliban.* New Haven: Yale Univ. Press.

Raudvere, Catharina. 1998. "Female Dervishes in Contemporary Istanbul: Between Tradition and Modernity." In *Women and Islamization,* edited by Karin Ask and Marit Tjomsland, 125–46. New York: Berg.

Rose, Gillian. 2002. Conclusion to *Subjectivities, Knowledges, and Feminist Geographies,* edited by Bondi et al., 253–58. Lanham, Md.: Rowman and Littlefield.

Rose, Nikolas. 1996. *Inventing Ourselves.* New York: Cambridge Univ. Press.

Rosenbloom, Rachel. 1995. "Islam, Feminism, and the Lay in Pakistan under Zia." In *Islam and Democracy in Pakistan,* edited by Muhammad Aslam Syed, 243–86. Islamabad: Crystal Printers.

Rouse, Shahnaz. 1984. *Women's Movements in Contemporary Pakistan: Results and Prospects.* Working paper 74. East Lansing: Michigan State Univ.

———. 1996. "Gender, Nationalism(s), and Cultural Identity: Discursive Strategies and Exclusivities." In *Embodied Violence: Communalising Women's Sexuality in South Asia,* edited by Kumari Jayawardena and Malathi Alwis. New Delhi: Kali for Women.

Saeed, Fouzia. 2001. *Taboo! The Hidden Culture of a Red Light Area.* Karachi: Oxford Univ. Press.

Said, Edward. 1981. *Covering Islam.* New York: Pantheon Books.

Saigol, Rubina. 1994. "Boundaries of Consciousness: Interface Between the Curriculum, Gender, and Nationalism." In *Locating the Self*, edited by Nighat S. Khan, Rubina Saigol, and Afiya S. Zia, 41–76. Lahore: ASR Publications.

Saliba, Therese. 2002. "Introduction: Gender, Politics, and Islam." In *Gender, Politics, and Islam*, edited by Therese Saliba, Carolyn Allen, and Judith A. Howard, 1–14. Chicago: Univ. of Chicago Press.

Saliba, Therese, Carolyn Allen, and Judith Howard, eds. 2002. *Gender, Politics, and Islam*. Chicago: Univ. of Chicago Press.

Samiuddin, Abida, and R. Khanam, eds. 2002. *South Asia*. Vol. 2 of *Muslim Feminism and Feminist Movement*. Delhi: Global Vision.

Schensul, Jean, and Margaret LeCompte. 1999. *Ethnographer's Toolkit*. Walnut Creek, Calif.: Alta Mira Press.

Scheper-Hughes, Nancy. 1995. "The Primacy of Ethical: Propositions for a Militant Anthropology." *Current Anthropology* 36, no. 3: 409–20.

Schimmel, Annamerie. 1985. *And Muhammad Is His Messenger: The Veneration of the Prophet in Islamic Piety*. Chapel Hill: Univ. of North Carolina Press.

———. 1994. *Deciphering the Signs of God: A Phenomenological Approach to Islam*. Albany: State Univ. of New York Press.

Schultze, Quentin. 1993. "The Two Faces of Fundamentalist Higher Education." In *Fundamentalisms and Society*, edited by Martin Marty and Scott Appleby, 490–535. Chicago: Univ. of Chicago Press.

Sethi, Najam. 2004. "Pakistan on the Eve of the New Millennium." *Friday Times* (Pakistan).

Shah, Nasra. 1986. *Pakistani Women*. Islamabad: Pakistan Institute of Development Economics.

Shehzad, Mohammad. 2005. "MMA to Ban Women's Photography, Dance, Music." Women Living under Muslim Laws, Feb. 24. http://www.wluml.org/english/newsfulltxt.shtml?cmd%5B157%5D=x-157-121192.

Shostak, Marjorie. 2000. *Return to Nisa*. Cambridge: Harvard Univ. Press.

Siddiqi, Kamal. 2004. "Dars of Pakistan." *Stringer Story: Racconti e storie dall'Asia*. http://www.stringer.it/Stringer%20Schede/STORY/Stringer_story_karachi2.htm.

Smith, Wilfred Cantwell. 1962. *The Meaning and End of Religion*. New York: Macmillan.

Snow, David, Lois A. Zurcher, and Sheldon Ekland-Olson. 1980. "Social Networks and Social Movements: A Micro-Structural Approach to Differential Recruitment." *American Sociological Review* 45: 787–801.

Sonn, Tamara. 2005. "Islam and Modernity: Are They Compatible?" In *Modernization, Democracy, and Islam*, edited by Shireen Hunter and Huma Malik, 65–81. Westport, Conn.: Praeger.

Stacey, Judith. 1988. "Can There Be a Feminist Ethnography?" *Women's Studies International Forum* 11, no. 1: 21–27.

Stowasser, Barbara. 1994. *Women in the Qur'an, Traditions, and Interpretation*. New York: Oxford Univ. Press.

Tadjbaksh, Shahrbanou. 1998. "Between Lenin and Allah: Women and Ideology in Tajikistan." In *Women in Muslim Societies: Diversity Within Unity*, edited by Herbert L. Bodman and Nayereh Tohidi. Boulder: Lynne Rienner.

Tehranian, Majid. 1993. "Fundamentalist Impact on Education and the Media: An Overview." In *Fundamentalisms and Society*, edited by Martin Marty and Scott Appleby, 313–40. Chicago: Univ. of Chicago Press.

Tessler, Mark. 1996. "Gender and Support for Islamist Movements: Evidence from Egypt, Kuwait, and Palestine." *Muslim World* 86: 200–228.

Thornham, Sue. 2000. *Feminist Theory and Cultural Studies: Stories of Unsettled Relations*. New York: Oxford Univ. Press.

Tohidi, Nayereh. 1998. "The Issues at Hand." In *Women in Muslim Societies: Diversity Within Unity*, edited by Herbert L. Bodman and Nayereh Tohidi. Boulder: Lynne Rienner.

Tyler, Stephen. 1986. "Postmodern Ethnography." In *Writing Culture: The Poetics and Politics of Ethnography*, edited by James Clifford and George Marcus, 122–40. Berkeley and Los Angeles: Univ. of California Press.

Upadhyay, R. 2003. *Islamic Institutions in India: Protracted Movement for Separate Identity?* Paper no. 599. Noida, India: South Asia Analysis Group.

Visweswaran, Kamala. 1994. *Fictions of Feminist Ethnography*. Minneapolis: Univ. of Minnesota Press.

Wadley, Susan S. 1983. "Popular Hinduism and Mass Literature in North India: A Preliminary Analysis." In *Religion in Modern India*, edited by Giri Raj Gupta, 81–104. Delhi: Vikas.

———. 1994. *Struggling with Destiny in Karimpur, 1925–1984*. Berkeley and Los Angeles: Univ. of California Press.

Warriach, Aliya. 1997. "An Ethnographic Study of the Shrine of Madhu Lal Husain Shah." Master's thesis, Quaid-e-Azam Univ.

Watt, William Montgomery. 1968. *Muhammad: Prophet and Statesman*. Oxford: Oxford Univ. Press.

———. 1998. *The Formative Period of Islamic Thought.* Oxford: Oneworld Publications.

Weiss, Anita. 1998a. "Pakistan: Some Progress, Sobering Challenges." In *India and Pakistan: Fifty Years of Independence.* Baltimore: John Hopkins Univ. Press.

———. 1998b. "The Slow yet Steady Path to Women's Empowerment in Pakistan." In *Islam, Gender, and Social Change,* edited by Yvonne Haddad and John L. Esposito. Oxford: Oxford Univ. Press.

———. 2002. *Walls Within Walls: Life Histories of Working Women in the Old City of Lahore.* Karachi: Oxford Univ. Press.

Werbner, Pnina. 1996. "The Making of Muslim Dissent: Hybridized Discourses, Lay Preachers, and Radical Rhetoric among British Pakistanis." *American Ethnologist* 23, no. 1: 102–22.

Wickham, Carrie. 2004. "Interests, Ideas, and Islamist Outreach in Egypt." In *Islamic Activism: A Social Theory Movement Approach,* edited by Quintan Wiktorowicz, 231–49. Bloomington: Indiana Univ. Press.

Wickham-Crowley, Timothy. 1992. *Guerrillas and Revolution in Latin America.* Princeton: Princeton Univ. Press.

Wiktorowicz, Quintan. 2004. "Introduction: Islamic Activism and Social Movement Theory." In *Islamic Activism: A Social Theory Movement Approach,* edited by Quintan Wiktorowicz, 1–33. Bloomington: Indiana Univ. Press.

Wilder, Andrew. 1995. "Islam and Political Legitimacy in Pakistan." In *Islam and Democracy in Pakistan,* edited by Muhammad Aslam Syed, 31–88. Islamabad: Crystal Printers.

Williams, Raymond. 1958. *Culture and Society, 1780–1950.* Harmondsworth: Penguin.

Wolf, Diane L. 1996. "Situating Feminist Dilemmas in Fieldwork." In *Feminist Dilemmas in Fieldwork,* edited by Diane L. Wolf, 1–55. Boulder: Westview Press.

Wolf, Margery. 1992. *A Thrice-Told Tale.* Stanford: Stanford Univ. Press.

Woodhull, Winifred. 2003. "Unveiling Algeria." In *Feminist Postcolonial Theory: A Reader,* edited by Reina Lewis and Sara Mills, 567–85. New York: Routledge.

Yegenoglu, Meyda. 2003. "Veiled Fantasies: Cultural and Sexual Difference in the Discourse of Orientalism." In *Feminist Postcolonial Theory: A Reader,* edited by Reina Lewis and Sara Mills, 542–66. New York: Routledge.

Yuval-Davis, Nira. 1997. *Gender and Nation*. London: Sage.

Zavella, Patricia. 1996. "Feminist Insider Dilemmas: Constructing Ethnic Identity with Chicana Informants." In *Feminist Dilemmas in Fieldwork*, edited Diane L. Wolf, 138–59. Boulder: Westview Press.

Index

Abu-Lughod, Lila, 11, 54, 57, 186
Ahmad, Kamran, 27, 28, 53, 143, 149, 189, 190
Ahmad, Mirza Ghulam, 72n
Ahmad, Mumtaz, 33, 161
Ahmed, Akbar, 30, 102n, 132, 133, 138, 150
Ahmed, Leila, 124, 160, 161, 169n9
Alcoff, Linda, 147, 172, 173n
Al-Huda: aim, 2, 58–59, 181; branches, 47; claim to promote "true" Islam and its consequences, 40, 140, 189; constructing culture, 24, 68; courses and curriculum, 41–42, 43, 44; creation of hegemonic Islamic ideology, 74–76; criticism of, 88–89; da'wa, 1, 45–46; discourse on gender roles, 89, 114, 184; on folk Islam, 3, 40, 140–41 (see also chalisva, milad, pir, qawwali, shabrat); funding, 46, 46n; global expansion, 46–47, 196; internal tensions, 84–86, 159n; markers of success, 1, 52, 60, 82, 189; meaning of, 1; on male-female friendships, 87; in media, 1, 3; "modern" and "rational," 66, 67–69, 70n, 71–74, 73n, 85, 103, 133, 159; national expansion, 45, 46; reliance upon media/technology, 48–50, 133; religious positioning, 38, 40 (see also Hashmi, Farhat: ideology); as social

movement, 61–62; social welfare, 195–96; teachers and staff, 83–84; uniform, 45, 155
Americans: anger toward, 152–53; perception of, 133–34, 148. See also West
Arabic: at Al-Huda, 41, 68, 76, 77, 79, 157; Farhat Hashmi's degree in, 39; importance given to, 65 (see also du'a: emphasis on Arabic); at Islamic University, 42; students' exposure to, 62, 65, 125; usage in various dars, 95, 96, 100, 101, 119; visibility in public, 37
Armstrong, Karen, 93
Asad, Talal, 2, 15, 23, 60, 62, 67, 69, 75, 79
Aziz, K. K., 33, 143

basant, 141, 142, 186
Benford, Rob, 62, 66, 67, 72, 73, 74, 83
Bhutto, Benazir, 35, 37
Bhutto, Zulifqar Ali, 31–32, 35, 72n
biddat, 88, 99, 100, 106, 107, 111, 115, 145
birthday, 27, 107, 146, 188. See also milad
bodies: defining boundaries, 160; inscribed and layered, 162, 164, 171–73, 172n12; and national development, 171–72; and patriarchy,

221

Gandhara Civilization, 187, 188
Geertz, Clifford, 17, 19, 57
Gellner, Ernest, 73
Ghaznavi, Mahmud, 191
Gilmartin, David, 30
globalization, 131, 132, 133, 186
Gold, Ann, 18, 21, 105, 108, 161, 173
Graham-Brown, Sarah, 160, 161, 185

Haeri, Shahla, 21, 55, 57, 58n, 72, 105
Hajj, 14, 44, 116
Hall, Stuart, 56, 58, 75, 113, 146, 171, 173
Haq, Abrar-ul, 190
Haq, Zia-ul, 32–35, 35n, 37, 55, 103n, 137, 137n5
Haraway, Donna, 11, 15, 16, 17, 20, 181
Harding, Sandra, 15, 18, 19
Hasan, Riffat, 98, 161, 162n
Hashmi, Farhat: characteristics and style, 72, 74, 76, 108; creating the sexual body, 158n; criticism of, 139; education, 38, 39–40; ideological positioning, 40, 74–75 (see also Al-Huda: religious positioning); on "the West," 139, 141
Hindu: and Two-Nation Theory, 53; construction of, 132, 132n; fear of being dominated by, 29; as "Other," 54–55, 147, 148, 149; traditions as a threat, 149 (see also basant; holi; mehndi)
Hinduism (perceived links with basant), 142
Hindu Nationalist Movement, 13, 195
Hobsbawm, Eric, 17
Hodgson, Marshall, 28, 28n2
holi, 148, 148n
homosexuality, 141

Hoodbhoy, Parvez, 37, 39n12, 54
Hudood Ordinance, 33–34, 34n, 36, 37, 103n

'id, 14, 44, 70n, 81, 108
identity: fear of losing, 149; formation, 146–47, 149; multiple and expansive, 11, 57–58, 181, 187; Muslim, refashioned and heightened, 131, 151, 153–54, 186, 187, 188
immorality, 120n, 133, 136, 196
imperialism, 136, 160, 186
Indus Valley Civilization, 187
Islam: Ahl-e-Hadith, 27, 28, 28n2, 29, 37, 40, 93; Ahmadi, 32, 72, 72n, 189; Barailvi, 26–27, 28, 40, 88, 93; Deobandi, 27–28, 28n2, 29, 33, 37, 38, 40, 93, 101; and formation of Pakistan, 29–30; high and low, 72–73; ideological disagreements among women, 92, 98, 99–100, 107–8, 111, 114; sectarian division in Pakistan, 26; Shiite, 25–26, 33; Wahabi, 27, 33, 111, 111n, 114
Islamabad: Al-Huda's location in, 41; culture of, 131; distance to Taxila, 188; Farhat Hashmi's history in, 40; history of Islamic education in, 4, 5, 6, 65; layout of, 22; researcher's connection to and impact of, 1, 7, 11, 12; site of fieldwork, 1, 5; visible Islamization of, 37–38, 155.
Islamic Grammar School, 150–51
Islamic schools of law, 28n2
Islamic University (Islamabad), 40, 42
Islami Jam'iat-e-Tulabah, 39, 39n12
Islamization: contribution of U.S. foreign policy, 36, 53; external links, 32, 33, 37; reaction to social change, 138;

distraction and danger, 102, 139, 147; given up, 3, 122, 145, 162, 178; and Pakistani culture, 57–58, 130, 142 (*see also* Junoon; Mazmoon-e-Shauq); and Sufism/indigenous Islam, 6, 93, 99 (*see also* qawwali); reduction through da'wa, 45, 197

Muslim League, 29, 35, 53

Muttehida Majlis-e-Amal (MMA), 36, 37

Narayan, Kirin, 7, 10, 12, 16, 18, 20

Nasr, Seyyed Vali, 5, 6, 39, 39n12, 61

national ideology (of Pakistan). *See* Two-Nation Theory

native anthropologist, 3, 7, 12, 15

nikah, 57, 57n, 142n10

patriarchy: facilitating violence, 172; and good woman–bad woman divide, 135n3, 136, 184; in Pakistan, 55, 105; reinforced at Al-Huda, 73, 89. *See also* bodies: and patriarchy; women: honor and sexual "purity"

People of the Book, 149

piety: differential constructions, 192; leading to cultural change, 186; means of resisting the West, 134; product of particular Islamic framework, 24, 64, 129; through a singular path, 4. *See also* Mahmood, Saba: creation of pious subjects; veiling: manifestation of faith/piety

Pinault, David, 25

pious subjects: Al-Huda's goal, 2, 106; creation of, 2, 8, 23, 24, 67, 79, 91, 119, 129, 149, 158, 170, 181, 182 (*see also* Al-Huda: "modern" and "rational"; Mahmood, Saba: creation of pious subjects); desire to be, 61–62, 140, 159, 170, 182, 183 (*see also* students: changes undergone; veiling: manifestation of faith/piety)

pir, 27, 50

Qasim, Muhammad Bin, 143, 191

qawwali, 27, 98, 101

Ramadan: activities in, 40, 44, 50, 58, 64, 70, 118, 119, 121, 122; fasting in, 14, 62, 80, 118, 125

rape, 103–4, 169, 172, 185, 185n. *See also* Hudood Ordinance; sexual offenses

research: emic/etic, 16–17, 20, 181; motivation for, 4, 8, 16, 17; objective/subjective, 15–16, 19; people's opinion of, 10; positionality, 3–4, 11–12, 16, 19, 181, 191 (*see also* situated knowledge); power displayed by researcher, 17–18, 19; power displayed by subjects, 18; research question, 5; Self/Other, 10; subjects of, 21, 96n; tools, 8–9

Rich, Adrienne, 172

Rouse, Shahnaz, 31, 33, 54n, 83

Rubina, 12–13, 80–82, 191–93

Saeed, Fouzia, 15, 58n, 136, 145n

Said, Edward, 149, 150, 153

Saigol, Rubina, 29, 35n, 53, 83

Saudi Arabia, 27, 28n2, 32, 33, 37, 46–47n, 122, 143

Schimmel, Annamerie, 26, 27

sectarianism, 33, 75; transcending sectarianism, 29n, 38